The Practice of Theory

Also by Keith Moxey

Pieter Aertsen, Joachim Beuckelaer, and the Rise of Secular Painting in the Context of the Reformation (1977)
Peasants, Warriors, and Wives: Popular Imagery in the Reformation (1989)
Visual Theory: Painting and Interpretation, coeditor (1991)

The Practice ~ of ~ Theory

Poststructuralism, Cultural Politics,
and Art History

Keith Moxey

Cornell University Press

ITHACA AND LONDON

First published 1994 by Cornell University Press.
First printing, Cornell Paperbacks, 1994.
Second printing 1994.

Printed in the United States of America

♾ The paper in this book meets the minimum requirements of the American National Standard for Information Sciences—Permanence of Paper for Printed Library Materials, ANSI Z39.48-1984.

Library of Congress Cataloging-in-Publication Data

Moxey, Keith, P. F., 1943–
The practice of theory : poststructuralism, cultural politics, and art history / Keith Moxey.
p. cm.
Includes bibliographical references and index.
ISBN 0-8014-2933-1 (cloth). —ISBN 0-8014-8153-8 (paper)
1. Art—Historiography. 2. Deconstruction—Influence. 3. Art criticism—Methodology. I. Title.
N380.M68 1994
707′ .2—dc20
93-27229

To Alexander (1977–1992)

It is rightly said that theory, if not received at the door of an empirical discipline, comes in through the chimney like a ghost and upsets the furniture. But it is no less true that history, if not received at the door of a theoretical discipline dealing with the same kind of phenomena, creeps into the cellar like a horde of mice and undermines the groundwork.

—Erwin Panofsky, *Meaning in the Visual Arts*

Contents

List of Illustrations ix

Preface xi

Introduction: *History, Theory, Cultural Politics* 1

PART ONE Cultural Politics: Theory

Introduction 23

Chapter One *Representation* 29

Chapter Two *Ideology* 41

Chapter Three *Authorship* 51

PART TWO Cultural Politics: Practice

Chapter Four *Panofsky's Melancolia* 65

Chapter Five *The Paradox of Mimesis* 79

Chapter Six *Seeing Through* 99

Chapter Seven *Making "Genius"* 111

Index 149

Illustrations

1. Albrecht Dürer, *Melencolia I* 73
2. *Erwin Panofsky*, photograph 76
3. Erhard Schön, *There Is No Greater Treasure Here on Earth Than an Obedient Wife Who Covets Honor* 84
4. Barbara Kruger, *Untitled (We won't play nature to your culture)* 95
5. Julian Schnabel, *Exile* 97
6. Hans Burgkmair the Elder, *Portrait of Martin Schongauer (?)* 100
7. Martin Schongauer, *Virgin in a Rose Arbor* 104
8. Stefan Lochner, *Virgin in a Rose Arbor* 105
9. Hieronymus Bosch, *The Garden of Earthly Delights* 116–17
10. Jan Gossaert, *Hercules and Dejaneira* 118
11. Hieronymus Bosch, *The Cure of Folly* 120
12. Jan Gossaert, *Neptune and Amphitrite* 121
13. Anonymous, *Ventricles of the Brain* 124
14. Leonardo da Vinci, *Ventricles of the Brain* 125
15. Albrecht Dürer, *Self-Portrait* 126
16. Jan van Eyck (copy), *Holy Face of Christ* 127
17. Master of the Die, *Grotesque Ornament* 130
18. Anonymous, "Men Defending Castle against Hares," *Metz Pontifical* 132
19. Anonymous, "Battle for the Pants," *Voeux du Paon* 133
20. Anonymous, "Man Hunted by Hare," *Romance of Alexander* 134
21. Anonymous, "Double-headed Monster," *Luttrell Psalter* 135
22. Hieronymus Bosch, *The Garden of Earthly Delights* (detail of pool occupied by nude women in middle ground of central panel) 137
23. Master of the Power of Women, *Allegory of the Power of Women* 138
24. Hieronymus Bosch, *The Garden of Earthly Delights* (detail of couple in bubble in middle ground of central panel) 139
25. Hieronymus Bosch, *The Garden of Earthly Delights* (detail of center of fountain in background of central panel) 141
26. The Housebook Master, *Parodic Coat of Arms* 142
27. Hieronymus Bosch, *The Garden of Earthly Delights* (detail of foreground of right wing) 143

Preface

The title of this book requires some explanation. "The Practice of Theory" is not meant to suggest that theory and practice constitute a binary opposition, an antithetical polarity. "The practice of theory" is not just another way of saying that theory must be put into practice. It is meant to suggest that these apparently incompatible concepts are symbiotically related, that the historian cannot have one without the other. "The Practice of Theory" claims that just as any cultural practice, say, the writing of history, cannot be undertaken without reference to theory, so theory cannot be formulated outside of historical circumstances. Rather than invoke the traditional metaphors of surface and depth, according to which theory is said to lie at a deeper, more foundational level than practice, I would argue that both types of cultural activity lie in the same intellectual plane.

Such ideas are hardly new. In fact they have become something of a commonplace in other fields of the humanities and have already had enormous effects on art history. I believe, however, that their full implications for art historical practice have not yet been fully articulated. Far from constituting an assault on previous conventions of art history writing, for which the assembling and interpretation of empirical evidence remains a crucial concern, this book is intended to promote a theoretical awareness that will enable such traditions to locate themselves within the broader intellectual landscape offered by the humanities as a whole. Far from suggesting that what has come to be known as "traditional" art history is untheorized, I believe that it is important to denaturalize its theoretical assumptions so that they can be evaluated in the context of the intellectual concerns of our own time. This book is meant to challenge the claim that there is no place in art history for theory and that our discipline's success depends upon its capacity to assume that the theories on which it bases its results cannot be called into question. James Elkins, for example, has maintained that art history's refusal of self-reflexivity, its deliberate avoidance of theoretical speculation, is a characteristic of its identity as a discipline. He suggests that this lack of theoretical

awareness, art history's unacknowledged debt to Hegelianism, is what endows its texts with their cultural interest.[1] In my opinion, this theoretical justification of theoretical innocence serves to prevent art historians from coming to grips with the broader cultural implications of their scholarly activity. Whereas Elkins posits a simple, unconflicted art historical voice, I would argue for the recognition of many. As long as art history is thought to speak with one voice, it will be impossible to recognize the viability of contestatory discourses. An appreciation of theoretical differences will enable us to understand how the dominant voice is associated with a political position, one that can either be supported or be called into question.

An insistence on historical circumstance as the ultimate ground of both theorization and empirical investigation in historical interpretation opens the door to a consideration of politics. Historical circumstances are inevitably characterized by political conflicts and ideological struggles. This book argues that these struggles and conflicts are necessarily manifested in historical writing. All cultural practice is shaped by political considerations. Such views will undoubtedly be regarded with distaste by many in academic life. As a cultural institution, higher education makes every effort to differentiate itself from the rough and tumble of political strife. Scholarship is supposed to rise above such matters, and the "ivory tower" is still as much an ideal as it is a caricature. It is by excluding politics from its purview that the academy continues to serve as a bastion of the status quo. If academies refuse to cater to the myth of their political neutrality, then they are considered to have exceeded the bounds of their social function. The recent battles over "political correctness" are testimony to the intolerance of political conservatism for a professoriat that fails to subscribe to its racial, social, and gender hierarchies.

The argument that all interpretation is political has traditionally been pilloried as reductive. Those who suggest that intellectual positions cannot be divorced from the cultural location in which they are produced are accused of failing to respect the subtlety and complexity, not to mention the lofty idealism, of the hermeneutic enterprise. From this perspective, what I propose appears to short-circuit a painstaking engagement with the past by insisting that historical writing must necessarily project the values of the present. An awareness of the role of the historian in shaping the textual and pictorial remains of the past does not entail a neglect of the historical horizon under consideration. It does mean, however, that it is only if we historicize the position of the interpreter, if we can attempt to articulate our values and relativize our claims to knowledge in the light of our cultural specificity, that

1. James Elkins, "Art History without Theory," *Critical Inquiry* 14 (1988): 354–78. For the opposite argument, an attack on the Hegelian tradition in art historical writing, see Stephen Melville, "The Temptation of New Perspectives," *October* 52 (1990): 3–15.

we can fully recognize the political significance of what we write. This insistence on the "politics" of history will be particularly irksome to those who believe in the immanence of their own interpretations, those who believe that their histories actually coincide with the "order of things." The scholar's identification with the interpretation of the historical circumstances he or she purports to explain, a methodological strategy of foundational importance for the writing of history, can no longer be subscribed to without challenge. The circumstances in which history is written have been dramatically transformed by political and cultural developments. It cannot be assumed that author and reader will share a common set of cultural values. Factors of race, class, gender, sexual preference, and cultural background play an important role in both the production and consumption of knowledge. Every cultural discourse, including that of history, must acknowledge the extent to which the values it depends on are both partisan and relative.

What I argue here, however, does not amount to a facile new form of relativism. In claiming that historical interpretation is politically inflected, that there is no access to the truth, I do not suggest that all histories are equally valid. An argument that insists on the political ground of interpretation cannot conceal its own commitment to a particular perspective. Historical interpretations are valued or devalued according to the way in which their articulation of the concerns of the present in the context of the study of the past either coincides or differs with our own perspective on the political and cultural issues of our time.

This book was written at the Getty Center for the History of Art and the Humanities during the academic year 1991–1992. I am grateful to the former director, Kurt Forster, and to Thomas Reese, now acting director, for the opportunity to take part in their extraordinary intellectual venture and to make use of the center's superb facilities. My stay in Santa Monica was made productive and pleasant by all those associated with the Scholars Program. I especially thank Herbert Hymans, Gretchen Trevisan, Maria Deluca, Kimberley Santini, Daisy Diehl, Arthur Elswood, and Brent Maddox.

The theoretical issues considered in Part I have concerned me for a number of years. I first began to think about them seriously in connection with a Summer Institute, "Theory and Interpretation in the Visual Arts," sponsored by the National Endowment for the Humanities, which was held at Hobart and William Smith Colleges in Geneva, New York, in 1987. As codirector of the institute (along with Michael Holly), I was able to help organize a seminar that brought together art historians of widely differing methodological approaches. In addition to fellow faculty members Svetlana Alpers, Michael Podro, and David Summers, we invited Michael Baxandall, Norman Bryson, Arthur Danto, Michael Fried, Rosalind Krauss, Dominick LaCapra, Linda

Nochlin, and Richard Wollheim as speakers. Since the speakers often stayed for several days, it was possible to pursue extended discussions about the methodological structure of their contributions. Seminar discussions were lively and intense, passionately engaged with the intellectual debates that were entering art historical discourse.

Inspired by the success of the 1987 institute, we planned a second one for the summer of 1989, this one held at the University of Rochester. Faculty members were Mieke Bal, Norman Bryson, and Wolfgang Kemp. On this occasion we made a special effort to include lecturers from other disciplines, such as film studies and cultural studies, whose work focused on the interpretation of images. We were fortunate to elicit contributions from Thomas Crow, Michael Podro, David Summers, Griselda Pollock, Lisa Tickner, John Tagg, Constance Penley, Kaja Silverman, and Andrew Ross. Much of this book is indebted to the insights of the faculty and lecturers associated with the institutes, as well as to the participants. Among the latter, I learned a great deal from conversations with Stephen Melville, Shelly Errington, Annabel Wharton, Ellen Todd, Martin Donougho, George Custen, Irit Rogoff, Whitney Davis, Ernst von Alphen, Michael Quinn, and Julie Codell.

The ideas developed in the context of these seminars have also become part of my graduate and undergraduate teaching, and I thank my students at the University of Virginia, Barnard College, and Columbia University for the opportunity to keep thinking and talking about them. Among those I recall most vividly are Elisa Barsoum, Asha Chatlani, Matthew Bottvinik, Gary van Wyk, Benjamin Binstock, Marek Wieczorek, John Peffer, Alastair Wright, Gordon Simpson, Jonathan Applefield, Meredith Davis, Jennifer Kabat, and Moé Chang.

The chapters in Part I constitute an expansion and revision of the ideas published in the following articles: "Semiotics and the Social History of Art," *New Literary History* 22 (1991): 985–99, and "The Social History of Art in the Age of Deconstruction," *History of the Human Sciences* 5 (1992): 37–46. The essays collected in Part II are based on talks given at a number of institutions and symposia in the past few years. Chapter 4 began as a talk delivered at a symposium held in honor of Julius Held at the Department of Art History and Archaeology, Columbia University, in April 1990. Another version was read at the International Congress of the History of Art, Berlin, in July 1992. Chapter 5 grew out of a talk delivered at the "Attending to Women" symposium held at the Center for Renaissance and Baroque Studies at the University of Maryland in November 1990. I thank Nanette Salomon for the invitation to take part. Chapter 6 is based on a talk delivered at the Martin Schongauer Colloquium held in Colmar in September 1991, to which I was invited by Albert Châtelet. Chapter 7 was first presented at a conference titled "The Pursuit of the Ordinary" organized by Ruth Mellinkoff for the Center

for Medieval and Renaissance Studies at the University of California, Los Angeles, in December 1987. All these talks have been reworked and rewritten for inclusion here.

The ideas that animate this book have been shaped by both the work and the conversation of many of my colleagues and friends, among whom Norman Bryson, Mieke Bal, Natalie Kampen, John Tagg, Janet Wolff, Mark Cheetham, Kaja Silverman, Peter Parshall, Ernst van Alphen, Tony Vidler, and Emily Apter deserve particular mention. Special thanks are due to John Tagg for sharing the manuscript of his book *Grounds of Dispute* with me prior to its publication. I also acknowledge Pauline Maguire, Claudia Swan, Katie Hauser, Pamela Fletcher, and Lisa Zeidenberg for their invaluable assistance in the preparation of the manuscript and Barnard College for a grant that covered most of the expense involved in the acquisition of the photographs and the permissions to reproduce them. My greatest debt, both intellectual and personal, is to Michael Holly, without whom I would not have found the space to write this book. It is dedicated in loving memory to her son Alexander.

KEITH MOXEY

New York City

The Practice of Theory

Introduction:
History, Theory, Cultural Politics

It is therefore far from being the case that the search for intelligibility comes to an end in history as though this were its terminus. Rather, it is history that serves as the point of departure in any quest for intelligibility.
—Claude Lévi-Strauss, *The Savage Mind*

Every putative investigation of the past is and can only be a meditation on that part of the present that is really either a trace or a sublimation of some part of the past.
—Hayden White, *The Content of the Form*

The language of the past is always oracular: you will only understand it as builders of the future who know the present.
—Friedrich Nietzsche, *The Use and Abuse of History*

Art historians have tended to treat the theoretical innovations of poststructuralism with unease and suspicion, considering many of them ahistorical and inimical to history's status as a legitimate form of knowledge. As a consequence, these theoretical initiatives have been ignored as irrelevant or explicitly rejected and disparaged as misguided and wrongheaded. Of all the developments associated with poststructuralism, none has caused greater alarm and despondency than the intellectual movement of deconstruction associated with the work of the philosopher Jacques Derrida. Derrida's convincing exposure of the way in which language conveys both a presence and an absence of meaning, the way it creates "meaning effects" through a shifting and unstable system of signs, has been viewed, among other things, as an attack on the very possibility of writing history. If the use of language is inevitably associated with metaphysical claims its sign systems cannot substantiate, then the writing of historical narratives can be regarded only as an exercise in mythmaking.

It is not surprising that many historians should have closed ranks against what appears to be a devastating indictment of how they think and work. Historians have traditionally tended to believe that historical interpretation has something to do with the truth. Possessed of an undeniable guild mental-

ity, a certain pride in the craft skills required for admission to membership, historians often operate on the assumption that theirs is a communal effort in which every "discovery," every new "contribution," represents a step toward some never fully articulated goal of complete enlightenment.

In this chapter, I argue, however, that far from being either irrelevant or inimical to the writing of history, deconstruction contains an insight of fundamental importance for the historian's conception of what he or she is doing. An awareness of how historical narratives are invested with the values of the present serves to historicize the activity of the historian. I suggest, further, that in deconstructing the notion of history, we can historicize the notion of deconstruction. In other words, I propose to use theory to understand history and history to understand theory in order to argue that we can construct a more perceptive account of the cultural and social function of what we do if we acknowledge that history necessarily engages in the fabrication of metaphysical narratives that bear an arbitrary relation to reality. The historical enterprise takes on fresh significance and new meaning once the nature of its claims to knowledge have been recognized and accepted for what they are. Historians are thus empowered to eradicate the myth of objectivity with which our discipline has struggled for so long, as well as to manifest the concerns that animate the culture of which they are a part.

In rejecting poststructuralist theory, positivist historians have been reluctant to provide their own account or theory of just what history consists of. History is invoked as if it were an unchanging metaphysical essence whose meaning is self-evident. According to one unproblematized notion of history, historians work to elaborate narratives that correspond perfectly with the circumstances they purport to describe. In order to be completely faithful to the facts, to "let the facts speak for themselves," historians are supposed to divest themselves of any values belonging to the present which might distort an appreciation of the historical event "on its own terms." By contrast, historians with a more self-conscious grasp of the hermeneutic project, those who are prepared to admit that it is impossible ever to understand the past in all its complexity, often subscribe to a "developmental" view, according to which every new interpretation of a historical subject brings us closer to an understanding of its true significance. Although every particular interpretation must inevitably fail in one respect or another, the accumulation of interpretations is thought to lead to ever greater understanding. Like the belief that objectivity is attainable, this view ultimately depends on a commitment to empirical evidence. That is, the more of it that has been taken into consideration, the better the conditions for interpretation.

This positivistic understanding of history has been explicitly rejected by a number of studies in the philosophy of history. Hayden White, Dominick

LaCapra, Frank Ankersmit, and other historiographers have emphasized that historical narratives owe more to the language in which they are cast than to the circumstances they purport to relate.[1] According to White, an awareness of the autonomous power of language as a constitutive agent in the production of historical narratives has undermined the traditional epistemological foundation on which history was once thought to rest:

> It now seems possible to hold that [a historical] explanation need not be assigned unilaterally to the category of the literally truthful on the one hand or the purely imaginative on the other, but can be judged solely in terms of the richness of the metaphors which govern its sequence of articulation. . . . Then we should no longer naively expect that statements about a given epoch or complex of events in the past "correspond" to some pre-existent body of "raw facts." For we should recognize that *what constitutes the facts themselves* is the problem that the historian, like the artist, has tried to solve in the choice of the metaphor by which he orders his world, past, present and future.[2]

Just as important as the emphasis on the power of language in the construction of historical narratives is the concomitant awareness that the historian encounters the past only by means of linguistic representations. That is, historians do not deal with what might be called the raw material of history, with events and life experiences; instead, as LaCapra points out, their understanding of the past is always mediated by texts. Claiming that historians all too frequently read historical texts in a reductive, one-dimensional way, LaCapra describes the approach to historical texts, particularly texts of some literary pretensions, as an encounter with the "other." That is, the historian should not simply read the text as a document but enter into a "dialogue" with it:

> I want to begin to address these questions by distinguishing between "documentary" and "worklike" aspects of the text. The documentary situates the text

1. See, for example, Hayden White, *Tropics of Discourse: Essays in Cultural Criticism* (Baltimore: Johns Hopkins University Press, 1985); idem, *The Content of the Form: Narrative Discourse and Historical Representation* (Baltimore: Johns Hopkins University Press, 1987); Michel de Certeau, *The Writing of History*, trans. Tom Conley (New York: Columbia University Press, 1988); Donald Spence, *Narrative Truth and Historical Truth: Meaning and Interpretation in Psychoanalysis* (New York: Norton, 1982); Dominick LaCapra, *Rethinking Intellectual History: Texts, Contexts, Language* (Ithaca: Cornell University Press, 1983); idem, *History and Criticism* (Ithaca: Cornell University Press, 1985); idem, *Soundings in Critical Theory* (Ithaca: Cornell University Press, 1989); F. R. Ankersmit, *Narrative Logic: A Semantic Analysis of the Historian's Language* (The Hague: Martinus Nijhoff, 1983); idem, "The Dilemma of Contemporary Anglo-Saxon Philosophy of History," *History and Theory* 25 (1986): 1–27; Lionel Gossman, *Between History and Literature* (Cambridge: Harvard University Press, 1990).

2. Hayden White, "The Burden of History," in *Tropics of Discourse*, 27–50, 46–47.

in terms of factual or literal dimensions involving reference to empirical reality and conveying information about it. The worklike supplements empirical reality by adding to, and subtracting from, it. It thereby involves dimensions of the text not reducible to the documentary, prominently including the roles of commitment, interpretation and imagination. The worklike is critical and transformative, for it deconstructs and reconstructs the given, in a sense repeating it but also bringing into the world something that did not exist before in that significant variation, alteration, or transformation. With deceptive simplicity, one might say that while the documentary marks a difference, the worklike makes a difference—one that engages the reader in recreative dialogue with the text and the problems it raises.[3]

Just as the historian questions the text, says LaCapra, so the text questions the historian: "His own horizon is transformed as he confronts still living (but often submerged or silenced) possibilities solicited by an inquiry into the past. In this sense, the historicity of the historian is at issue both in the questions he poses and . . . in the 'answers' he gives in a text that itself reticulates the documentary and the worklike."[4]

Sensitive to how texts mediate historians' access to the past, LaCapra attempts to collapse the distinction between the text that concerns them and the historical context in which it was created. He argues that the context is not simply a prelinguistic given; it is just as thoroughly textualized as the text that is the object of the historians' interest. In other words, historians cannot interpret a privileged text against some "harder" reality, for that "reality" is itself constituted by other texts:

> More generally, the notion of textuality serves to render less dogmatic the concept of reality by pointing to the fact that one is "always already" implicated in problems of language use as one attempts to gain critical perspective on these problems, and it raises the question of both the possibilities and the limits of meaning. For the historian, the very reconstruction of a "context" or a "reality" takes place on the basis of "textualized" remainders of the past.[5]

Norman Bryson has developed these ideas—namely that the language of the interpreter shapes his or her account of the past and that the textuality of the historian's material blurs the distinction between text and context—in relation to art history. Bryson points out that there is nothing self-evident

3. Dominick LaCapra, "Rethinking Intellectual History and Reading Texts," in *Rethinking Intellectual History,* 23–71, 29–30. For a lucid account of LaCapra's position, see Lloyd S. Kramer, "Literature, Criticism, and Historical Imagination: The Literary Challenge of Hayden White and Dominick LaCapra," in *The New Cultural History,* ed. Lynn Hunt (Berkeley: University of California Press, 1989), 97–128.

4. LaCapra, "Rethinking Intellectual History," 54.

5. Ibid., 26–27.

about the goals and procedures of current art historical practice. Among its unexamined assumptions is the notion that its theoretical justification lies in the historical context in which works of art are produced. According to Bryson, social context cannot in itself account for the type of interpretation derived from its consideration. The evidence is infinite and can never determine the shape of the narratives it inspires. The conclusions drawn from a consideration of social context are always imposed on them by the interpreter. Bryson's critique draws attention to the extent to which history is a constructed narrative rather than one that is inscribed in the order of things. What matters is not the historical context in which the works under study were produced but the cultural context of the author's own time. It is the context of the present, he suggests, that determines the attitudes and values that permeate our interpretations of the past: "It is only by seeing from within our own context that institutional forces within art history have worked to silence the whole question of the roles played by gender and sexuality in the field of vision, that we are able *now* to begin to see the ellipses and silences within the archive. *Our* context has latterly enabled us to realize different contexts, and that it is we who set them up."[6]

The whole tendency of poststructuralist philosophy of history, of which Bryson's article is an example that has the advantage of being specifically addressed to art historians, suggests that the positivistic tradition in the history of art must develop a more considered account of what it considers history to be. If art history is to meet this challenge, it seems to me, it will have to abandon its traditional reliance on a correspondence theory of truth. Instead of believing that art history discovers the ways things really are, that its narratives map neatly onto the way in which events might actually have unfolded, art historians must appreciate how language invests their practice with the values of the present. Art history must claim a more limited and relative status for its conception of knowledge, while expanding the imaginative scope of its interpretations as well as their political and cultural relevance.

A consideration of the role played by language in the working of history must include an evaluation of the significance of the work of Jacques Derrida.[7] Whereas White and LaCapra have demonstrated that the production of

6. Norman Bryson, "Art in Context," in *Studies in Historical Change,* ed. Ralph Cohen (Charlottesville: University Press of Virginia, 1992), 18–42.

7. For Derrida's views, see, for example, *Speech and Phenomena and Other Essays on Husserl's Theory of Signs,* trans. David Allison (Evanston, Ill.: Northwestern University Press, 1973); idem, *Writing and Difference,* trans. Alan Bass (Chicago: University of Chicago Press, 1978); idem, *Of Grammatology,* trans. Gayatri Spivak (Baltimore: Johns Hopkins University Press, 1976); idem, *Dissemination,* trans. Barbara Johnson (London: Athlone Press, 1981); idem, *Margins of Philosophy,* trans. Alan Bass (Chicago: University of Chicago Press, 1981); idem, *The Truth in Painting,* trans. Geoff Bennington and Ian McLeod (Chicago: University of Chicago Press, 1987).

knowledge has more to do with the manipulation of language than with direct access to the phenomenal world and that this process is necessarily associated with the historian's life in the present, Derrida has shown that language is incapable of conveying the type of meaning that is usually ascribed to historical narratives. According to Derrida, linguistic signs are arbitrary constructs whose significance is impermanent and unstable. Language functions to suggest an absent presence of meaning. That is, the meanings of linguistic representations are always illusory, since they depend on metaphysical claims that cannot be substantiated. Derrida's writing has largely been dedicated to exposing the deceptiveness of language, how it simultaneously invokes and masks meaning, and how this "logocentrism," operates in the writing of others.

What are the implications of deconstruction for the writing of history? If language is necessarily invested with metaphysical significance that cannot be realized, if language depends on a game of absent presence by which more is promised than can ever be delivered, then how do we regard the project of history? If history merely records the failure of language to deliver the truth about the past and can only convey the attitudes and ideology of those involved in its production, how are we to conceive of its cultural status and function?

Donald Preziosi has employed Derrida's insight to maintain that there are no historical narratives to which art historians can subscribe without being aware that they are compromised by the values that went into their construction. He further suggests that the elaboration of historical narratives itself perpetuates metaphysical myths that mask language's incapacity to signify.[8] On this view, the only legitimate form of interpretation becomes the unmasking, or deconstruction, of the metaphysical fables manufactured by others. Any other form of historical writing is simply an exercise in "logocentrism," itself subject to deconstruction by others. By calling into question the legitimacy of the production of the kind of knowledge we know as art history, Preziosi challenges the very foundations of the discipline itself.

The type of criticism advocated by deconstructionists such as Preziosi often depends on the assumption that a form of writing which explores the metaphysical constructs of others escapes the logocentrism that is characteristic of every other form of writing. Such critics appear to believe, despite their recognition that language is necessarily involved in a play of absent presence, that their own language, the language of deconstruction, is not subject to the same conditions. If the use of language must always involve metaphysical claims, however, then language about language must also involve such claims.

8. Donald Preziosi, *Rethinking Art History: Mediations on a Coy Science* (New Haven: Yale University Press, 1989).

Derrida, while undermining the validity of the concept of the sign as a bearer

of meaning, has always recognized that the assertion of absent presence is one of the identifying characteristics of language as a signifying system. Duplicitous though the function of the sign may be, its operation in the linguistic signifying system cannot be accomplished without the type of effect Derrida has exposed.

Although the aim of deconstructive criticism may be to expose the metaphysical freight with which language has been invested, it cannot make use of language without invoking a transcendental narrative of its own. Richard Rorty suggests that the absent presence that deconstruction invokes is none other than language itself. The metaphysical narrative of deconstruction is about the operation of language. Even the so-called undecidables—those words such as "trace," "pharmakon," "différance," and "hymen," coined by Derrida so as to prevent their definition in terms of the value that accrues to words as a consequence of their location within the linguistic signifying system—can be interpreted as playing a metaphysical role of their own as part of his philosophy of language:[9]

> Derrida tells us, over and over, that *différance* is "neither a word nor a concept." This is, however, not true. The first time Derrida used that collocation of letters, it was, indeed, not a word, but only a misspelling. But around the third or fourth time he used it, it had *become* a word. All that it takes for a vocable or an inscription to become a word, after all, is a place in a language game. By now it is a very familiar word indeed. . . . Any word that has a use automatically signifies a concept. It can't *help* doing so.[10]

Much the same point is made by Edward Said with regard to the word "supplement": "Derrida has built a small repertory of words, including *supplémentarité* and the *supplément* of one thing or the other, all of which have had evident uses in the reading of other texts. More and more, a word like *supplément* gathers status and history; to leave it without some attention to its vital positional use in his work is, for Derrida, a strange negligence."[11]

9. See, for example, Richard Rorty, "Philosophy as a Kind of Writing," in *Consequences of Pragmatism: Essays, 1972–1980* (Minneapolis: University of Minnesota Press, 1982), 90–109; idem, "Deconstruction and Circumvention," *Critical Inquiry* 11 (1984): 1–23; idem, "Is Derrida a Transcendental Philosopher?" *Yale Journal of Criticism* 2 (1989): 207–17; idem, "Two Meanings of 'Logocentrism': A Reply to Norris," in *Redrawing the Lines: Analytic Philosophy, Deconstruction, and Literary Theory*, ed. Reed Way Dasenbrock (Minneapolis: University of Minnesota Press, 1989), 204–16; idem, "From Ironist Theory to Private Allusions: Derrida," in *Contingency, Irony, and Solidarity* (New York: Cambridge University Press, 1989), 122–37.

10. Rorty, "Deconstruction and Circumvention," 18.

11. Edward Said, "Criticism between Culture and System," in *The World, the Text, and the Critic* (Cambridge: Harvard University Press, 1983), 178–225, 210.

To appreciate the "logocentrism" involved in the use of language, however, is not to invalidate the project of history writing. The realization that the historian necessarily invests language with absent meaning, that history is not found but constructed, that it has to do with the values of the present rather than those of the past, does not vitiate the enterprise. Far from it, by making us aware of the extent to which history plays a role in the ideological struggles of the present day, Derrida's insight brings home to the historian the extent to which his or her characterization of the past serves to shape the present and the future. It seems evident that it is the very power of that ontological function which accounts for history's social and political importance. Whereas our culture has coded the language of fiction in such a way that we cannot admit the extent to which it shapes our assumptions and determines our attitudes toward the world around us, even though we may be fully aware that it does so, the epistemological status accorded to history means that we can openly acknowledge how it molds our social and political expectations. If we accept that the use of language is inextricably bound up with the construction of narratives and that these narratives are not necessarily compromised by an awareness that they create illusory "meaning effects," then, rather than viewing deconstruction as the form of interpretation before which all other interpretations crumble, we can regard it as just one of the many different ways in which cultural meaning can be created.

It has often been asserted that deconstruction offers cultural critics a more effective form of political intervention than the logocentric interpretation of historical writing. This view, however, once more depends on the assumption that deconstructionist criticism can somehow rise above itself, can escape the logocentric consequences of the use of language. Because it allegedly carries no metaphysical freight of its own, deconstructive writing is thought capable of criticizing all political positions without being identified with any one of them.

Preziosi, for example, dismisses the social history of art because of its association with the metaphysical claims of Marxist history. On this view, social history fails to challenge the social and political circumstances in which it is formulated because it simply replaces one transcendental narrative with another:

> In the final analysis (one says with some irony), any useful forms of opposition
> to the excesses of late capitalism are not compatible with historicism. As we
> have sought to demonstrate throughout this volume, if it is patent that any
> form of intellection or artistic activity is a mode of political activity, then the
> pertinent problem might be this: Could a socially responsible art history dem-
> onstrate and articulate, in its finest details, what cultural domination is about

(a) without relegitimizing historicist narrative knowledge and (b) without merely erecting alternate schemes of transcendence?[12]

In the absence of a comparable discussion in the history of art, it may be useful to review some of the ways in which the political effectiveness of deconstruction has been assessed by authors in neighboring disciplines. In a book that surveys the role of deconstruction within poststructural theory, Mark Poster comments on its political claims:

> Many American poststructuralists, especially deconstructionists, appear to believe that a political position and a social theory are built into their interpretive strategy. If one avoids closure and totalization in one's own discourse, they contend, if one unsettles, destabilizes, and complicates the discourses of the humanities, if one resists taking a stance of binary opposition in relation to the position one is criticizing, one has thereby instantiated a nonrepressive politics. Yet such a utopian epistemological vantage point may be more difficult to sustain than deconstructionists believe. Skeptics towards deconstruction are rightly bothered by the unique privilege it accords to language, by the unwillingness of deconstructionists to peek, even for an instant, outside an unending web of texts and signifiers.[13]

In much the same vein, LaCapra points out that deconstruction, the attack on the way in which language suggests metaphysical presence, is only part of what might be said to constitute a valid political program. That is, although the analysis of the values implicit in the use of language can often be of political value, it is not sufficient to constitute a coherent form of political criticism: "One cannot be content with the partially valid idea that the deconstruction of philosophical and literary texts is in and of itself a form of political intervention (I would interject here that this idea is partially valid

12. Preziosi, *Rethinking Art History,* 168.

13. Mark Poster, *Critical Theory and Poststructuralism: In Search of a Context* (Ithaca: Cornell University Press, 1989), 9. The political implications of deconstruction have been vigorously debated in the wake of the discovery that one of its leading exponents, Paul de Man, had been responsible for writing pro-Nazi, anti-Semitic journalism during his wartime years in occupied Belgium. Whereas some literary critics defended de Man, claiming, for example, that his later espousal of deconstruction represented a rejection of all forms of totalitarian thought and thus constituted an attempt to make amends for this chapter of his life, others were eager to use this episode to indict the method on the principle of guilt by association. The debate was acrimonious and inconclusive. For some of the arguments, see Jacques Derrida, *Memoires: For Paul de Man,* trans. Cecile Lindsay, Jonathan Culler, and Eduardo Cadava (New York: Columbia University Press, 1986); Werner Hamacher, Neil Hertz, and Thomas Keenan, eds., *Responses: On Paul de Man's Wartime Journalism* (Lincoln: University of Nebraska Press, 1989). The debate is reviewed by Louis Menand, "The Politics of Deconstruction," *New York Review of Books,* 21 November 1991, 39–44.

because of the relation of deconstruction to the undoing of binaries, which are crucial for the scapegoat mechanism. This undoing is necessary but not sufficient with respect to social and political criticism.)"[14] Frank Lentricchia makes this point with even greater force when he suggests that, in its concern to attack the epistemological claims of language, deconstruction fails to come to grips with the power it derives from those claims:

> Deconstruction's useful work is to undercut the epistemological claims of representation, but that work in no way touches the real work of representation—its work of power. To put it another way: deconstruction can show that representations are not and cannot be adequate to the task of representation, but has nothing to say about the social work that representation can and does do. Deconstruction confuses the act of unmasking with the act of defusing, the act of exposing epistemological fraud with the neutralization of political force. Deconstruction, then, is a "critical" philosophy, but only in the slimmest sense of the word—it may tell us how we deceive ourselves, but it has no positive content. . . . It has nothing to say.[15]

Perhaps the most thoughtful evaluation of the political potential of deconstruction is that provided by Edward Said:

> His work embodies an extremely pronounced self-limitation, an ascesis of a very inhibiting and crippling sort. In it Derrida has chosen the lucidity of the undecidable in a text, so to speak, over the identifiable power of a text. . . . Derrida's work thus has not been in a position to accommodate descriptive information of the kind giving Western metaphysics and Western culture a more than repetitively allusive meaning. Neither has it been interested in dissolving the ethnocentrism of which on occasion it has spoken with noble clarity. Neither has it demanded from its disciples any binding engagement on matters pertaining to discovery and knowledge, freedom, oppression, or injustice. If everything in a text is always open equally to suspicion and to affirmation, then the differences between one class interest and another, between oppressor and oppressed, one discourse and another, one ideology and another, are virtual in—but never crucial to making decisions about—the finally reconciling element of textuality.[16]

One critic who has argued for the political potential of deconstruction as a form of cultural criticism is John Tagg. In his book, *Grounds of Dispute,* Tagg adds an interest in deconstruction to his discussion of the theoretical alterna-

14. Dominick LaCapra, "Intellectual History and Critical Theory," in *Soundings in Critical Theory,* 182–209, 184.

15. Frank Lentricchia, *Criticism and Social Change* (Chicago: University of Chicago Press, 1983), 50–51.

16. Edward Said, "Criticism between Culture and System," 214.

tives available to cultural criticism. Accepting Derrida's insight concerning the
metaphysical investment of language, Tagg tries to avoid the invocation of the
"master narratives," such as Marxism, which dominate current forms of art
historical interpretation in favor of an analysis of the disciplinary institutions
of art history which are responsible for their production:

> If deconstruction of the institution of art history withdraws from "social" cri-
> tique, it does so, therefore, precisely in order to foreground the question of po-
> litical and ethical practice; precisely in order to drive home the stakes of the
> discipline. But stakes are not interests. They are not what lies behind, so that
> this political practice cannot take the form of an unmasking. Nor can it stop at
> a mapping or traversal of spaces, boundaries, closures, fractures, and linkages of
> the institutional formation. To question art history's finalities is to open the
> question of its ends. (What circles are described by this Center [for Advanced
> Study in the Visual Arts]? Who is the addressee of the *National* Gallery of Art?
> What end could there be to the transcendent narratives of pricelessness,
> timelessness, inexhaustibility and the great continuing tradition of Art?)[17]

According to this formulation, deconstruction is a politically more desirable
form of interpretation than the social history of art, because rather than spin
"master narratives" about the "real," it focuses on the social institutions that
are responsible for their production. Instead of affording us a vision of the
past that is informed by a predetermined political agenda, it criticizes the
political values on which narrative-producing institutions are based.

Curiously, but significantly, elided here are the political values on which
Tagg's critique of institutions is grounded. It would appear that his criticism
of the National Gallery of Art as an institution dedicated to the support of
transcendental narratives of the "pricelessness, timelessness, inexhaustibility
and the great continuing tradition of Art," was self-evident. What, however,
are the unarticulated political considerations that prompt Tagg to call the
Gallery's values into question? If the social function of the Center and the
Gallery are to be challenged, on what basis is this challenge undertaken? Since
his critique is not to be found within the institutions in question, it must be
located in the apparatus, the point of view, Tagg brings to his task as a critic.
It depends, in other words, on the political assumptions with which his
language is invested. His words imply that he does not share the Gallery's
view of the nature and status of art. They suggest that, unlike the Gallery, he
does not consider the value of works of art to be a function of their aesthetic
worth. Just as the Gallery subscribes to a "master narrative," so does Tagg. His
narrative appears to advance the view that works of art play a rich and

17. John Tagg, *Grounds of Dispute: Art History, Cultural Politics, and the Discursive Field*
(London: Macmillan, 1992), 32–33.

complex role in social life, one that involves them in the communication of many cultural values other than the aesthetic. Whatever the theoretical sources of his language, it is clear that Tagg could not operate without occupying a political position distinct from the one he criticizes. As Derrida has shown, the space where meaning is made is metaphysical, and this metaphysical space is a necessary condition of the use of language. The criticism of institutions cannot, thus, be preferred to the perpetuation of "master narratives" on the basis that it avoids metaphysics.[18]

In order to understand the power of language in the production of history, it becomes necessary to consider the cultural function of narrative. Narrative is, of course, one of the "deep structures" of the humanities, and a subject which has been extensively studied by anthropologists and literary theorists as well as psychoanalysts and historiographers.[19] According to Hayden White, historical narratives have traditionally performed a moralizing function: they function as moral allegories that depend on the tensions that characterize the individual's relation to the culture of which they are a part. Such narratives thus serve either to support and legitimate the status quo or to call it into question.

But once we have been alerted to the intimate relationship that Hegel suggests exists between law, historicity, and narrativity, we cannot but be struck by the frequency with which narrativity, whether of the fictional or the factual sort, presupposes the existence of a legal system against which or on behalf of which the typical agents of a narrative account militate. And this raises the suspicion that narrative in general, from the folktale to the novel, from the annals to the fully realized "history," has to do with the topics of law, legality, legitimacy, or, more generally, authority.[20]

18. While agreeing that the use of language must inevitably involve logocentrism, Tagg argues that hitherto unknown forms of meaning making may afford us a more satisfactory critical alternative in the future. Such forms would not be subject to the negative characteristics of the old logocentrisms, namely, those of the "master narratives" on which interpretation has traditionally relied (letter to the author, dated 5 August 1992).

19. For discussions of the role of narrative in historical writing, see, for example, Louis Mink, "Narrative Form as a Cognitive Instrument," in *The Writing of History: Literary Form and Historical Understanding,* ed. Robert Canary and Henry Kozicki (Madison: University of Wisconsin Press, 1978), 129–49; Lionel Gossman, "History and Literature," in *The Writing of History,* 3–39; Roland Barthes, "The Discourse of History" (1968), in *The Rustle of Language,* trans. Richard Howard (Berkeley: University of California Press, 1989), 127–54; Paul Ricoeur, "Narrative Time," *Critical Inquiry* 7 (1980): 169–90; Hayden White, "The Value of Narrativity in the Representation of Reality," and "The Question of Narrative in Contemporary Historical Theory," both in *The Content of Form,* 1–25, 26–56; Ankersmit, *Narrative Logic.*

20. White, "The Value of Narrativity," 13. For an analysis of how the epistemological claims of history depend on analogies with legal procedure, see Mark Cousins, "The Practice of Historical Investigation," in *Post-structuralism and the Question of History,* ed. Derek Attridge,

On a deeper level, White claims that historical narratives may be related to the structures that constitute the human subject. Following the psychoanalytic theory of Jacques Lacan, he maintains that such narratives are a symptom of our inability to transcend the culture that defined our social being in order to know the world in some direct and unmediated fashion. These narratives belong to the cultural forces that both empower us as social beings and subject us to codes that are not of our own invention. The function of historical narratives is thus to offer us an account of something we can never experience ourselves; their power derives from their apparent ability to afford us access to that which we cannot know:

> The historical narrative, as against the chronicle, reveals to us a world that is putatively "finished," done with, over, and yet not dissolved, not falling apart. In this world, reality wears the mode of a meaning, the completeness and fullness of which we can only imagine, never experience. Insofar as historical stories can be completed, can be given narrative closure, can be shown to have had a plot all along, they give to reality the odor of the ideal. That is why the plot of a historical narrative is always an embarrassment and has to be presented as "found" in events rather than put there by narrative techniques.[21]

White's views on the cultural function of historical narrative support the conclusion that an awareness that language is not transparent, that it is not a tool that affords us access to nondiscursive realities, serves to empower and enhance the work of the historian by revealing the extent to which we can actively shape the myths by which we live.

If we believe that historical writing is involved in the elaboration of narratives that are formulated with an awareness of their social and political function within contemporary culture, do we not adopt a relativist position? If we forsake the notion of truth, if we dispense with an epistemological basis for knowledge, are we not placed in a situation where we possess no rationale for preferring one historical interpretation to another? The difficulty with this question is that it presupposes its own answer. That is, the question makes sense only if we subscribe to a correspondence theory of truth. Only if it is possible to get it right, to find the "truth," can we have criteria by which to choose between alternative interpretations. If we claim that there is no truth to be found, then we cannot be accused of not having a means of establishing what the truth might be. Historians are "always already" embedded in a social

Geoff Bennington, and Robert Young (Cambridge: Cambridge University Press, 1987), 126–36. Jacques Derrida has used the link between narrativity and the law as a way of attacking the narrativity's epistemological and ontological status; see "The Law of Genre," trans. Avital Ronell, *Critical Inquiry* 7 (1980): 55–81.

21. White, "The Value of Narrativity," 21.

situation that determines the social and political views with which their opinions will be informed. Far from choosing freely between competing historical accounts, historians will prefer those that coincide with their own social values. Richard Rorty sums up the situation in which such decisions are made:

> "Relativism" is the view that every belief on a certain topic, or perhaps about any topic, is as good as any other. No one holds this view. Except for the occasional cooperative freshman, one cannot find anybody who says that two incompatible opinions on an important topic are equally good. The philosophers who get called "relativists" are those who say that the grounds for choosing between such opinions are less algorithmic than they had been thought.[22]

The claim that the language of interpretation is more important than its object and that social subjects are as much the objects of cultural representation as they are its agents means that we must also revise our views of critical pluralism. Pluralism in intellectual matters is based on the premise that it is possible to consider more than one interpretation of the same subject as valid or true. The view depends on the notion of determinate meaning; that is, that there are meanings that are epistemologically true or false. On this view, it is our incapacity ever to know the whole truth which enables us to recognize more than one account as affording us at least a partial truth about the subject in question. Our choice between competing accounts is said to depend on the persuasiveness of the interpretations in question.[23] Such views are clearly incompatible with a position that has abandoned all claims to an epistemological basis for knowledge. If no interpretation can be judged true, then we cannot entertain the possibility that more than one interpretation can be true. Furthermore, the notion that competing interpretations depend for their success or failure on their powers of persuasion suggests a naive and unlikely paradigm of intellectual debate. There is, in other words, a politics of pluralism, a politics that has traditionally masked the ways in which cultural and social interests intersect with and determine the value we find in specific intellectual positions.[24] Pluralism fails to acknowledge the role of power in

22. Richard Rorty, "Pragmatism, Relativism, and Irrationalism," in *Consequences of Pragmatism,* 160–75, 166. See also the critique of "relativism" in favor of "local or situated knowledges" in Donna Haraway, "Situated Knowledges: The Science Question in Feminism and the Privilege of Partial Perspective," *Feminist Studies* 14 (1988): 575–99.

23. See Wayne Booth, *Critical Understanding: The Powers and Limits of Pluralism* (Chicago: University of Chicago Press, 1979); Paul Armstrong, *Conflicting Readings: Variety and Validity in Interpretation* (Chapel Hill: University of North Carolina Press, 1990).

24. See W. J. T. Mitchell, "Pluralism as Dogmatism," *Critical Inquiry* 12 (1986): 494–502; Ellen Rooney, *Seductive Reasoning: Pluralism as the Problematic of Contemporary Literary Theory* (Ithaca: Cornell University Press, 1989).

the process of selecting and promoting the forms of interpretation which are considered legitimate by a particular culture at a particular moment. It suggests that all voices can be heard and that rational evaluation and debate determine which succeed and which fail.

If, as I have maintained, knowledge is inextricably wedded to the social circumstances in which it is produced, we must ask who or what determines the forms of interpretation to be included in intellectual debate and who or what determines the ones that are to be excluded? Why are some forms of interpretation considered acceptable and others not? While we can readily accept that we listen to and learn from a variety of interpretative studies, it is reductive to suggest that those we are offered have been selected by means of a purely rational process. The concept of pluralism is thus to be rejected on two grounds: first, insofar as it depends on a notion of determinate meaning, it rests on an epistemology that fails to recognize the socially and historically compromised nature of knowledge; second, it promotes a political perspective that suggests that intellectual discussions are free and open and does not acknowledge the extent to which intellectual debate is shaped by social and political values.

The recognition that the historian's discourse is always "situated," always invested with social and political implications, should not be regarded as a call for the straightforward imposition of political values on our understanding of the past. A persuasive historical argument would be one that made every effort to grapple with the strangeness or "otherness" of the historical horizon it sought to understand. It is only through an appreciation of the radical alterity of the past that we can become aware of the particular qualities of the cultural and intellectual environment in which we ourselves operate. As LaCapra puts it, we must let the past interrogate us as much as we interrogate the past.[25] The hermeneutic process must be genuinely dialogic. Those interpretations that flatten the texture of the historical horizon through the imposition of a reductive political agenda do violence to the complexity of what is to be interpreted and blind us to the way in which the past can effectively illuminate the values that have determined the interpreter's own point of view. A failure to do justice to the unique character of the historical horizon in the interest of the values of the present serves to caricature both the past and the present.

Regardless of how sensitive we may aspire to be in our appreciation of the special qualities of a different age, however, we cannot hope to understand it without manifesting assumptions that are more characteristic of our own time than of that which is the object of study. The dream of transparency, accord-

25. LaCapra, "Rethinking Intellectual History and Reading Texts," 29–30.

ing to which the past is accessible to the historian in such a way that under-standing is full and final, must be abandoned if we appreciate that language is a mediating screen that separates us from the object of study. Every interpreta-tion must be regarded as compromised by the historical circumstances in which it is formulated.

The historiography of art history demonstrates that the production of knowledge is always historically determined and knows no closure. This realization permits us to understand more fully the interpretations proposed by the scholars of the past; that is, it sensitizes us to how the values of their own time colored their accounts of the past, as it makes us cognizant of the social and political function of our own activity as purveyors of culture.

To claim that knowledge is inextricably related to the social configuration that surrounds it is also to claim that knowledge is always invested with political significance. Such an assertion seems all the more relevant in the context of the current debate about "political correctness."[26] The term "polit-ical correctness," of course, was coined by political conservatives who believe that knowledge should be free of social and political considerations in order to denounce liberals who believe it should take into consideration the perspec-tives of different races, nationalities, genders, and classes. Political liberals believe that the character of knowledge is responsive to the cultural and social circumstances in which it is produced. They view knowledge as changing and

26. The literature on "political correctness," both that which accuses higher education of having politicized knowledge and that which defends the current state of higher education, includes works by assorted political theorists, academics, politicians, and journalists and has become too vast to review easily. The following are some of the contributions to the debate: William Bennett, *To Reclaim a Legacy: A Report on the Humanities in Higher Education* (Wash-ington, D.C.: National Endowment for the Humanities, 1984); Allan Bloom, *The Closing of the American Mind* (New York: Simon and Schuster, 1987); Charles Sykes, *Profscam: Professors and the Demise of Higher Education* (New York: St. Martin's Press, 1988); Roger Kimball, *Tenured Radicals* (New York: Harper and Row, 1990); Dinesh D'Souza, *Illiberal Education: The Politics of Race and Sex on Campus* (New York: Free Press, 1991); Paul Berman, ed., *Debating P.C.: The Controversy over Political Correctness on College Campuses* (New York: Dell, 1992); Martin Ander-son, *Impostors in the Temple* (New York: Simon and Schuster, 1992); and David Bromwich, *Politics by Other Means: Higher Education and Group Thinking* (New Haven: Yale University Press, 1992). For reviews of some of these books, see John Searle, "The Storm over the Univer-sity," *New York Review of Books,* 6 December 1990, 34–42; and C. Vann Woodward, "Freedom and the Universities," *New York Review of Books,* 18 July 1991, 32–37. For a vigorous defense of higher education, see the essays by Gerald Graff, Barbara Herrnstein Smith, Henry Louis Gates, Jr., Henry Giroux, Eve Kosofsky Sedgwick, Alexander Nehamas, Phyllis Franklin, George Kennedy, and Richard Rorty, among others, in *South Atlantic Quarterly* 89 (1990); and Gerald Graff, *Beyond the Culture Wars: How Teaching the Conflicts Can Revitalize American Education* (New York: Norton, 1992). For the charge that "political correctness" has negatively affected artistic production, see Donald Kuspit, "Art and the Moral Imperative: Analyzing Activist Art," *New Art Examiner* (January 1991): 18–25.

relative rather than immutable and transcendent, since its configuration and
texture are dependent on historical change. Consider, as an example, the
anonymous plea put forward during the debate over the reform of the West-
ern civilization course at Stanford University in 1988:

> The character of U.S. society is changing. More and more North Americans in-
> sist on affirming the specificity of their class, ethnicity, gender, region, race, or
> sexual orientation, rather than melting into the homogenizing pot. They see
> such affirmations as *intrinsic to their citizenship*. Culture, literature, and the
> academy have been important sites for these affirmations: it will be neither pro-
> ductive nor comfortable to commit ourselves only to resisting these develop-
> ments, rather than engaging with them.[27]

By insisting on the "objectivity" of their own view of knowledge, conserva-
tives refuse to recognize how such knowledge has been marked by the inter-
ests and prejudices of a privileged elite. As Gerald Graff has put it,

> Unfortunately, the educational fundamentalists fail to confront the question of
> whose common culture it is to be. Educational fundamentalists look back
> fondly to a past where there was still enough consensus over the content of
> higher education that this question did not have to arise. They conveniently ig-
> nore the fact that the past consensus was made possible only by the narrow and
> exclusive social base from which educators and educated then were drawn. It is
> not too hard to get a consensus if you start by excluding most Jews, blacks, im-
> migrants, women, and others who figure to make trouble.[28]

Conservatives accuse those who take social and cultural change into consider-
ation in the production of knowledge of playing politics and refuse to ac-
knowledge that their own position is also political. The politics of those who
accuse others of "political correctness" is to pretend that it is their opponents
rather than themselves who have a political agenda. Their own covert and
unstated agenda, however, is the maintenance and support of the status quo,
the preservation of a situation in which knowledge continues to be unrespon-
sive to the processes and pressures of social and cultural change.

These reflections should not be regarded as a plea for the revival and
reinstatement of the social history of art. An appreciation of the role of
language in the construction of history must necessarily lead to the abandon-
ment of a methodology that subscribes to a reflection theory of culture. In the

27. See Mary Louise Pratt, "Humanities for the Future: Reflections on the Western Culture
Debate at Stanford," *South Atlantic Quarterly* (1990): 7–25, 9.
28. Gerald Graff, "Teach the Conflicts," *South Atlantic Quarterly* (1990): 51–67, 52.

light of Derrida, it becomes impossible to subscribe to the view that any historical interpretations are endowed with truth value, let alone one that purports to record how economic circumstances have inscribed themselves in cultural production. Mine is rather a call for a politically committed form of art historical interpretation, which acknowledges that the narratives we construct are the products of our own values as these have been shaped by, and in reaction to, the social forces responsible for the construction of our subjectivity.[29] A recognition that our narratives are subject to logocentrism cannot be used to put them into question. Every narrative, including the deconstructionist one, is invested with transcendental values whose claims exceed the signifying power of language. Rather than challenge the cultural function of narrative, we ought to use Derrida's insight to understand its social and political power. Rather than abandon the construction of historical narratives because they possess no epistemological guarantee, we must realize that the creation of politically informed interpretations of the past can significantly affect the social myths that determine our lives in the present. If we do,

29. This call for a politically engaged form of historical interpretation has its parallels in some of the work produced under the banner of the New Historicism. Although this movement is methodologically heterogenous, much of it is inspired by a desire to make historical interpretation relevant for the political circumstances we occupy today. See, for example, Stephen Greenblatt, *Renaissance Self-Fashioning: From More to Shakespeare* (Chicago: Chicago University Press, 1980); idem, *Shakespearean Negotiations: The Circulation of Social Energy in Renaissance England* (Oxford: Clarendon Press, 1988); idem, *Marvelous Possessions: The Wonder of the New World* (Chicago: Chicago University Press, 1991); Louis Montrose, "'Shaping Fantasies': Figuration of Gender and Power in Elizabethan Culture," in *Representing the Renaissance,* ed. Stephen Greenblatt (Berkeley: University of California Press, 1988), 31–64; idem, "Renaissance Literary Studies and the Subject of History," *English Literary Renaissance* 16 (1986): 5–12; idem, "Professing the Renaissance: The Poetics and Politics of Culture," in *The New Historicism,* ed. Aram Veeser (New York: Routledge, 1989), 15–36. In England this type of work has been called "cultural materialism." See Jonathan Dollimore, *Radical Tragedy: Religion, Ideology, and Power in the Drama of Shakespeare and His Contemporaries* (Chicago: Chicago University Press, 1984); Jonathan Dollimore and Alan Sinfield, *Political Shakespeare: New Essays in Cultural Materialism* (Ithaca: Cornell University Press, 1985); Alan Sinfield, *Literature in Protestant England 1560–1680* (London: Croom Helm, 1982). For some evaluations of "new historicist" writing, see Jonathan Goldberg, "The Politics of Renaissance Literature: A Review Essay," *ELH* 49 (1982): 514–42; Jean Howard, "The New Historicism in Renaissance Studies," *English Literary Renaissance* 16 (1986): 13–43; Edward Pechter, "The New Historicism and Its Discontents: Politicizing Renaissance Drama," *Publications of the Modern Language Association* 102 (1987): 292–303; Walter Cohen, "Political Criticism of Shakespeare," in *Shakespeare Reproduced: The Text in History and Ideology,* ed. Jean Howard and Marion O'Connor (New York: Methuen, 1987): 327–37; idem, *Rewriting Shakespeare, Rewriting Ourselves* (Berkeley: University of California Press, 1991); Carol Thomas Neely, "Constructing the Subject: Feminist Practice and New Renaissance Discourses," *English Literary Renaissance* 18 (1988): 5–18; Carolyn Porter, "Are We Being Historical Yet?" *South Atlantic Quarterly* 87 (1988): 743–86; Brook Thomas, *The New Historicism and Other Old-Fashioned Topics* (Princeton: Princeton University Press, 1991).

deconstruction can become the basis for a new construction, for a new form
of interpretation, one that refuses to locate its hermeneutic conclusions in its
subject matter but one that finds them, instead, in the dialogic relationship ∿
between the subjectivity of the interpreter and the object of study.

Introduction

PART ONE

Cultural Politics: Theory

Introduction

It seems to me that any critical practice which hopes to be a historical force must be deeply ideological in the sense that its concern will be to engage in the struggle for the terms in which individuals are to be produced and mobilized as subjects in history.

—Tony Bennett, "Texts in History"

You can explain the past only by what is most powerful in the present.
—Friedrich Nietzsche, *The Use and Abuse of History*

The abandonment of an epistemological foundation for art history and the acknowledgment that historical arguments will be evaluated according to how well they coincide with our political convictions and cultural attitudes collapses the traditional distinction between history and theory. Theory, in other words, does not exist at some deeper and more foundational level than historical interpretation, for interpretation is inevitably theoretical and vice versa. If language is compromised and determined by the historical circumstances in which it is articulated, then all forms of discourse, whether they are historical or theoretical, bear the imprint of a specific location in time and space. The distinction between historical interpretation and theoretical justification is, therefore, one we can *choose* to make depending on whether or not the identification of these rhetorical genres coincides with our political and social agenda.

The following essays are based on the assumption that the current art historical situation, which is marked by a multiplicity of theoretical alternatives, dictates that a politically committed form of historical interpretation must address theoretical as well as historical issues in the interest of clarifying what is at stake in choosing one alternative over another. In the absence of an epistemological basis for art historical knowledge, a plethora of theoretical alternatives now clamor for our attention, purporting to offer firm foundations on which to build our historical narratives. Theories come and go with disconcerting regularity, and it sometimes appears that all that matters is that we should be acquainted with the latest proposal. In such circumstances, "theory" serves as a substitute for the epistemological empiricism of the past. That is, theory purports to offer us the harder stuff, the contact with reality which will guarantee that our conclusions will last.

The point of discussing theory in this context is not to suggest that any of the theories mentioned in what follows can validate our historical interpretations but rather to evaluate and to select those theoretical alternatives that are most useful for a politically informed approach to historical interpretation. Following Max Horkheimer, I want to distinguish between "traditional" theory, which seeks to establish an epistemological basis for knowledge, and "critical" theory, which seeks to make knowledge relevant to the cultural and political circumstances in which it is formulated.[1] Traditional theory posits an eternal foundation for knowledge, thus naturalizing the values with which that knowledge is associated and confirming and supporting the social status quo; critical theory assumes that knowledge incorporates the values of the circumstances in which it is created and that its status is consequently contingent and impermanent. Knowledge produced by critical theory is therefore forever in flux—a potential agent of social change. As Mark Poster has put it:

> It [critical theory] sustains an effort to theorize the present as a moment between the past and the future, thus holding up a historicizing mirror to society, one that compels a recognition of the transitory and fallible nature of society. . . . Critical theory goes against the grain of a legitimating process endemic to power formations, a discursive mechanism through which the finitude of institutions is naturalized and universalized. Critical theory is a disruptive counterforce to the inscription on the face of social practices which says, "Do not tamper with me for I am good, just and eternal."[2]

In what follows therefore, several poststructuralist theories will be adapted to political ends. Rather than attempt an allegedly objective and neutral assessment of the theoretical options available in the humanities, I have chosen to discuss only those that seem most useful to a conception of art history as cultural politics.[3] Current theory is thus not so much surveyed as plundered for what may be integrated into a particular political perspective.

Because I wish to develop a politically committed form of historical interpretation based on the theoretical developments of structuralism and poststructuralism, I conceive of art history as a form of political intervention which includes historical interpretation as well as theoretical argumentation. If art history is to take part in the processes of cultural transformation which

1. Max Horkheimer, "Traditional and Critical Theory," *Critical Theory: Selected Essays,* trans. Matthew O'Connell et al. (New York: Continuum, 1982), 188–243.

2. Mark Poster, *Critical Theory and Poststructuralism: In Search of a Context* (Ithaca: Cornell University Press, 1989), 3.

3. For the conceptualization of art history as a form of cultural politics, see Nicholas Green and Frank Mort, "Visual Representation and Cultural Politics," *Block* 7 (1982): 59–68.

characterize our society, then its historical narratives must come to terms with the most powerful and influential theories that currently determine how we conceive of ourselves and our relation to one another and how we conceive of cultural artifacts and their role in society. Art historical discourse, in other words, must become cognizant of the historical circumstances in which it currently finds itself.

The "holier than thou" attitude of the politically committed who insist that practice (that is, the writing of historical narratives) is more important than reflection on the means by which narratives are constructed can lead only to an estrangement of the social history of art from the most creative forms of cultural production in the humanities today. My attempt to historicize the conceptual apparatus of art history depends more on an awareness of our current situation, of how we understand the world today, than on a traditional awareness of the past. It makes no sense for art historians to retain archaic notions of the nature and status of language, for these will not only color our approach to the documents but determine the character of our writing; and it makes no sense to study artistic objects according to notions of representation which are inadequate to the cultural function of the work of art. Similarly, it makes no sense to study artistic creativity according to notions of subjectivity which are uninformed by considerations of social class, gendered identity, and the role of the unconscious.

Conservatives like to characterize the attempt to integrate history and theory as superficial and inconsequential. They believe that the boundaries of art history should be carefully policed in order to prevent what they consider illegal border crossings of theory from one sector of the humanities to another. What such critics fail to recognize is that the concept of disciplinary autonomy can be as stultifying as it is empowering. The attempt to isolate art history from ideas produced in other fields can institutionalize a kind of self-satisfied provincialism. It also results in forms of historical writing that are profoundly ahistorical since they fail to pay attention to the types of questions that are most relevant to research and reflection in the humanities today. What are needed are historians who are intellectuals—more pointedly, historians who have an interest in the intellectual life of our time and who thus have the capacity to conceptualize our disciplinary work within the context offered by the humanities as a whole.

This call for an integration of history and theory is born of an awareness of the instability and impermanence—the historical specificity—of all cultural representations. The recognition that knowledge cannot be separated or isolated from the cultural circumstances in which it is produced, an awareness that the social and political transformations associated with historical change necessitate different styles of knowledge at different historical moments, entails a continuous reassessment of its shape and function. One might argue

that each generation must come to knowledge on its own terms if it is to transform rather than reproduce the culture it received from the past. Without the capacity to challenge those institutions that have already been established, reassessing their significance and value in the face of changing historical conditions, we would be doomed to observe cultural conventions that no longer bore any relation to the circumstances in which they were invoked.

The rehearsal of structural and poststructural theory in the following pages is meant to address both those readers who have subscribed to some of the theoretical models cited and those who feel puzzled and confused by the whole project of integrating history with theory. Although some of these ideas have appeared in essays I have written over the past few years,[4] they have been recast here in the form of a sustained argument. It is important to note that what is being proposed here is not a new art historical "method," a handy means by which art historical knowledge might be mechanically produced in the future. In this respect it differs quite deliberately from Erwin Panofsky's famous introduction to *Meaning in the Visual Arts,* with its specific recommendations regarding the steps to be followed in the production of a "correct" interpretation.[5] Rather, I want to review some aspects of structural and poststructural theory, pointing out how they may be usefully incorporated in historical narratives that are written with a political objective in mind.

The aspects of structural and poststructural theory which are discussed in the following chapters have been assembled under three headings: representation, ideology, and authorship. The first chapter examines the leading theories of representation available to historians of the visual arts. Opting for a semiotic approach to the issue, I discuss which of the semiotic theories seems to me to be best suited to historical narratives that are interested in characterizing the image in terms of its social function, that is, as an active agent in the production of cultural meaning. The second chapter reviews some of the leading theories of ideology in order to select the most appropriate for discussing the role of images in creating and disseminating social attitudes. A semiotic theory of ideology enables us to understand images as complex representations rather than simple reflections of social attitudes. The choice of this approach represents a conscious attempt to distinguish images and their social messages from whatever might be the "real" state of affairs existing in the world. The chapter on authorship explores the mediation of reality by linguistic and visual sign systems. A semiotic theory of subjectivity enables us to

4. Keith Moxey, "Semiotics and the Social History of Art," *New Literary History* 22 (1991): 985–99; idem, "The Social History of Art in the Age of Deconstruction," *History of the Human Sciences* 5 (1992): 37–46; idem, "The Politics of Iconology," in *Iconography at the Crossroads,* ed. Brendan Cassidy (Princeton: Princeton University Press, 1993).

5. Erwin Panofsky, "Iconography and Iconology: An Introduction to the Study of Renaissance Art," *Meaning in the Visual Arts* (Garden City, N.Y.: Doubleday, 1955), 26–54.

appreciate the extent to which we are determined by the very social forces we attempt to manipulate through interpretation. The value of a semiotic conception of authorship lies in the recognition that knowledge is always partial and situated rather than complete and universal. Knowledge, it follows, is something that is always open to question on the basis of political considerations.

It will be noted that although I continually invoke the concept of politics—speaking of the politically committed/interested/involved/inspired—I say relatively little about any specific politics beyond recognizing that politics is concerned with issues of race, class, and gender, that there must be greater representation in the production of knowledge of the views of those who have traditionally been ascribed a marginal place in society. This silence is deliberate, for rather than propose some totalizing political viewpoint from which to evaluate the cultures of the present and the past, I want to suggest the means by which locally defined and culturally specific forms of politics can intervene in the production of art historical knowledge. The days of programmatic politics, which offered dogmatic solutions to every historical situation and to all life's ills, are long past. Teleological views such as Marxism, according to which our understanding of history can be "scientifically" derived from a set of transcendental principles, have been even more hopelessly discredited since the collapse of the Communist regimes in Eastern Europe. No one set of values, no one recipe, can be brought to bear on the different historical situations that confront us. Different values are appropriate to the resolution of different problems. Political action will be most effective when it is circumscribed and local rather than universal and global in its ambitions. As Ernesto Laclau and Chantal Mouffe have written, "There is no *unique* privileged position from which a uniform continuity of effects will follow, concluding with the transformation of society as a whole. All struggles, whether those of workers or other political subjects, left to themselves, have a partial character, and can be articulated to very different discourses."[6]

6. Ernesto Laclau and Chantal Mouffe, *Hegemony and Socialist Strategy: Towards a Radical Democratic Politics* (London: Verso, 1985), 169.

CHAPTER ONE

Representation

Images are readings, and the rewritings to which they give rise, through their
ideological choices, function in the same way as sermons: not a re-telling
of the text but a use of it; not an illustration but, ultimately, a new text.
The image does not replace a text; it *is* one. Working through the visual,
iconographic, and literary traditions that produced it, these images propose
for the viewer's consideration a propositional content, an argument, an idea,
inscribed in line and color, by means of representation. By means, also, of an
appeal to the already established knowledge that enables recognition of the
scene depicted. Paradoxically, this recognition is an indispensable step in the
communication of a new, alternative propositional content.
— Mieke Bal, "On Looking and Reading"

The "meaning" of a painting will not be discovered by the construction of
Saussurean *langues* for the discourses of the bodily hexis: gesture, posture,
dress, address. Nor can it be discovered *in* the painting, as a pre-formed
and circumscribed feature. It is in the interaction of painting with social
formation that the semantics of painting is to be found, as a variable term
fluctuating according to the fluctuations of discourse.
— Norman Bryson, *Vision and Painting*

The notion that representation has something to do with the
imitation of nature is deeply embedded in many of the oldest and most
widely accepted critical strategies of art history. This conviction, known as the
resemblance theory of representation, has found in our own time its most
eloquent advocate in Ernst Gombrich.[1] Gombrich has argued that artistic
change is fueled by the artist's desire to improve the illusionistic power of the
artistic tools he or she has inherited from the past. That is, artists allegedly
check the techniques used to capture the qualities of the perceptual experi-
ence of the world which are conventional in their culture against their own
experience of nature. Gombrich described this process in terms of the opera-
tions of "making" and "matching." Making corresponds to the representa-
tional skills passed down from generation to generation, and matching has to

1. Ernst Gombrich, *Art and Illusion: A Study in the Psychology of Pictorial Representation*
(Princeton: Princeton University Press, 1960).

do with the artist's personal observation of the surrounding world. According to Gombrich, the checking of image against world enabled artists to develop ever more sophisticated and effective means of obtaining illusionistically satisfying characterizations of nature. As will be readily appreciated, the process could work in only one direction. Artists would be expected to become increasingly expert at illusionism, and the art of the West could be seen as a kind of evolutionary progress toward the Impressionist movement of the late nineteenth century. In other words, resemblance theory works best in accounting for those periods characterized by an ever-increasing concern for the effects of perception, such as Greek sculpture of the fourth century B.C., Italian painting of the Renaissance, and French painting of the nineteenth century, and less well in dealing with periods of attenuated illusionism, such as the Middle Ages or the twentieth century. It also fails to confront the generally nonmimetic character of artistic production outside the European tradition.

The resemblance theory of representation has been challenged by Nelson Goodman, Norman Bryson, and others who believe that visual representation has less to do with a perennial desire to obtain mimetic accuracy—that is, the artist's desire to duplicate the objects of perception—and more to do with cultural projection, with the construction, presentation, and dissemination of cultural values.[2] Why, Gombrich's critics ask, should artists of all places and times have desired the same thing? In other words, they are predisposed to view the human subject less in terms of some unchanging abstraction (some transcendent "human nature") and more in terms of its historical and cultural location. Goodman, for example, pointed out that no matter how effective the illusionistic technique available to the artists might have been, a picture never resembles anything so much as another picture.[3] What is significant about an illusionistic representation is not the success or failure of its supposed attempt to capture the texture of our perceptual experience but rather its status as a cultural artifact of a particular type. Illusionism is not a characteristic of an eternal and unchanging relationship between two metaphysical constants, the artist on the one hand and nature on the other; rather, it is a feature of a certain type of cultural production. Pressing home this attack on the resemblance theory, Bryson emphasized the inability of Gombrich's model of representation to come to grips with the specific historical circumstances in which an artist worked.[4] By insisting that mimesis is a constituent element of

2. Nelson Goodman, *Languages of Art: An Approach to a Theory of Symbols* (Indianapolis: Hackett, 1976); Norman Bryson, *Vision and Painting: The Logic of the Gaze* (London: Macmillan, 1983).

3. Goodman, *Languages of Art*, 5.

4. Bryson, *Vision and Painting*, chap. 1.

artistic representation, the resemblance theory posits an ahistorical constant —namely, nature—against which all works are to be measured. If the history of art is to claim a genuinely historical status, then nothing about the objects of its study, works of art, should escape historical definition.

If we accept this critique of the resemblance theory, then what alternative theory of representation can we find to put in its place? Semiotics, or the theory of signs, can free the concept of representation from its dependence on mimesis. Semiotics views the work of art as a system of culturally and historically determined signs. It conceives of the work as part of a system of communication in which the artist makes use of conventional signs—that is, socially meaningful processes of signification—in order to construct a cultural object that articulates and disseminates the attitudes of the society of which he or she is a part. The work thus becomes a nexus of cultural activity through which social transactions circulate and flow.

Semiotic definitions of visual representation have been available since the 1930s, when they were first elaborated by the Prague school. The work of the Czech literary scholar Jan Mukarovsky is particularly important in this regard.[5] A semiotic definition of the work of art also played an important role in the photography criticism of Roland Barthes, and it has now achieved prominence in Anglo-American art history chiefly through the work of Norman Bryson.[6] The semiotic approach adopted by Barthes and Bryson is ultimately indebted to the linguistic semiotics of the Swiss theorist Ferdinand de Saussure. Saussure asserted that the linguistic sign is composed of a material sound-image, or *signifier*, and an ideal component or concept, the *signified*. The meaning of the sign or word, which is associated in his theory with the concept of the signified, derives from the relation of that word to all the other words in the language, rather than to its referents in the real world. Saussure not only dramatized the arbitrariness of the linguistic code but severed that code from the circumstances in which it is located. By isolating the significance of the linguistic sign within the context of the code rather than within the cultural context in which the code is used, Saussure safeguarded it from the significatory interference, or "noise," that results from the code's interaction with all the other codes that constitute the social setting. Semiotic theory based on the Saussurean model, therefore, has concentrated on how the play of differences within the linguistic system is capable of producing meaning.

5. Jan Mukarovsky, "Art as Semiotic Fact" (1934), trans. I. R. Titunik, in *Semiotics of Art: Prague School Contributions,* ed. Titunik and Ladislav Matejka (Cambridge: MIT Press, 1976), 3–9.

6. For an overview of the history of semiotic approaches to the work of art, see Mieke Bal and Norman Bryson, "Semiotics and Art History," *Art Bulletin* 73 (1991): 174–208. See also Bryson, *Vision and Painting.*

Much the same is true of the way in which this model has been applied to the visual arts. Many attempts have been made to analyze the material qualities of the work of art into a system of differences capable of conveying cultural meaning.[7] The major problem encountered by such attempts to offer a global theory of visual meaning, however, is what Goodman characterized as the "density" of visual sign systems: information is conveyed and values are manifested synchronically (in one moment rather than through time).[8] Therefore, individual systems of signification, such as light and shade as opposed to line or color, cannot convey meaning without reference to all the other systems that make up the work, since they depend upon one another for their effect. The values transmitted by the work of art depend on the interaction of all its component elements. As a consequence, semiotic theories that depend on an analysis of the material constitution of the image have been more rewarding to historical interpretation when they have been applied to specific examples.

One alternative to the Saussurean model that escapes the potential formalism entailed in making the significance of the sign depend on its location within a single sign system and, consequently, one that is better suited to historical interpretations that seek to understand the working of the sign within the entire spectrum of its cultural and social complexity, is found in the work of the American philosopher Charles Sanders Peirce. Rather than define the sign in linguistic terms, Peirce suggested that it could be used to cover all kinds of coded behavior. His definition of the sign is purposely abstract enough to include any kind of meaning production. A sign, says Peirce, "is something which stands to somebody in some respect or capacity. It addresses somebody, that is, it creates in the mind of that person an equivalent sign or perhaps a more developed sign."[9] On this basis, semiotics encompasses all forms of human interaction, including the production and use of pictorial sign systems. Peirce's division of the concept of the sign into a triad consisting of a "representamen," its "object," and the "interpretant" removes the necessity of defining the sign in terms of the system to which it belongs— say, language or facial expression. Instead, it must be interpreted in terms of how it characterizes its referent and according to the human action that results from it. As Teresa de Lauretis has put it, "For Peirce . . . the 'outer world' enters into semiosis at both ends of the signifying process: first through

7. See, most recently, Fernande Saint-Martin, *Semiotics of Visual Language* (Bloomington: Indiana University Press, 1990); and Göran Sonesson, *Pictorial Concepts: Inquiries into the Semiotic Heritage and Its Relevance to the Analysis of the Visual World* (Lund: Lund University Press, 1989). Both books are reviewed by Lev Manovich, *Art Bulletin* 73 (1991): 500–502.

8. Goodman, *Languages of Art,* 225–32.

9. Charles Sanders Peirce, "Logic as Semiotic: The Theory of Signs," in *Semiotics: An Introductory Anthology,* ed. Robert Innis (Bloomington: Indiana University Press, 1985), 5.

the object, more specifically the 'dynamic object,' and second through the final interpretant."[10] The "dynamic object" is the external object or referent to which the sign refers by means of the "immediate object," which is considered to be an integral part of the sign. Unlike the Saussurean model, according to which the sign is wholly alienated from its referent, the Peircian system suggests that signs, though they bear only an arbitrary relation to the world, are conditioned by the circumstances in which they are produced. The "interpretant" is not to be equated with the interpreter but is to be regarded as the new sign created by the interpreter in the process of understanding.[11] The interpretant is the means by which the interpreting subject gives specific meaning to a sign; it is the result of a projection by which signs are invested with meaning. The meaning of signifying systems is thus never stable, for signs are continually being interpreted by means of other signs. In other words, signs bear the mark of the interpretations placed on them by other subjects in the past, so that our reception of signs is conditioned by the ways in which our culture has taught us to recognize them. On this view, the sign is involved in endless semiosis. Signs engender other signs ad infinitum, and in doing so, they are involved in bringing about the kind of cultural change we know as history.

The endless production of meaning is interrupted from time to time by what Peirce calls the "final interpretant": that is, the specificity of meaning attached to a sign by a subject results in the formation of a habit, which in turn produces action. Peirce's notion of the sign thus opens out onto the world in the form of an adjustment to reality or in the production, transformation, or modification of a new sign, something that will begin the whole process of semiosis once again, as de Lauretis indicates: "As we use or receive signs, we produce interpretants. Their significant effect must pass through each of us, each body and each consciousness, before they may produce an effect or an action upon the world. *The individual's habit as a semiotic production is both the result and the condition of the social production of meaning.*"[12]

The tripartite Peircian sign is of greater interest to a politically inspired

10. Teresa de Lauretis, "The Violence of Rhetoric: Considerations on Representation and Gender," in *Technologies of Gender: Essays in Theory, Film, and Fiction* (Bloomington: Indiana University Press, 1987), 31–50, 39.

11. For a useful discussion of Peirce's notion of the "interpretant," see Umberto Eco, "Peirce and the Semiotic Foundations of Openness: Signs as Texts and Texts as Signs," in *The Role of the Reader: Explorations in the Semiotics of Texts* (Bloomington: Indiana University Press, 1979), 175–99. See also his comments in *A Theory of Semiotics* (Bloomington: Indiana University Press, 1976), 68–71.

12. Teresa de Lauretis, "Semiotics and Experience," in *Alice Doesn't: Feminism, Semiotics, Cinema* (Bloomington: Indiana University Press, 1984), 158–86, 178–79. The importance of de Lauretis's discussion of Peirce is pointed out by Bal and Bryson, "Semiotics and Art History," 202.

form of historical interpretation than the bipartite Saussurean model. That the sign includes its object and an interpretant has important consequences for the work of interpretation. Because it includes the object, the sign is never completely severed from its referent: that is, the sign is never wholly divorced from the circumstances in which it is formulated, for those very circumstances bring it into being. A Peircian theory of semiotics recognizes the anterior existence of the world, while positing that we can never know it except by means of the projection and manipulation of signs. Signs are never wholly autonomous of the world, for they exist only to provide us with a means of understanding it.

Although signs are not motivated by the world and bear only an arbitrary relation to it, their character is nevertheless conditioned by the circumstances in which they are produced. In establishing the meaning of a pictorial sign, therefore, a historical interpretation based on a Peircian model would have the advantage of considering not only that sign's place in the system to which it belonged but how its interpretants had characterized the objects to which they referred. Of course, the relationship posited by the historian between the historical sign's interpretants and their object would be constituted by the historian's own interpretants in a way that ensured that the referent itself was never reached and that the interpretation remained a representation about a representation.

The Peircian notion of the interpretant recognizes that our understanding of historical signs is always tentative and never final. Whereas the instability of the Saussurean sign results from the continual shifting and changing of the significance of the linguistic sign system, according to evolutionary principles that are internal to the language, the instability of the Peircian sign depends on the various ways it has been understood. The instability of the sign is thus not an inherent characteristic of the system to which it belongs but part of the process of interpretation. Whatever knowledge is produced by this process will be conditioned by the interpretants projected into the creation of new signs by the interpreter. A Peircian view of semiosis thus serves as a metaphor for the relativity of knowledge to the cultural and social location of those responsible for its production.

Peirce's theory of the sign helps us understand that while the sign is autonomous and independent of its referent, to which it bears only an arbitrary relation, it is still capable of being affected and inflected by it. In contrast to the dualism of the Saussurean sign, in which the terms "signifier" and "signified" are qualities that derive the sign's meaning from an internal set of differences, Peirce's three-part division allows for the possibility of communication between sign system and reality. Yet, while the referent is something invoked by the sign, the sign does not correspond with it because of the

function of the interpretant, which ensures that the sign is engaged in an "endless semiosis," that its meaning can never be fixed because it is continually being interpreted and reinterpreted by specific historically determined individuals.

When applied to the understanding of visual sign systems, Peirce's theory allows us to replace a static model of the work of art—for example, that implied by Panofsky's notion of iconography, according to which the work is a repository of the values invested in it during its creation—with an active one, according to which the work continues to make meaning long after its completion. The significance of the work for its original audience would thus not be the only question of interest to the history of art. If the work continues to play a role in the creation of culture throughout its existence, then the scope of art historical investigation is broadened enormously.

Peirce's notion of the interpretant also affords insight into the role of the artist. If the mimetic artist never encounters nature directly but only on the basis of sign systems that bear the traces of the way in which nature has been culturally coded in the past, then the inability of mimesis to attain closure, something that would appear inexplicable on the resemblance theory, becomes more readily comprehensible. Peirce's concept of the final interpretant, moreover, permits us to describe how the work acts as a dynamic agent in the life of culture. The subject's appreciation of the significance of pictorial sign systems ultimately results in the formation of cultural habits that have the potential to result in social action. Just as the work bears within its sign system evidence of the material conditions in which it was created, so its cultural significance within a specific set of historical circumstances ensures that it has the power to affect the social structure.

The work of Marxist authors involved in the Soviet reaction to Saussure is relevant to the semiotic theory adopted here. The literary theorists Valentin Volosinov and Mikhail Bakhtin argue that the study of language as a signifying system cannot be divorced from a consideration of the other dimensions of the culture of which it forms a part. According to their view, language is shaped and colored by the social location of its utterance, so that the lexical sign or word draws its meaning from the full complexity of its social function, rather than from the qualities that define its place within a system of internal differences.[13] These authors broke away from the dualism implied in Saussure's distinction between signifier and signified in order to open the concept

13. Valentin Volosinov, *Marxism and the Philosophy of Language,* trans. Ladislav Matejka and I. R. Titunik (Cambridge: Harvard University Press, 1983); and Mikhail Bakhtin, *The Dialogic Imagination: Four Essays,* ed. Michael Holquist, trans. Caryl Emerson and Holquist (Austin: University of Texas Press, 1981).

of the sign to other dimensions of culture and experience. Bakhtin captures some of the complexity he ascribes to the semiotic process when he describes the linguistic sign:

> The word, directed toward its object, enters a dialogically agitated and tension-filled environment of alien words, value judgments and accents, weaves in and out of complex interrelationships, merges with some, recoils from others, intersects with yet a third group: and all this may critically shape discourse, may leave a trace in all its semantic layers, may complicate its expression or influence its entire stylistic profile.[14]

The sign is thus not only open to its object but shaped by the semiotic activity that characterizes the historical moment in which it is used. Bakhtin uses the concept of dialogism to refer to what Peirce might call interpretants. His account of the sign's dialogic structure is equivalent to the process by which, on Peirce's view, the subject projects values into the reception of the sign in an effort to make it meaningful. "The word in living conversation is directly, blatantly, oriented toward a future answer-word: it provokes an answer, anticipates it and structures itself in the answer's direction. Forming itself in an atmosphere of the already spoken, the word is at the same time determined by that which has not yet been said but which is needed and in fact anticipated by the answering word."[15] Bakhtin's notion of the "dialogic" suggests that the artist's pictorial signs are always produced in a complex environment of alternative signs and that they always presuppose a cultural response. In other words, pictorial signs are formulated in circumstances that dictate that the artist take into consideration the ways in which other artists and other social subjects might react to or answer the sign systems he or she manipulates and transforms.

The Peircian/Bakhtinian conception of the sign as open and porous both to its object and to the other sign systems that surround it provides us with a semiotic model of representation that is at once fully historicized and politically inflected. It becomes possible to view representation as a historically compromised process of cultural and social projection in which pictorial signs manifest the values of the societies in which they were created, rather than as the product of a timeless confrontation of artist and nature. It also becomes possible to see that the process of interpretation is ceaseless, and insofar as it is determined by historical circumstances, it bears the imprint of the political forces responsible for its formulation.

The adoption of a semiotic definition of the work of art has far-reaching implications for the way in which we think about its aesthetic status and

14. Bakhtin, "Discourse in the Novel," in *The Dialogic Imagination*, 276.
15. Ibid., 280.

value. Just as an epistemological basis for art historical knowledge based on a correspondence theory of truth has been explicitly rejected here, so is any notion that aesthetic value may reside in the inherent qualities of the work of art. Just as there is no truth to be found in history but only ideologically inflected narratives of one kind or another, so there is no aesthetic value to be found in the work beyond that which we put there ourselves. If the work's status as a sign means that it is involved in an endless production of meaning, then one of the codes in which meaning is created will be the aesthetic one. Just as the significance of the work is ever shifting and changing, so is its aesthetic value.

For a semiotic theory of aesthetic value and function, we can turn once again to Mukarovsky's work.[16] Mukarovsky rejected Kant's view that aesthetic value is intrinsic to the work of art. To Kant's claim that art has the power to provoke a recognition of its aesthetic status regardless of the time and place in which it is encountered,[17] Mukarovsky replied that aesthetic value is always in flux and depends on the intersection of the values invested in the work by the culture that created it with the values of the cultures through which it passes in the course of its subsequent history: "There are no objects or actions which, by virtue of their essence or organization would, regardless of time, place or the person evaluating them, possess an aesthetic function and others which, again by their very nature, would be necessarily immune to the aesthetic function."[18]

On this view, what is considered to have aesthetic significance and what is not shade into each other imperceptibly. What one period or culture finds aesthetically valuable is not necessarily what other periods and cultures regard as an aesthetic achievement. Yet far from being an aesthetic subjectivist, far from believing that all aesthetic judgments are personal and private, Mukarovsky believed in aesthetic objectivity. His aesthetic objectivism, however, is based on the mediating function of the social collectivity. Mukarovsky defined this mediating function in terms of what he called a "collective

16. Jan Mukarovsky, *Structure, Sign, and Function: Selected Essays,* trans. John Burbank and Peter Steiner (New Haven: Yale University Press, 1977); idem, *Aesthetic Function, Norm, and Value as Social Facts,* trans. Mark Suino, Michigan Slavic Contributions, 3 (Ann Arbor: Department of Slavic Languages and Literature, University of Michigan, 1979).

17. For Kant's aesthetic theory, see *Critique of Aesthetic Judgement,* trans. James Meredith (Oxford: Clarendon Press, 1952). For recent criticism of Kant's views in Marxist and deconstructionist writing, see Pierre Bourdieu, *Distinction: A Social Critique of the Judgement of Taste,* trans. Richard Nice (London: Routledge, 1986); Jacques Derrida, *The Truth in Painting,* trans. Geoff Bennington and Ian MacLeod (Chicago: University of Chicago Press, 1987); idem, "Economimesis," trans. R. Klein, *Diacritics* 11 (1981): 3–25; David Rodowick, "Impure Mimesis, or the End of the Aesthetic," in *Deconstruction and the Spatial Arts: Art, Media, Architecture,* ed. Peter Brunette and David Wills (Cambridge: Cambridge University Press, forthcoming).

18. Mukarovsky, *Aesthetic Function,* 1–2.

awareness," by which he seems to have meant the semiotic codes that consti-
tute social life rather than a psychological reality or the sum total of individual
states of consciousness:

> Collective awareness is a social fact. It can be defined as the locus of existence
> of individual systems of cultural phenomena such as language, religion, science,
> politics, etc. These systems are realities even though they cannot be perceived
> by the senses. They reveal their existence by exerting a normative influence on
> empirical reality. Thus, for example, any deviation from a linguistic system em-
> bedded in the collective awareness is spontaneously noted and is evaluated as a
> mistake. The aesthetic also appears in the collective awareness, primarily as a
> system of norms.[19]

Mukarovsky developed a theory concerning the optimal qualities of a work of
art, which posited that it should consist of a unity of similar and dissimilar
"extra-aesthetic values" existing in dynamic tension with one another. Only
in its intersection with the cultural values of the perceiving subject could the
work be judged aesthetically valuable or worthless:

> We should not forget, however, that in addition to the internal arrangement of
> the artwork, and closely tied to it, there also exists a relationship between the
> work as a collection of values and those values possessing practical validity for
> the collective which perceives the work. . . . Only a tension between extra-
> aesthetic values of a work and life-values of a collective enable a work to affect
> the relation between man and reality, and to affect is the proper task of art.[20]

The task of theorizing the way in which the collectivity might determine
the aesthetic value of works of art was later taken up by Hans Robert Jauss.
Jauss described how an interpreter, say a critic or historian, can assess the
"horizon of expectation" of the period in which the work was produced—
that is, both the history of its artistic forms and the historical situation that
determined its original reception—in relating it to the "horizon of expecta-
tion" of the present day. In other words, the critic or historian seeks to
establish the aesthetic value of the work on the basis of how the aesthetic
value attributed to the work in its historical horizon intersects with the
aesthetic values of the present. Like Mukarovsky, he believed that it is the
tension between the aesthetic values of the two horizons, how one demands
appreciation of the other, which determines the objective aesthetic value of
any particular work.

> The way in which a literary work, at the historical moment of its appearance,
> satisfies, surpasses, disappoints, or refutes the expectations of its first audience

19. Ibid., 20.
20. Ibid., 92.

obviously provides a criterion for the determination of its aesthetic value. The distance between the horizon of expectations and the work, between the familiarity of previous aesthetic experience and the "horizonal change" demanded by the reception of the new work, determines the artistic character of the literary work according to the aesthetics of reception: to the degree that this distance decreases, and no turn toward the horizon of yet-unknown experience is demanded of the receiving consciousness, the closer the work comes to the sphere of "culinary" or entertainment art.[21]

Janet Wolff has pointed out that this account of the tensions involved in the meeting of the aesthetic values of different historical horizons makes use of an abstract notion of quality that would appear to transcend the historical circumstances in which it was invoked.[22] From the perspective of the argument pursued in this chapter, Jauss's account of the way in which new aesthetic value results from the confrontation of the value systems of the past and the present would only be useful if his concept of quality were identified with the ideological commitments of the person making the judgment.

A discussion of objective aesthetic value must inevitably raise the institution of the canon of great artists and great works.[23] In the case of art history, educational institutions are only one of a variety of social organizations that actively promote and disseminate the idea that the discipline is dedicated to the study of those works whose value has been universally recognized. The idea is crucial, for example, to the operations of the art market, in which the actual monetary value of works of art hinges on their association with our relation to a standard corpus of canonical works. One has only to think of how connoisseurs invest the concept of "quality" with absolute rather than relative value, to realize the power of the social forces at work in maintaining a

21. Hans Robert Jauss, "Literary History as a Challenge to Literary Theory," in *Towards an Aesthetic of Reception*, trans. Timothy Bahti, intro. Paul de Man (Minneapolis: University of Minnesota Press, 1982), 3–45, 25.

22. Janet Wolff, *Aesthetics and the Sociology of Art*, (Ann Arbor: University of Michigan Press, 1993), 35.

23. The concept of the canon has been much discussed in literary criticism. See Leslie Fiedler and Houston Baker, eds., *English Literature: Opening up the Canon* (Baltimore: Johns Hopkins University Press, 1981); Robert von Hallberg, ed., "Canons," a special issue of *Critical Inquiry* 10 (1983), which included contributions by Barbara Herrnstein Smith, Charles Altieri, Jerome McGann, John Guillory, Richard Ohmann, and others; Jane Tompkins, *Sensational Designs: The Cultural Work of American Fiction, 1790–1860* (New York: Oxford University Press, 1985); Robert Scholes, "Aiming a Canon at the Curriculum," *Salmagundi* 72 (1986): 101–17, and the responses by E. D. Hirsch, Marjorie Perloff, Elizabeth Fox-Genovese, and others; Charles Altieri, *Canons and Consequences: Reflections on the Ethical Force of Imaginative Ideals* (Evanston, Ill.: Northwestern University Press, 1990); Jan Goran, *The Making of the Modern Canon: Genesis and Crisis of a Literary Idea* (Atlantic Highlands, N.J.: Athlone Press, 1991); Paul Lauter, *Canons and Contexts* (New York: Oxford University Press, 1991); and Henry Louis Gates, Jr., *Loose Canons: Notes on the Culture Wars* (New York: Oxford University Press, 1992).

criterion of objective aesthetic value.[24] Museums also contribute to status of canonical works by competing with one another in a sometimes frenzied attempt to include as many as possible in their collections. Furthermore, their exhibitions often serve the purpose of inculcating or indoctrinating the public about the canon by focusing on the work of "great" artists.

A semiotic conception of aesthetic value, which defines the value of the individual work (or artist) in terms of how the values with which it was originally invested intersect with the values of the culture in which it is viewed, enables the interpreter to de-naturalize the concept of the canon and to regard it not as something transcendent and eternal but as something that must be negotiated by each generation in the light of its particular political and cultural interests. For politically committed academics this might entail deliberate efforts to try to alter or manipulate the canon so as to accommodate artists or works that it has previously excluded. Such has been the strategy of those feminists, for example, who have sought to obtain recognition for hitherto neglected women artists. Another alternative has been to continue to teach canonical artists and works but to do so in such a way as to accentuate the relativity of their cultural significance, both in their own historical horizon and in ours. Such an approach might emphasize how allegedly "great" artists have experienced different evaluations at different times. It might also compare and contrast the values associated with such artists and works in their original horizons with the values associated with them today. In such cases the pedagogical goal would be to bring out the extent to which canonical status depends on cultural values, as well as to assess the nature of those values in the light of a particular set of political priorities.

Given the enormously powerful cultural and social forces associated with the preservation of the canon, what is the purpose of espousing a view that denies the existence of universal aesthetic value? The point of challenging the canon by describing how the ideological programs that have sponsored and support it are animated by political considerations, or of expanding the canon so as to include works that have usually been excluded from it for similar reasons, is to promote a set of cultural values that find their justification in a different political agenda. Far from suggesting that the history of art can operate without a canon, an impractical view given its power to maintain the values that structure our society, I believe that it is politically important to adapt and shape that canon in accordance with contemporary ideological agendas.

24. For a discussion of the invocation of the notion of "quality" in the construction of the canon of American literature, see Tompkins, *Sensational Designs,* chap. 7: "But Is It Any Good? The Institutionalization of Literary Value."

CHAPTER TWO

Ideology

The domain of ideology coincides with the domain of signs. They equate one another. Wherever a sign is present, ideology is present too. *Everything ideological possesses semiotic value.*
> —Valentin Volosinov, *Marxism and the Philosophy of Language*

If the sign is regarded as open and porous to all the forms of social value which characterize a particular historical moment, then we must consider its ideological status. Since the concept of ideology has had a complex and varied history, it is important to describe what I mean by ideology in this context. First and foremost, I do not want to invoke the traditional Marxist definition of ideology as belonging to the social "superstructure" and representing the "false consciousness" of the dominant classes. According to Marx, society consists of a "base," understood as the material circumstances of human existence (the means of production and the organization of labor), and a "superstructure," which contains the sphere of cultural ideas, such as religion, philosophy, law, literature, and art.[1] The relationship between the base and the superstructure is defined as specular; that is, the superstructure is said to reflect the circumstances that reign in the base.[2] Thus, in a feudal

1. The literature on the concept of ideology is enormous. Some of the following might serve as an introduction to the subject: Karl Marx and Friedrich Engels, *The German Ideology* (Moscow: Progress, 1976); Georg Lukács, *History and Class Consciousness: Studies in Marxist Dialectics,* trans. Rodney Livingstone (Cambridge: MIT Press, 1971); Karl Mannheim, *Ideology and Utopia,* trans. Louis Wirth and Edward Shils (New York: Harcourt, Brace, 1936); George Lichtheim, *The Concept of Ideology and Other Essays* (New York: Random House, 1967); Louis Althusser, "Ideology and the Ideological State Apparatuses," in *Lenin and Philosophy and Other Essays,* trans. Ben Brewster (New York: Monthly Review Press, 1971), 126–86; Alvin Gouldner, *The Dialectics of Ideology and Technology: The Origins, Grammar, and Future of Ideology* (New York: Seabury Press, 1976); Martin Seliger, *The Marxist Conception of Ideology: A Critical Essay* (Cambridge: Cambridge University Press, 1977); Jorge Larrain, *The Concept of Ideology* (London: Hutchinson, 1979); Paul Hirst, *On Law and Ideology* (London: Macmillan, 1979); Raymond Geuss, *The Idea of Critical Theory: Habermas and the Frankfurt School* (Cambridge: Cambridge University Press, 1981); John Thompson, *Studies in the Theory of Ideology* (Berkeley: University of California Press, 1984); idem, *Ideology and Modern Culture* (Stanford: Stanford University Press, 1990); Terry Eagleton, *Ideology: An Introduction* (London: Verso, 1991).

2. For a discussion of the "base/superstructure" distinction in Marxist theory, see Raymond Williams, "Base and Superstructure in Marxist Cultural Theory," *New Left Review* 82 (1983): 3–16.

society the ownership of land by the aristocracy and the enslavement of the peasants as serfs are said to have been reflected in the realm of ideas as a set of values that served to justify the oppression of the poor by the powerful. The ideology of the dominant classes maintained that it was the duty of the peasant to work to support the classes that either defended society (knights) or interceded for it before God (clerics). Ideology was thus a distorted reflection of the economic circumstances of the age, it was a "false consciousness" in that it sponsored and supported the privileges of the dominant classes by concealing or masking the true nature of class relations.

While this definition of ideology has remained dominant in the Marxist tradition, it has been used quite differently by non-Marxist theorists. Karl Mannheim, for example, distinguished the concept of ideology from the notion of false consciousness. According to Mannheim, ideology is to be viewed not as the thought system of any one particular class but as a feature of the life of all social groups.[3] Mannheim thus preserved that aspect of the Marxist definition of ideology which viewed it as a manifestation of the way in which the material conditions of existence experienced by human beings shaped and molded their systems of ideas, while abandoning that dimension which associated it with the dominant classes. The notion that ideology is part of the common parlance of social life, that every social transaction is invested with ideological values, comes close to the concept of ideology that I want to adopt in this chapter.

Mannheim also provides us with a useful account of the relation of the thought systems of the individual to those of his or her class or group, by countering the assumption that every member of a group shares exactly the same set of ideas: "Every individual participated only in certain fragments of this thought-system, the totality of which is not in the least a mere sum of these fragmentary individual experiences."[4] Mannheim's conception of "total" ideology as opposed to "particular" ideology is thus simply a heuristic device with which to capture the relation of thought to the social circumstances in which it occurs: "As soon as the total conception of ideology is used, we attempt to reconstruct the whole outlook of a social group, and neither the concrete individuals nor the abstract sum of them can legitimately be considered as bearers of the ideological thought-system as a whole."[5]

More important than the expansion of the notion of ideology to cover the particular thought systems of all social groups, however, is the relation of thought systems to sign systems. The earliest attempt to reconcile a Marxist notion of ideology with a Saussurean notion of the sign is found among

3. Mannheim, *Ideology and Utopia.*
4. Ibid., 58.
5. Ibid., 59.

Soviet linguists of the 1920s. Adopting a position similar to Bakhtin's, Volosinov insisted that the linguistic sign system is open to the cultural environment that surrounds it and that this situation endows it with ideological value: "The sign is a creation between individuals, a creation within a social milieu. Therefore the item in question must first acquire inter-individual significance, and only then can it become an object for sign formation. *In other words, only that which has acquired social value can enter the world of ideology, take shape and establish itself there.*"[6] Because of its status as a sign system, language registers the full complexity of the circumstances that surround it, as well as changes of those circumstances in the course of time. The ideological quality of sign systems depends on the movement or slippage between representation and reality. The dynamic interaction between representations and the circumstances they seek to represent means that in the very act of defining the real, representations, like chameleons, take on the shape and color of that which they seek to define:

> Countless ideological threads running through all areas of social intercourse register effect on the word. It stands to reason, then, that the word is the most sensitive *index of social changes,* and what is more, of changes still in the process of growth, still without definitive shape and not as yet accommodated into already regularized and fully defined ideological systems. The word is the medium in which occur the slow quantitative accretions of those changes which have not yet achieved the status of a new ideological quality, not yet produced a new and full-fledged ideological form. The word has the capacity to register all the transitory, delicate, momentary phases of social change.[7]

In what follows, I maintain that a semiotic understanding of ideology, based on a conception of the sign as permeable and open both to the sign systems that surround it and to the circumstances in which it is articulated and used, is of greater relevance to a politically motivated form of art historical interpretation than a base/superstructure model. Whereas the concept of false consciousness associates ideology with the dominant class, thus insisting that the interests of those without power are without ideology, a semiotic view of ideology allows us to define the political interests of all social groups as ideologically motivated. Whereas a base/superstructure interpretation depends on an epistemological claim to knowledge, which privileges the views of one class (the proletariat) over those of another (the bourgeoisie), a semiotic conception of ideology requires no such foundation and, furthermore, permits us to regard the views of all classes as ideologically compromised. The

6. Valentin Volosinov, *Marxism and the Philosophy of Language,* trans. Ladislav Matejka and I. R. Titunik (Cambridge: Harvard University Press, 1983), 22.

7. Ibid., 19.

abandonment of the epistemological claim means that it is no longer neces-
sary to view cultural life through the filter of a totalizing social myth. It
becomes possible to recognize that the complexity of the historical moment
cannot be captured by a set of principles that have been invested with meta-
physical significance. Political struggle is viewed as a conflict between differ-
ent voices and different sign systems, rather than as a manifestation of some
transhistorical dialectic that works itself out in history. The historical mo-
ment, in other words, has not been determined by the state of the class
struggle; rather, in the historical moment opposing systems of cultural and
social signification clash in pursuit of political domination.

While a semiotic conception of ideology forgoes the security and certainty
purportedly afforded by the epistemological claims of Marxism, it enables us
to perceive political conflict as changing and uncertain rather than the inevi-
table result of historical circumstances that are beyond our control. In relin-
quishing Marxist epistemology, a semiotic view of ideology empowers us to
expand the notion of ideological struggle beyond the concept of class to
incorporate notions of race, gender, sexual preference, ecological concern, and
any other interest that may figure among the discourses that constitute cultur-
al life. The sacrifice of a spurious claim to certainty is, therefore, more than
offset by the variety and flexibility to be gained from the recognition that far
from being identified with the views of one particular class, ideology is an
integral part of every social transaction.

Of particular interest to this view of ideology is the work of Louis Al-
thusser, which enables us to understand not only the social function of
ideology but, most important, how it is responsible for the formation of
human subjectivity.[8] Althusser reexamines the Marxist account of how social
formations reproduce the conditions of production on which they depend.
He finds that the role ascribed to the state, as the repressive instrument by
which the dominant classes are said to impose their will on those that are
subordinate, is inadequate to account for the perpetuation of the class struc-
ture. In addition to the repressive powers of the state, therefore, he posits the
operation of "ideological state apparatuses," social institutions by which the
state can pursue its aims without recourse to repression. Such ideological state
apparatuses as religion, education, the family, law, politics, trades unions,
communications media, and culture promulgate and disseminate the values
of the dominant classes throughout the population, thus ensuring that their
interests go unchallenged from generation to generation.

Of interest here is the suggestion that it is the processes of communication,

8. Althusser, "Ideology." For a lucid analysis and critique of this essay, see Hirst, *On Law and
Ideology*, chap. 3. See also John Tagg, *The Burden of Representation: Essays on Photographies and
Histories* (Amherst: University of Massachusetts Press, 1988), 24–29; and idem, *Ground of
Dispute: Art History, Cultural Politics, and the Discursive Field* (London: Macmillan, 1992), 4–7.

systems of signification, that are responsible for shaping and molding the
cultural attitudes on which the social order depends. In other words, the
dominance of the dominant classes is not immediately referred to their own-
ership of the means of production but to their control of the institutions
where social meaning is created. Of course, Althusser never completely sev-
ered the connection between the ideological state apparatuses and the "hard-
er" reality that supported them, and he thus preserved the "base/superstruc-
ture" distinction that had previously characterized Marxist culture criticism.
However, his equation of ideology and signification affords us an opportunity
of developing a genuinely semiotic notion of ideology. The Peircian concep-
tion of the sign, for example, permits us to posit a relation between sign and
world according to which the sign is in some sense determined by the nature
of its object, without subscribing to the view that the sign is an effect of the
world. The object rendered by the sign is mediated and refracted through the
culture in whose signifying systems it has habitually been represented. Since
the relation between the sign and the way that sign is understood by an
individual is arbitrary rather than motivated, the relation between world and
sign cannot be characterized as a relation of cause and effect. On this view the
dominance of the dominant classes would not be referred to their ownership
of the means of production but would be regarded as a function of their
discourse.

Althusser's account of the operation of the ideological state apparatuses
contains a description of the formation of the subject that is relevant to a
semiotic theory of ideology. According to Althusser, the ideological appara-
tuses call us into being through a process of "interpellation." That is, their
message is aimed at individuals, and consequently our subjectivity is consti-
tuted in relation to that expectation. Taking religion as his example, he uses
the distinction between Subject with a capital *S* and subject with a small *s* to
suggest the relation between God and man: "The individual *is interpellated as
a (free) subject in order that he shall submit freely to the commandments of the
Subject, i.e. in order that he shall (freely) accept his subjection.*"[9] The same is
true of the other ideological state apparatuses, each creating a subject that will
duplicate the terms that brought it into existence. The law informs us of our
right so that we can fulfil our duties; the family's authority over its children
depends on their care.

Althusser's theory of interpellation is based on the claim of Lacan's psycho-
analytic theory that the human subject is brought into existence through its
encounter with the "symbolic."[10] That is, it allows the subject to become a

9. Althusser, "Ideology," 182.

10. See, for example, Jacques Lacan, "The Mirror Stage as Formative of the Function of the I"
and "The Agency of the Letter in the Unconscious, or Reason since Freud," in *Ecrits: A Selection,*
trans. Alan Sheridan (New York: Norton, 1977), 1–7 and 146–78.

social being by providing it with the signifying systems that both alienate it from and enable it to manipulate the real conditions of existence. What is important for both theorists is the semiotic notion that access to the real world is mediated through the cultural codes we inherit from the society to which we belong.

Althusser's definition of ideology, that "ideology represents the imaginary relationship of individuals to their real conditions of existence,"[11] has been criticized by Paul Hirst as an indication of his continuing allegiance to an epistemological rather than a semiotic conception of ideology.[12] If ideology is a representation—that is, if it represents the imaginary relation of the individual to his or her lived experience—then it implies the existence of a subject capable of negotiating the space between the symbolic and the real, to use Lacan's terms (or the superstructure and the base). Such a notion of subjectivity would contradict Althusser's Lacanian definition of the subject as interpellated by the ideological forces that constitute the symbolic. If the subject's subjectivity is the effect of a process rather than an inherent characteristic, then how does it come by its powers of agency? If the subject is itself a representation, how can it produce representations of its own?

Criticism of this kind appears to respond to the sense of determinism that pervades Althusser's essay. There would appear to be no escape from the circularity of the thesis that it is the rhetoric of the dominant classes, rather than their control of the means of production, which is responsible for the reproduction of the conditions of production. Althusser's failure, from the traditional Marxist standpoint, lies in the absence of a theory of human agency. Marxist theory had, after all, held out the hope that proletarian control of the means of production might alter the dominant ideology; Althusser, by contrast, appears to offer no theory of ideological change.

These views of Althusser can be revised in the light of changing approaches to Lacan's psychoanalytic theory of subjectivity. It is only recently that the work of Kaja Silverman has stressed the relevance of Lacan's concept of the "gaze." That is, Lacan's chapters on the gaze have been productively related to the basic account of the construction of subjectivity found in his essay on the "mirror stage."[13] According to Lacan, during the mirror stage, the subject is split between an identification with the reflection in a mirror, a reflection that would appear to realize the psychic plenitude of a subject still undifferentiated from its mother, and an alienation from that reflection as a consequence of the realization that it is an object for the gaze of others. It is the double movement between identification and alienation which enables the subject to realize itself as a social being.

11. Althusser, "Ideology," 162.
12. Hirst, *On Law and Ideology,* 68–73.
13. Lacan, "The Mirror Stage," in *Ecrits.*

Adding to this account of the formation of the subject, Silverman calls attention to Lacan's description of how the subject is capable of projecting and manipulating a mask or "screen" before the gaze.[14] In this instance the gaze is clearly defined as analogous to the symbolic, that is, equivalent to the social conventions that interpellate the subject as a social being. It is by means of the screen that the subject's particularity, the unique quality of its split subjectivity, finds social manifestation. Although the subject is itself a representation of the gaze or of the symbolic order, it has the power to offer the gaze a representation of its own and is thus endowed with certain limited powers of agency.

The concept of the screen is crucial to an appreciation of the agency of the subject on the Lacanian view, and we can also use it to recuperate Althusser's theory as more than an account of the ideology of the dominant classes. If ideology is the representation of the imaginary relationship of individuals to the real conditions of their existence, ideology does not depend on its relation to economic reality but to the way in which that reality is processed by the individual unconscious, or filtered through a personal screen. This adaptation of Althusser's theory enables us to factor in the possibility of resistance as well as of the development of contestatory ideologies. It also suggests that the theory's representational status need not depend on the assumption of an autonomous subject. Far from it. The model of agency afforded us by the Lacanian model is severely limited in its scope and restricted in its power. It suffices, however, to introduce a conception of personal agency, one which, because it is based on the individual unconsciousness, escapes the laws of economic determinism.

Slavoj Žižek's interpretation of Lacan also provides us with a means of understanding the representational status of ideology. According to Žižek, the symbolic is always in process of formation. Far from being fixed, eternal, comprehensive and all embracing, its social codes are characterized by transformation and change. At the moment it affords the subject a system by which to make sense of the world, it imparts the awareness that such systems are incomplete. This realization permits the subject to recognize that the real conditions of existence can never be captured by the signifying systems of the symbolic order. The conditions of existence are associated with an "excess" of meaning, which is beyond the capacity of the symbolic to define.[15] Žižek's

14. Kaja Silverman, "Fassbinder and Lacan: A Reconsideration of the Gaze, Look, and Image," in *Male Subjectivity at the Margins* (New York: Routledge, 1992), 125–56, 145–52. For a useful discussion of the intersection of the theoretical interests of Althusser and Lacan, see also Paul Smith, *Discerning the Subject* (Minneapolis: University of Minnesota Press, 1988), chap. 1.

15. Slavoj Žižek, *The Sublime Object of Ideology* (London: Verso, 1989), 122: "So it is precisely this lack in the Other which enables the subject to achieve a kind of 'de-alienation' called by Lacan *separation:* not in the sense that the subject experiences that now he is separated forever from the object by the barrier of language, but that *the object is separated from the Other itself,*

account of the symbolic draws attention to the powers of agency ascribed to the subject by Lacan. If the symbolic serves not only to define the subject but also to make it aware that its powers of definition are not comprehensive, if the symbolic's power to fashion and shape subjectivity cannot be realized without imparting a sense of its own limitations, then the subject becomes aware of its own role in the extension and manipulation of the social codes that govern its life experience.

Michael Foucault's concept of "discursive practices" has often been preferred to the notion of ideology, because it seems less attached to the kind of economic determinism that characterizes Marxist thinking on this subject.[16] According to Foucault, discursive practices are always engaged in the transfer and dissemination of power from one point in the social fabric to another in a way that does not depend on the social hierarchy or class structure for its direction. That is, power is said to circulate through society in a way that resists definition in terms of systems of domination and repression. Unlike the concept of ideology which has traditionally been defined in terms of the false consciousness of the dominant classes, Foucault's notion of discursive practices conceives of power as unstable, shifting its force and direction according to local circumstances.

> Power must be analyzed as something which circulates, or rather as something which only functions in the form of a chain. It is never localized here or there, never in anybody's hands, never appropriated as a commodity or piece of wealth. Power is employed and exercised through a net-like organization. And not only do individuals circulate between its threads; they are always in the position of simultaneously undergoing and exercising this power. They are not only its inert or consenting target; they are always also the elements of its articulation. In other words, individuals are the vehicles of power, not its point of application.[17]

The flexibility of Foucault's conception of power has made it an attractive model for political interpretation. It has enabled the analysis of the institutions and the mechanisms through which power circulates without predetermining the source and direction of its flow. Not only is it possible to register the dissemination of dominant values, but it is also possible to discuss in-

that the Other itself 'hasn't got it,' hasn't got the final answer—that is to say, it is itself blocked, desiring; that there is also a desire of the Other. This lack in the Other gives the subject—so to speak—a breathing space, it enables him to avoid the total alienation in the signifier not by filling out this lack but by allowing him to identify himself, his own lack, with the lack in the Other."

16. Tagg, *Burden of Representation*, 21.

17. Michel Foucault, "Two Lectures," in *Power/Knowledge: Selected Interviews and Other Writings, 1972–1977*, ed. Colin Gordon (New York: Random House, 1980), 78–108, 98.

stances of resistance and the development of oppositional values.[18]

Foucault's emphasis, however, on the way in which dominant discursive practices are capable of absorbing and re-incorporating resistance to their authority has been criticized as a drawback to forms of political interpretation which are interested in political change.[19] Similarly his resolute avoidance of notions of agency, of the interventions of the individuals in the discursive practices involved in the transmission of power, is seen as a failure to recognize an important instrument of social transformation. The description of discursive practices as processes that merely constitute class interests as well as racial and gendered identities rather than processes that also interact with them serves to mystify the nature of social change. As Edward Said has objected: "If power oppresses and controls and manipulates, then everything that resists it is not morally equal to power, is not neutrally and simply a weapon against that power. Resistance cannot equally be an adversarial alternative to power and a dependent function of it, except in some metaphysical ultimately trivial sense."[20] To participate in a discursive practice is be to caught up in it without remainder. On this view, the notion that the individual has any degree of autonomy, even that small degree of agency ascribed to it on the Lacanian view of subjectivity, is false. As a consequence, discursive practices are clearly not the equivalent of the representations that constitute processes of signification.[21] Whereas semiotic codes change according to the way they are ascribed new significance by individuals who use them in their encounter with the real, Foucault provides little insight into the genesis and development of change within discursive practices. Discursive practices thus cannot be reconciled with the semiotic and psychoanalytic conception of ideology which I have adopted in this chapter. Neither can they be reconciled with a form of historical interpretation which is conceived as political intervention. Furthermore, Foucault's definition of individuals as the "vehicles of power, not its points of application," offers little basis for a self-reflexive account of the process of interpretation itself.

18. See John Tagg, *The Burden of Representation: Essays on Photographics and Histories* (Amherst: University of Massachusetts Press, 1988); Jonathan Crary, *Techniques of the Observer: On Vision and Modernity in the Nineteenth Century* (Cambridge: MIT Press, 1990).

19. See the criticisms leveled at Stephen Greenblatt's use of Foucault in *Renaissance Self Fashioning: From More to Shakespeare* (Chicago: Chicago University Press, 1980) by Carolyn Porter, "Are We Being Historical Yet?" *South Atlantic Quarterly* 87 (1988): 743–86, and Frank Lentricchia, "Foucault's Legacy—A New Historicism?" In *The New Historicism*, ed. Aram Veeser (New York: Routledge, 1989), 231–42.

20. Edward Said, "Traveling Theory," in *The World, the Text, and the Critic* (Cambridge: Harvard University Press, 1983), 226–47, 247.

21. See "The Subject and Power," in *Art after Modernism: Rethinking Representation,* ed. Brian Wallis (New York: New Museum of Contemporary Art; Boston: D. R. Godine, 1984), 417–32, 425.

Returning to Althusser, it is possible to interpret his conception of ideology in such a way that the ideological sign systems that structure social life are conceived of as reproducing themselves without a causal relation to reality. Representations or ideological sign systems are defined as possessing a life of their own which is quite distinct from (yet intimately related to) the material conditions with which they are associated. Ideological sign systems represent the interests of all races, classes, and genders, not just those in positions of power. On this view, ideologies of class do not simply depend on some direct causal relationship between sign and material wealth but on the imaginary relation of particular individuals to the material conditions of their existence. As Gareth Steadman Jones has put it, "The language of class was not simply a verbalization of perception or the rising to consciousness of an existential fact, as Marxists and sociological traditions have assumed. But neither was it simply the articulation of a cumulative experience of a particular form of class relations. It was constructed and inscribed within a complex rhetoric of metaphorical associations, causal inference and imaginative construction."[22]

Althusser's theory of ideology also casts the role of the interpreter or the historian in a new light. The autonomous subject of Enlightenment humanism, possessed of the capacity to survey culture without being implicated in it, is revealed to be nothing but an ideology effect. The historian must instead be regarded as a continually evolving subjectivity, called into being by the intersection of the ideological state apparatuses, or the symbolic, with the individual unconscious. It is out of the historical specificity of that interaction that the historian can manipulate the screen of his or her identity so as to either conform or contend with the values that structure and support the status quo.

22. Gareth Steadman Jones, *Languages of Class: Studies in English Working Class History, 1832–1982* (Cambridge: Cambridge University Press, 1983), 101–2.

CHAPTER THREE

Authorship

Once the author is removed, the claim to decipher a text becomes quite futile. To give a text an Author is to impose a limit on that text, to furnish it with a final signified, to close the writing.
　　　　　　　　　　　　—Roland Barthes, "The Death of the Author"

But the subject should not be entirely abandoned. It should be reconsidered, not to restore the theme of an originating subject, but to seize its functions, its intervention in discourse, and its system of dependencies.
　　　　　　　　　　　　—Michel Foucault, "What Is an Author?"

The adoption of a semiotic approach to both representation and ideology has important consequences for understanding the work of inter-pretation. Just as linguistic or visual signs are involved in a process of endless semiosis, so the interpreters of signs are involved in a never-ending cycle of interpretation. Just as interpreters of signs use and manipulate the signs they study, so their interpretations, or the signs they produce, are used and manip-ulated by others. This view of social signification as an endless production of meaning has important implications for our understanding of human subjec tivity. The interpreting subject becomes a sign for those who interpret its interpretations in the future. Semiotic theory thus prompts us to reevaluate the subjectivity of the historian as well as the function of interpretation.

For a semiotic theory of the interpreter as social subject, we can turn to Jacques Lacan's application of Saussure's linguistics to psychoanalysis.[1] Ac-

1. See Jacques Lacan, "The Mirror Stage as Formative of the Function of the I" and "The Agency of the Letter in the Unconscious, or Reason since Freud," in *Ecrits: A Selection,* trans. Alan Sheridan (New York: Norton, 1977), 1–7 and 146–78. For useful introductions to Lacan's thought, see Anika Lemaire, *Jacques Lacan,* trans. David Macey (London: Routledge, 1977; 1st French ed., 1970); Juliet Mitchell and Jacqueline Rose, *Feminine Sexuality: Jacques Lacan and the Ecole Freudienne* (London: Macmillan, 1982); Jane Gallop, *Reading Lacan* (Ithaca: Cornell University Press, 1985); Ellie Ragland-Sullivan, *Jacques Lacan and the Philosophy of Psychoanalysis* (Urbana: University of Illinois Press, 1986); Juliet Flower MacCannell, *Figuring Lacan* (Lincoln: University of Nebraska Press, 1986); Shoshana Felman, *Jacques Lacan and the Adventure of Insight: Psychoanalysis in Contemporary Culture* (Cambridge: Harvard University Press, 1987); Elizabeth Grosz, *Jacques Lacan: A Feminist Introduction* (London: Routledge, 1990); Malcolm Bowie, *Lacan* (Cambridge: Harvard University Press, 1991). For a discussion of the value of

cording to Lacan, the subject is created as a consequence of the child's encounter with the alienating power of language. Language alienates because it splits the unified subject by introducing the concept of the "other." The subject, in other words, no longer exists by and for itself once it becomes aware that it is itself an object to another subject. While language—or, in Lacan's terms, the symbolic—grants the subject access to cultural and social life, it also defines the subject in terms of what it is not. Such a view of human subjectivity implies that the sign systems manipulated by the subject must always be unstable in their meaning. If the human subject is both the subject and the object of language, the possibility of univocal meaning is necessarily lost. Language defines the author's subjectivity to the same extent as the author's subjectivity defines the language. Language structures and shapes the utterance as much as the utterance instantiates and materializes the language. Neither the sign systems that belong to the historical horizon nor the discourse of the historian is univocal. What the author wishes to say is never found in the place where it is said.

On a semiotic view, since the artist is both an interpreter and a producer of signs, his or her subjectivity is included in my sketch of Lacan's position. Inasmuch as the artist is specifically a producer of visual rather than linguistic signs, however, it may be useful to locate his or her position within the context of Lacan's theory of the gaze. Lacan's model of the splitting of the subject on its accession to the symbolic finds its counterpart in his account of the subject's acquisition of subjecthood by means of vision. In his essay "The Mirror Stage," Lacan makes use of a hypothetical incident in the early life of the child to illustrate his point.[2] The child's first experience of a mirror—its realization that its subjectivity is objectified in the mirror's surface—is used as a metaphor to describe how our awareness of our status as objects to other subjects is crucial in defining our own sense of self. Lacan argues that the experience of the mirror is responsible for two very different types of response in the child. On the one hand, the child identifies with the reflection and rejoices in this identification with the materialization of its subjectivity; on the other hand, the child is troubled by the realization that this materialization limits its conception of that subjectivity, reducing it to the status of an object in the eyes of others.

This account of the acquisition of subjecthood by means of vision lies at the heart of Lacan's approach to the understanding of the visual arts. In several chapters of *The Four Fundamental Concepts of Psychoanalysis,* Lacan

Lacan's theory of subjectivity for understanding the nature of artistic production, one that comes to somewhat different conclusions from mine, see Janet Wolff, *The Social Production of Art* (New York: New York University Press, 1984), 132–36.

2. Lacan, "The Mirror Stage," *Ecrits.*

discusses the implications for the visual arts of his claim that the subject is
alienated from itself through its awareness of the gaze, just as it is through the
acquisition of language.[3] He unpacks the implications of having claimed that
the subject never sees what it wants to see, or as he put it, "*You never look at
me from this place from which I see you.* Conversely, *what I look at is never what
I wish to see.*"[4] Lacan suggests that just as animals acquire the camouflage that
permits them to manipulate and thus to survive the gaze of other animals, so
human beings are accustomed to manipulating the masks they offer the gaze
of other subjects:

> Only the subject—the human subject, the subject of the desire that is the es-
> sence of man—is not, unlike the animal, entirely caught up in this imaginary
> capture. He maps himself in it. How? Insofar as he isolates the function of the
> screen and plays with it. Man, in effect, knows how to play with the mask as
> that beyond which there is the gaze. The screen is here the locus of mediation.[5]

Lacan provides the reader with an illustration. On one side of the two
overlapping triangles is the gaze, or the visual equivalent of the symbolic, in
which the subject must find a place. The gaze represents the concept of the
other in the field of vision, just as language does in the realm of the symbolic.

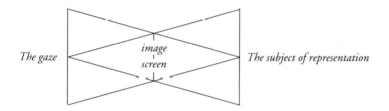

The subject finds its location within the gaze by means of the screen, a
concept that can be metaphorically extended to cover the image produced by
the artist. The screen is thus not only the means by which the subject copes
with the alienating power of the gaze; it can also be understood as the work of
art. It can be regarded as the subject's personal mask insofar as it incorporates
the unique qualities of his or her individuality in a form that can be recon-
ciled with the impersonal otherness of the gaze, or it can be viewed as the way
in which the artist expands or supplements the gaze's control of the real (the
material conditions of existence, which are forever beyond its powers to

3. Jacques Lacan, *The Four Fundamental Concepts of Psychoanalysis,* ed. Jacques-Alain Miller,
trans. Alan Sheridan (New York: Norton, 1981), chaps. 6–9: "Of the Gaze as *Objet Petit a.*"
 4. Ibid., 103.
 5. Ibid., 107.

define) by offering it that which it cannot see. The artist's subjectivity, marked and defined by the social codes that constitute the symbolic or the gaze, has the capacity to extend the gaze's power to define the real by offering it images or visions of that which escapes its purview, by developing means to capture that which the gaze cannot encode. Lacan's conception of how the artist exploits the excess of meaning associated with the real assumes a mimetic or naturalistic visual vocabulary. It can be used to help explain the fascination of Western culture with illusionistic art:

> What is it that attracts and satisfies us in *trompe l'oeil?* What is it that captures our attention and delights us? At the moment when, by a mere shift of our gaze, we are able to realize that the representation does not move with the gaze and that it is merely *trompe l'oeil.* For it appears at that moment as something other than it seems, or rather it now seems to be that something else. The picture does not compete with appearance, it competes with what Plato designates for us as being the Idea. It is because the picture is the appearance that says it is that which gives the appearance that Plato attacks painting, as if it were an activity competing with his own.[6]

The artist's image thus appears to transcend the visual codes by which our approach to the real is mediated by the concept of the gaze. In defining for the gaze that which has escaped its capacity to codify, the artist offers it something to feed on, something it can subsequently incorporate into its own visual codes. The image, being the artist's account of what the gaze cannot see, momentarily appeases its search for meaning by offering it a substitute for that which must forever escape its grasp.

Lacan's notion of the gaze helps us to map how the subject becomes a social agent by acquiring the cultural codes of vision. The concept of the screen suggests that this process of definition is not total. Because the Real, the conditions of existence, is beyond culture's capacity to define, the individual subject is able both to develop a personal mask that allows it to manifest a representation of its own subjectivity and to offer the gaze a representation of what it cannot see.

One of the most important consequences of the adoption of a semiotic definition of subjectivity is that it makes it possible for us to understand the work of art as the product of both conscious and unconscious forces. Every work represents both the texture of the symbolic, the values that flowed through a culture at a particular moment, and the artist's manipulation of those values in constructing a personal mask or an artistic image in which his or her own individuality can be displayed. I do not claim that we can

6. Ibid., 112.

understand those aspects of subjectivity that escape definition by the symbolic
(for those belong by definition to the unconscious), but the semiotic defini-
tion of subjectivity allows for a recognition not only of the incapacity of the
symbolic to encompass the real but also of the subject's power to develop an
interpretation of the real which was not provided by the symbolic. The work
of interpretation is thus both a manifestation of the values of the symbolic
which define the historian's subjectivity and a mask or screen developed by
the historian to cope with the power of the gaze. It affords us a means of
accounting both for the definition of subjects by the cultures to which they
belong and for their capacity to challenge and resist certain of the values that
characterize those cultures. In Kaja Silverman's words:

> It is crucial that we insist upon the social and historical status of the screen by
> describing it as that culturally generated image or repertoire of images through
> which subjects are not only constituted, but differentiated in relation to class,
> race, sexuality, age and nationality. The possibility of "playing" with these im-
> ages then assumes a critical importance, opening up as it does an arena for po-
> litical contestation.[7]

A semiotic conception of subjectivity is relevant to a politically motivated
form of art historical interpretation because it permits us to abandon the
epistemological claims associated with the notion of the humanist subject. An
acknowledgment that our subjectivity is determined by psychoanalytic forces
beyond our control serves to dramatize the tentative and impermanent status
of our claims to knowledge. Whereas the humanist subject is conceived as an
autonomous agent endowed with complete objectivity, a subject whose capac-
ity to rise above the pull and tug of historical circumstances enables it to make
knowledge claims that transcend time and place, the semiotic subject is seen
as split on the acquisition of the symbolic and thus as much defined by
established social codes as it is capable of manipulating and altering them.
This view allows us to understand how claims to knowledge are compromised
by the historical situation in which they are made. It emphasizes the role of
politics in the creation and dissemination of knowledge. Just as the subject is
shaped by the political codes that structure the culture to which it belongs, so
its own limited powers of agency (Lacan's mask or screen) is invested with
values that either coincide with and support or question and challenge those
that constitute the status quo.

Many of the implications of a semiotic understanding of human subjec-
tivity have already been brought to bear on the theorization of the role of the

7. Kaja Silverman, "Fassbinder and Lacan: A Reconsideration of Gaze, Look, and Image,"
Camera Obscura 19 (1989): 55–84, 75–76.

author or the artist in literary and artistic production. Roland Barthes's essay "The Death of the Author" employed semiotics, that is, an understanding of writing as a system of codes that exist prior to the author's personal intervention, to claim that literary conventions were more important than authorial invention.[8] In an attack on romantic humanist notions of the transcendental nature of literary creativity, Barthes argued that the author's personal contribution was strictly circumscribed: "The writer can only imitate a gesture that is always anterior, never original. His only power is to mix writings, to counter the ones with the others, in such a way as never to rest on any one of them."[9]

One of the implications of insisting that language speaks through the author as much as the author speaks him- or herself through language is the evacuation of the notion of artistic intention. If the author does not express him- or herself, if there is no movement from inside to outside in the act of literary creation, if all there is is inflected language, then it no longer makes sense to talk about the artist's intentions. What the author contributes to the language becomes inseparable from the way in which the language constituted the author. The collapse of the distinction between author and writing, the notion that there is nothing beneath the surface of language, also has consequences for our view of interpretation. Instead of being an act of penetration, instead of moving from surface to depth, interpretation remains on the surface of the work, refusing to "stand/under" (understand). As Barthes put it, "In the multiplicity of writing, everything is to be *disentangled*, nothing *deciphered*; the structure can be followed, run (like the thread of a stocking) at every point and at every level, but there is nothing beneath: the space of writing is to be ranged over, not pierced."[10]

Michel Foucault also critiqued the romantic notion of the author or artist as an autonomous genius. Unlike Barthes, Foucault is unwilling to ascribe to writing a dominant role in the process of literary production. To Foucault it seems that the characterization of writing as that which determines the author's intervention serves to transcendentalize language rather than the author: "In granting a primordial status to writing, do we not, in effect, simply reinscribe in transcendental terms the theological affirmation of its sacred origin or a critical belief in its creative nature?"[11] Instead of dissolving the writer into the writing and vice versa, as Barthes had done, Foucault devel-

8. Roland Barthes, "The Death of the Author," in *Image, Music, Text,* ed. and trans. Stephen Heath (New York: Hill and Wang, 1977), 142–48.

9. Ibid., 146.

10. Ibid., 147.

11. Michel Foucault, "What Is an Author?" *Language, Counter-Memory, Practice: Selected Essays and Interviews,* ed. Donald Bouchard, trans. Bouchard and Sherry Simon (Ithaca: Cornell University Press, 1977), 113–38, 120.

oped a more historical argument, suggesting that what we call an author varies from period to period according to the social function he or she is assigned. He points out for example, that during the Middle Ages many literary texts circulated anonymously without the necessity of being identified as the work of an author. The rise of the notion of literary value, however, made it necessary to identify the author so as to separate this particular form of writing from any other. He concludes:

> The "author function" is tied to the legal and institutional systems that circum-scribe, determine, and articulate the realm of discourses; it does not operate in a uniform manner in all discourses, at all times, and in any given culture; it is not defined by the spontaneous attribution of a text to its creator, but through a series of precise and complex procedures; it does not refer, purely and simply, to an actual individual insofar as it simultaneously gives rise to a variety of egos and to a series of subjective positions that individuals of any class may come to occupy.[12]

According to Foucault, therefore, while the notion of the author's subjectivity is not to be discarded as irrelevant for purposes of interpretation, we must keep in mind the varying status accorded to that subjectivity in different cultures: "We should ask: under what conditions and through what forms can an entity like the subject appear in the order of discourse; what position does it occupy; what functions does it exhibit; and what rules does it follow in each type of discourse? In short, the subject (and its substitutes) must be stripped of its creative role and analyzed as a complex and variable function of discourse."[13]

Alexander Nehamas has expanded Foucault's discussion of the "author function" to suggest that the concept of the author is a heuristic device.[14] The author is not something that precedes the text, for as Foucault pointed out, there have been periods of European history when literature circulated without there being a perceived need to associate it with particular subjectivities. The author, rather, is something that is created by the process of interpretation. Nehamas thus introduces a distinction between the writer, the individual responsible for writing the text and to whom it may legally be said to belong, and the author, a mythical subjectivity created by the text and by those who interpret it. Whereas the writer is a repressive figure, whose association with the legal codes of ownership serves as a metaphor for the closure imposed on textual interpretation by the strategy of reading texts in relation

12. Ibid., 130–31.

13. Ibid., 137–38.

14. Alexander Nehamas, "Writer, Text, Work, Author," in *Literature and the Question of Philosophy,* ed. Anthony Cascardi (Baltimore: Johns Hopkins University Press, 1987), 265–91.

to the individuals who composed them, the author is an expansive concept that is the product of the text and of those texts to which it has given rise. The author, in other words, is a creation of the interpretations to which his or her work has been subjected in the course of time.

Needless to say, this distinction depends on a particular conception of interpretation. Rather than search for meanings that can be located in a writer's intention or experience, Nehamas conceived of interpretation as an expansion of the text's significance: "Interpretation, therefore, must be pictured not as an effort to place a text with[in] a continually deepening context but as an attempt to place it within a perpetually broadening one."[15] The advantage of Nehamas's formulation of the author function is that it promotes an interpretation that abandons metaphors of depth and penetration, that refuses to attempt to see behind or through the text into authorial intention or even into the historical circumstances that may underlie and thus determine the text's constitution, an interpretation that depends on surfaces, that elaborates on what is already there and constructs new meaning from it: "To interpret a text, on this model, is not to go underneath it, into a meaning covert within it, but to connect it to other texts and to their authors, to see what texts have made [it] possible and what texts it, in turn, has made possible itself."[16]

Some of these critiques of the traditional conception of the author have been taken up by art historians in their discussion of the notion of the artist. Griselda Pollock, for example, follows Foucault in suggesting that we must dispense with the narrative closure brought to the writing of history by the notion of authorial or artistic authority and that it is important to ascertain the author function served by biography within a particular discipline, in this case art history, at any particular moment.[17] In a detailed analysis of the literature on van Gogh, she demonstrates how art history constitutes itself as a discipline by insisting on the insane genius of the artist as the ground of the cultural value of his work: "For the present I want to suggest that the discourse on madness and art operates to sever art and artist from history and to render both unavailable to those without the specialized knowledge of its processes which art history claims for itself."[18] Both the medical and the art historical literature on van Gogh depend on a careful reading of his life and his art as a teleological descent into madness and suicide. The two discourses are mutually interdependent and mutually supportive. The alleged madness

15. Ibid., 278.
16. Ibid., 287.
17. Griselda Pollock, "Artists Mythologies and Media Genius: Madness and Art History," *Screen* 21 (1980): 57–96.
18. Ibid., 65.

of van Gogh, which flies in the face of the historical evidence that he was in fact repeatedly diagnosed as epileptic, becomes the ground on which art historical claims about the transcendental aesthetic value of his work can be formulated.

In a later essay, Pollock focuses on the notion of the author function as a heuristic device deployed by the historian in order to locate the individual artist in the context of cultural and social forces that defined the historical moment in which he or she lived.[19] She develops the notion of the author function by means of Raymond Williams's concept of "cultural practice." According to Williams, cultural practice can cover both collective activity (conceived of as the conditions of action) and individual activity (conceived of as their instantiation). Pollock proposes that the function of the study of biography is to determine the angle at which a particular manifestation of the dominant social and cultural forces, that is, the individual subjectivity, works its way across a historical field that is constituted by them: "Van Gogh becomes historically useful by throwing into relief those cultural formations [the Dutch and Parisian avant-garde] precisely through the degree that Van Gogh was incapable of accommodating his practice to them and normalising their protocols and concerns."[20]

Fred Orton and John Christie have also reflected on the concept of the artist and the role of art historical biography in the context of critical theory. They claim that critical theory is responsible for a view of human subjectivity as "dispersed, divided and decentered by language."[21] Not only does critical theory suggest that the author is an effect of the text rather than that which produced it, they maintain, but the primacy it ascribes to language serves to collapse the distinction between "primary" and "secondary" sources since they share the same status as linguistic representations. By insisting that language is not a transparent medium that enables the historian to approach the past with any degree of objectivity, critical theory is said to imply that the historian can never come to grips with historical events, for these are always mediated by the opaque medium of language. According to Christie and Orton, such a predicament means that the historian can no longer talk about origins, can no longer offer causal explanations, and as a consequence, historical narratives are no longer valid. Since they regard causal explanation as indispensable to the historical enterprise, they attempt to build a defense of such narratives on phenomenological grounds: "Humans are irreducibly nar-

19. Griselda Pollock, "Agency and the Avant-Garde: Studies in Authorship and History by Way of Van Gogh," *Block* 15 (1989): 4–15.

20. Ibid., 15.

21. John Christie and Fred Orton, "Writing on a Text of the Life," *Art History* 11 (1988): 545–64, 556.

ratable and narrating beings. . . . Stories indeed, are the primary device through which we first begin to apprehend consciously the possible connected meanings of the world. We not only internalize and retain these stories, but the idea of story, too, and we never abandon it."[22] They further suggest that biographical writing should have a dual nature: it should be as much about the person doing the writing as it is about the subject ostensibly under discussion. Only on this basis, they feel, can traditional biographical narratives be relativized by their status as part of another narrative, namely, the biography of the culturally and historically situated historian.

Christie's and Orton's relation to critical theory seems ambivalent, for while appearing to sympathize with views of the subject as unstable and decentered, they fall back on a phenomenological argument about narrative. Rather than adopt their position, which depends on a humanist notion of the subject, I have suggested that a psychoanalytical one, particularly one with a semiotic basis such as that proposed by Lacan, affords a stronger basis for a defense of historical writing. If human subjectivity is split on the acquisition of language, the historian can never be outside the medium he or she processes in the production of historical narratives. Such narratives will always be compromised by the individual historian's manipulation of his or her screen in the context of the gaze, and by the way in which language, or the symbolic, will always speak itself through his or her subjectivity. Far from eliminating the possibility of the production of causal narratives, such a view serves as their justification or rationale. Just as the symbolic defines a real that always exceeds its capacities of definition, so the historian offers us knowledge about that which we can never know. The fascination of history and the historian's power lie precisely in purporting to afford us access to what is by definition inaccessible.

The model of historical interpretation associated with this view is that described by Alexander Nehamas. He suggests that we should conceive of the historian's work not as delving beneath the surface of appearances in pursuit of something hidden but as an endless expansion across a surface. The spatial axis of interpretation becomes horizontal rather than vertical. Nehamas's references to surfaces brings to mind Barthes's metaphor of fabric, specifically the threads of a stocking, as an appropriate analogy for the way in which the interpreter can trace meaning without leaving a single plane. The truth, therefore, like the subject, is no longer viewed as stable and constant. Truth is constructed and reconstructed in a never-ending and inescapable process of meaning production.

When the epistemological basis for art historical knowledge is abandoned, the historian must find other ways of justifying the shape and structure of the

22. Ibid., 559.

narratives he or she wishes to tell. As we have seen, historical narratives are never a simple reflection of the events they purport to relate but a construction placed on those events by the author. The historian cannot relate one event to another without some kind of theoretical speculation. Just as the historian's narrative is determined by his or her cultural and political views, so is his or her use of theory. There is nothing neutral and "pure" about theory. Far from it, every theory possesses political implications that affect the histories created by those who make use of them. I have therefore chosen the theoretical perspectives reviewed in this part of the book primarily on the basis of their usefulness to a particular political perspective.

The choice of semiotics as a theoretical position that is congruent with and sympathetic to a politics interested in cultural and social change should be self-evident. Semiotics affords such a politics many distinct advantages. Semiotics makes us aware that the cultural values with which we make sense of the world are a tissue of conventions that have been handed down from generation to generation by the members of the culture of which we are a part. It reminds us that there is nothing "natural" about our values; they are social constructs that not only vary enormously in the course of time but differ radically from culture to culture. Semiotics enables us to realize that our reaction to experience has more to do with our status as members of a community than with our own personal perception. On this view, what we call knowledge is always determined by the intersection of our cultural values with the changing historical circumstances in which we find ourselves.

Second, semiotics enables us to understand that while the cultures to which we belong play a crucial role in defining the values we bring to the work of interpretation, the cultures themselves are neither static nor stable but rather find themselves in an eternal process of redefinition. Just as the shape of the culture is determined by the politics of the past, so its shape in the future is capable of being defined by the politics of the present. We do not inherit a set of petrified conventions and unchanging codes but active and dynamic values, which change according to the new significance invested in them by succeeding generations. Semiotic theory thus enables us to account for the variety and relativity of the cultural values we inherit from the past, as well as for our ability to interpret and manipulate those values in the creation of new cultural meaning.

Cultural Politics:
Practice

CHAPTER FOUR

Panofsky's Melancolia

> History is a search for truth that always eludes the historian but also informs
> her work, but this truth is not an objective one in the sense of a truth
> standing outside the practices and concerns of the historian. History is better
> defined as an ongoing tension between stories that have been told and stories
> that might be told. In this sense, it is more useful to think of history as an
> ethical and political practice than as an epistemology with a clear ontological
> status.
>
> —Lynn Hunt, "History as Gesture"

One of the most important debates of contemporary art history
concerns the epistemological ground of its discourse. Does the history of art
lay claim to knowledge that is forever valid, or are art historical interpreta-
tions to be viewed as relative to the time and place of their formulation? Most
art historians would probably prefer not to think about such matters. Not
only do we not like to theorize about the nature of our claims to knowledge,
but we would probably wish to avoid both the notion that we had access to
historical "truth" and the view that our findings have only relative value, in
favor of some position in between. Such a lack of theoretical precision, however,
serves to perpetuate the notion that there are certain correct ways of doing his-
tory, certain ways of getting it right, even though what exactly those might be is
rarely, if ever, spelled out. In such a context, it is easy for those who support the
status quo, those who believe that the present state of art historical scholarship
is optimal, to dismiss those who challenge their view of the situation without
bothering to formulate the grounds on which such dismissal depends.

A frequent criticism of approaches that attempt to make issues of race,
class, and gender relevant to art history, for example, is that they are "ideolog-
ical." By defining them as ideological, conservative critics implicitly contrast
them to the art historical discourse which is considered ideology-free. They
suggest that these new initiatives give knowledge a political bias that they
plainly regard as subversive of the truth. Unlike the art historical knowledge
of the past, carried on in a positivistic spirit through empirical research, the
"isms" that characterize contemporary practice—usually Marxism and femi-
nism, but including other forms of gender studies such as gay and lesbian
studies—are said to impose a predetermined agenda on the past in such a way

as to mediate and thus distort our understanding. What is disturbing is that such forms of interpretation expose, rather than conceal, the political perspectives from which they are written. Because these views are plainly defined, they are more visible than the views of those who prefer to hide their own beneath a mass of empirical information.

With this in mind, I could not fail to observe that one of the most outstanding contributions to the study of the art of the northern Renaissance, a "classic" of art historical scholarship, namely, Erwin Panofsky's book on Albrecht Dürer, is animated by assumptions and manifests values that can only be regarded as socially and politically motivated. The claim that Panofsky's text displays his own particular cultural bias will come as no surprise since sophisticated historians have always recognized that authors write from a "point of view." Nevertheless, it is striking that Panofsky's values and their incorporation in his historical interpretations should rarely have been examined. Although the intellectual history of Panofsky's ideas has been carefully traced, their relation to his social values has not yet been assessed.[1] This chapter seeks to demonstrate that Panofsky's cultural values are an intimate and essential aspect of his theoretical ideas.

I hope its purpose will not be misunderstood. My account of the presence of Panofsky's cultural and social values in his historical writing is not an attempt to denigrate his memory, for any such analysis necessarily depends on the assumption that a similar inquiry could be carried out on the work of any historian. Far from being a sign of disrespect for his achievement, this essay is a tribute to the intellectual challenge of his interpretations and a recognition that they have decisively determined our own approach to the art of the past.

Another source of misunderstanding which I am anxious to avoid is that

1. See Lorenz Dittmann, *Stil, Symbol, Struktur* (Munich: Wilhelm Fink, 1967); William Heckscher, "The Genesis of Iconology," in *Stil und Überlieferung in der Kunst des Abendlandes: Akten des 21 Kongress zur Kunstgeschichte, Bonn, 1964*, vol. 3: *Theorien und Probleme* (Bonn: F. Deuchler, 1964); Goeran Hermeren, *Representation and Meaning in the Visual Arts: A Study in the Methodology of Iconography and Iconology* (Stockholm: Laeromedelsfoerlagen, 1969); Kurt Forster, "Critical History of Art or Transfiguration of Values?" *New Literary History* 3 (1972): 459–70; Renate Heidt, *Erwin Panofsky. Kunsttheorie und Einzelwerk* (Cologne: Böhlau, 1977); Ekkehard Kaemmerling, *Ikonographie und Ikonologie: Theorien, Entwicklung, Probleme* (Cologne: DuMont, 1979); Michael Podro, *The Critical Historians of Art* (New Haven: Yale University Press, 1982); Jacques Bonnet, ed., *Erwin Panofsky: Cahiers pour un temps* (Paris: Centre Georges Pompidou, 1983); Michael Ann Holly, *Panofsky and the Foundations of Art History* (Ithaca: Cornell University Press, 1984); Keith Moxey, "Panofsky's Concept of 'Iconology' and the Problem of Interpretation in the History of Art," *New Literary History* 17 (1985–86): 265–74; Silvia Ferretti, *Cassirer, Panofsky, and Warburg: Symbol, Art, and History*, trans. Richard Pierce (New Haven: Yale University Press, 1989); Georges Didi-Huberman, *Devant l'image* (Paris: Minuit, 1990); Brendan Cassidy, ed., *Iconography at the Crossroads* (Princeton: Princeton University Press, 1993).

which may be occasioned by my analysis of Panofsky's values in terms of his
Jewish heritage. The mere identification of a person as a Jew by a non-Jew
living in an anti-Semitic culture is sometimes interpreted as a means of
expressing anti-Semitic sentiments. Nothing could be further from my inten-
tion. A failure to discuss the specific experiences of ethnic, religious, and
gendered minorities on the grounds that reference to such groups constitutes
a manifestation of the very feelings that subordinate them refuses to come to
grips with the heterogeneity of our culture. Only by recognizing the extent
to which dominant and hegemonic values represent megalomaniacal and un-
realizable dreams of ethnic, religious, national, or gendered unity, can we
appreciate the extent to which such values are constructed fabrications that
may be challenged and changed both by those whom they have historically
excluded and by those whom they have traditionally favored.

Panofsky begins his introduction to the Dürer book by drawing an analogy
between paintings and music:

> The evolution of high and post-medieval art in Western Europe might be
> compared to a great fugue in which the leading theme was taken up, with vari-
> ations, by different countries. The Gothic style was created in France; the Re-
> naissance and Baroque originated in Italy and were perfected in cooperation
> with the Netherlands; Rococo and nineteenth-century Impressionism are
> French and eighteenth-century Classicism and Romanticism are basically En-
> glish.
>
> In this great fugue the voice of Germany is missing. She has never brought
> forth one of the universally accepted styles the names of which serve as head-
> ings for the chapters of the History of Art.[2]

The analogy is revealing on several counts. In comparing the visual arts to
music, Panofsky draws an analogy with an art form that has traditionally been
regarded as abstract and that has been discussed in terms of form rather than
content. The comparison reveals Panofsky's continuing adherence to a notion
of the history of art as the history of style, a view popularized by his contem-
porary Heinrich Wölfflin. The idea that the history of art is a record of the
ways in which the artistic production of different ages may be distinguished
on the basis of form is ultimately based on a Kantian view of aesthetic value.[3]
The universalist claims of the Kantian aesthetic, according to which works of
art should command the same response from all human beings regardless of
their location in space and time, places greater emphasis on the allegedly

2. Erwin Panofsky, *The Life and Art of Albrecht Dürer* (Princeton: Princeton University Press,
1955; originally published in 2 vols. in 1943), 3.

3. Immanuel Kant, *Critique of Aesthetic Judgement*, trans. James Meredith (Oxford: Claren-
don, 1952).

eternal harmonies of line and color than on the contingency of the culturally specific meaning of subject matter. Cultural significance is sacrificed in the interest of defining aesthetic value as something that could be recognized by all humans in their capacity as members of the species. Aesthetic value becomes defined as something endowed with transcendental status, something that rises above the context of cultural and historical location, something that is a fixed and eternal constituent of the work of art, regardless of the circumstances in which it is placed. Of course, a theory that seeks to legislate the universality of aesthetic response must depend on a notion of unchanging human nature. It is only if human beings are always and everywhere essentially the same that the work's universal appeal can be acknowledged. The universality ascribed both to aesthetic response and, as a consequence, to human nature, can be viewed as a metaphor of a Eurocentric epistemology in an age of imperialism and colonization. As Edward Said has suggested, such transcendental categories are inseparable from the ethnocentrism that empowered Europeans to subjugate most of the cultures they encountered in the course of the nineteenth and early twentieth centuries.[4]

Panofsky also suggests that the analogy between the visual arts and music should be seen in the light of national identities. In doing so, he echoes nineteenth-century nationalist theories, such as Alois Riegl's notion of the *Kunstwollen,* or "will to art," which was thought to animate the artistic production of different races and peoples. That is, the art produced by different nations was thought to bear the imprint of national character.[5] Not only does

4. Edward Said, "The Politics of Knowledge," in *Debating P.C.: The Controversy over Political Correctness on College Campuses,* ed. Paul Berman (New York: Dell, 1992), 172–89.

5. Riegl's concept is unstable; it changed throughout the course of his career, so that it is not susceptible to precise definition. Its racial and national connotations may be observed in *Late Roman Art Industry,* ed. and trans. Rolf Winkes (Rome: Bretschneider, 1985); and *Das Holländische Gruppenporträt* (Vienna: Oesterreichische Staatsdruckerei, 1931). For a discussion of the meaning of this concept, see Erwin Panofsky, "Der Begriff des Kunstwollens," *Zeitschrift für Ästhetik und allgemeine Kunstwissenschaft* 14 (1920): 321–39. For discussions of Riegl's work, which often include a consideration of this concept, see Hans Sedlmayr, "Die Quintessenz der Lehren Riegls," *Alois Riegl: Gesammelte Aufsätze,* ed. K. M. Swoboda (Augsburg: Benno Filser, 1929); Meyer Schapiro, "Style," *Anthropology Today,* ed. A. L. Kroeber (Chicago: University of Chicago Press, 1953); Otto Pächt, "Art Historians and Art Critics, VI: Alois Riegl," *Burlington Magazine* 105 (1963): 188–93; Henri Zerner, "Alois Riegl: Art, Value, and Historicism," *Daedalus* 105 (1976): 177–88; Margaret Iversen, "Style as Structure: Alois Riegl's Historiography," *Art History* 2 (1979): 62–72; Willibald Sauerländer, "Alois Riegl und die Enstehung der autonomen Kunstgeschichte am 'Fin de Siècle,'" *Fin de Siècle: Zur Literatur und Kunst der Jahrhundertwende,* ed. Roger Bauer et al. (Frankfurt: Klostermann, 1977); Barbara Harlow, "Realignment: Alois Riegl's Image of Late Roman Art Industry," *Glyph* 3 (1978): 118–36; Margaret Olin, *Forms of Representation in Alois Riegl's Theory of Art* (University Park: Pennsylvania State University Press, 1992). Margaret Iversen also has a book on Riegl forthcoming with the Massachusetts Institute of Technology Press.

Panofsky identify different art historical styles with different nationalities, but he conceives of the relationship between them as competitive. The great nations of Western Europe are associated with different moments in the history of style, but no style can be identified as "German." This absence, which is identified as a lack, is to be made up by the claims of Panofsky's book: "It was by means of the graphic arts that Germany finally attained the rank of a Great Power in the domain of art, and this chiefly through the activity of one man who, famous as a painter, became an international figure only in his capacity of engraver and woodcut designer: Albrecht Dürer."[6] Germany's name merits inclusion in the canon of great artistic cultures on the basis of the achievement of a single genius—Albrecht Dürer.

The connotations of the term "Great Power" reverberate with echoes of the nationalistic competition that characterized European culture in the late nineteenth and early twentieth centuries. Panofsky first became involved in Dürer studies when he wrote his dissertation in 1914. He continued to work on Dürer during the interwar years, yet his monograph on the artist appeared only in 1943, after he had been forced into exile by the National Socialists and was living in the United States. While Panofsky's desire to claim a place for Germany within the art historical canon may be regarded as a manifestation of the nationalistic values that characterized his generation, the appearance of his book after his expulsion from his teaching post at the University of Hamburg by a Nazi decree aimed at depriving Jews of influential political and academic positions, makes such nationalism seem paradoxical. How are we to interpret his apparent identification with the cause of Germany in the history of culture, when he had been exiled because his fellow Germans viewed his status as a Jew as more essential than his status as a German?

If Dürer was to be Germany's contribution to a "Great Power" history of Western art, then it is not surprising that the qualities attributed to him should correspond to Panofsky's view of the archetypal German personality. According to Panofsky,

> German psychology is marked by a curious dichotomy clearly reflected in Luther's doctrine of "Christian Liberty," as well as in Kant's distinction between an "intelligible character" which is free even in a state of material slavery and an "empirical character" which is predetermined even in a state of material freedom. The Germans, so easily regimented in political and military life, were prone to extreme subjectivity and individualism in religion, in metaphysical thought and, above all in art.[7]

Just as the German personality is said to be divided against itself, so is Dürer's:

6. Panofsky, *Dürer*, 3–4.
7. Ibid., 3.

Dürer was the most patient observer of realistic details and was enamored of the most "objective" of all techniques, line engraving in copper; yet he was a visionary, "full of inward figures," to quote his own characteristic words. Convinced that the power of artistic creation was a "mystery," not to be taught, not to be learned, not to be accounted for except by the grace of God and "influences from above," yet he craved rational principles.[8]

Dürer's personality is neatly characterized by the materialism and subjectivity that are considered typical of the German temperament. Both Dürer and the Germans are seen as torn between an attachment to the world of the senses and immersion in the metaphysical concerns of the spirit. In Dürer's case, the tension produced by this unresolved dichotomy is said to have resulted in an enduring conflict: "The constant struggle between reason and intuition, generalizing formalism and particularizing realism, humanistic self-reliance and medieval humility was bound to produce a certain rhythm comparable to the succession of tension, action and regression in all natural life, or to the effect of two interfering waves of light or sound in physics."[9]

Although Panofsky explicitly states that the duality of Dürer's personality antedates his contact with Italian Renaissance culture—as indeed he must if the artist is to be considered a manifestation of German national consciousness—he claims that this dualism was exacerbated by Dürer's interest in Italian humanism. In the struggle between reason and intuition, theory and practice, rationality and theory translate as references to humanist culture, while intuition and practice refer to Dürer's Germanic heritage. One might say that in Panofsky's scheme, Dürer's German nature is offset by a humanist rationalism that allows us to recognize him as a worthy counterpart of his Italian contemporaries Leonardo, Michelangelo, and Raphael.[10]

The role played by humanism in this account of Dürer's greatness is significant. Panofsky's scholarly work was in large part dedicated to the study of humanist culture. Not only was he responsible for elucidating the complexities of humanist iconography in the art of the canonical masters of the Italian Renaissance and Baroque on the basis of an exceptional familiarity with ancient, medieval, and Renaissance texts, but he was also a student of humanist art theory. Indeed, the significance of humanist values for Panofsky far exceeded his interest in the Renaissance. In an address given to the American Academy of Arts and Sciences in 1940, which was later published as "The History of Art as a Humanistic Discipline," Panofsky comments on the

8. Ibid., 12.

9. Ibid., 14.

10. This point has been made by Svetlana Alpers, "Is Art History?" *Daedalus* 106 (1977): 1–13, 5: "He [Panofsky] sees Dürer as a kind of captive of the alien northern darkness struggling toward the southern light."

notion of *humanitas,* or humanity: "It is not so much a movement as an
attitude which can be defined as the conviction of the dignity of man, based
on both the insistence on human values (rationality and freedom) and the
acceptance of human limitations (fallibility and frailty); from this two postu-
lates result—responsibility and tolerance."[11] Clearly, Panofsky identified per-
sonally with these values, investing them with a transcendental importance,
and he extolled their relevance for the wartime circumstances in which he
spoke:

> If the anthropocratic civilization of the Renaissance is headed, as it seems to
> be, for a "Middle Ages in reverse"—a satanocracy as opposed to a medieval
> theocracy—not only the humanities but also the natural sciences, as we know
> them, will disappear, and nothing will be left but what serves the dictates of the
> subhuman. Prometheus could be bound and tortured, but the fire lit by his
> torch could not be extinguished.[12]

Humanism becomes identified with the forces of rationality, which were at
that time engaged in a mortal struggle with those of unreason, a struggle on
which the fate of Western civilization depended. On this account, Nazi
Germany's failure to respect humanist values was threatening to plunge Eu-
rope back into the dark ages. Both the humanities and the sciences were in
danger of being obliterated by malevolent political forces.

Panofsky's views appear to have been characteristic of his generation, his
religion, and his class. In his study of German intellectuals who left Germany
before World War II, Peter Gay, for example, observes of Aby Warburg:

> The severe empiricism of the Warburg style, the very antithesis of the anti-
> intellectualism and uncritical mysticism that were threatening to barbarize Ger-
> man culture in the twenties, was Weimar at its best; Warburg's celebrated for-
> mula that Athens must be recovered, over and over again, from the hands of
> Alexandria, was not merely an art historian's prescription for the understanding
> of the Renaissance which had painfully struggled with alchemy and astrology,
> but an Aufklärer's prescription for his life in a world threatened by unreason.[13]

The value Panofsky placed on reason and the importance he ascribed to its
place in the German personality must be understood in light of the value
attributed to education and culture by the social group of which he was a

11. Erwin Panofsky, "The History of Art as a Humanistic Discipline," in *Meaning in the Visual Arts* (Garden City, N.J.: Doubleday, 1955), 1–25, 2.

12. Ibid., 25.

13. Peter Gay, "The Outsider as Insider," in *The Intellectual Migration: Europe and America, 1930–1960,* ed. Donald Fleming and Bernard Bailyn (Cambridge: Belknap Press of Harvard University Press, 1969), 11–93, 39.

member. Panofsky grew up in an upper-class Jewish family at a time when German Jews of this background strongly identified with German culture. The emancipation of Jews in Germany, which occurred at the beginning of the nineteenth century, took place at the prompting of Enlightenment ideals and was associated with the liberating power of reason. German-Jewish cultural identity was constituted in a period that valued rationality and the educational process by which it might be acquired, as George Mosse has noted:

> The term "inward process" as applied to the acquisition of *Bildung* did not refer to instinctual drives or emotional preferences but to the cultivation of reason and aesthetic taste; its purpose was to lead the individual from superstition to enlightenment. *Bildung* and the Enlightenment joined hands during the period of Jewish emancipation; they were meant to complement one another. Moreover, such self-cultivation was a continuous process which was never supposed to end during one's lifetime. Thus those who followed this ideal saw themselves as part of a process rather than as finished products of education. Surely here was an ideal readymade for Jewish assimilation, because it transcended all differences of nationality and religion through the unfolding of the individual personality.[14]

Panofsky's personal commitment to reason, therefore, must be viewed against the background of the social forces that shaped his subjectivity. The rational ideal was not an abstraction but an intimate dimension of his personality as a German of Jewish descent. In view of the positive means the Enlightenment ideal of reason afforded German Jews with which to identify and become assimilated within German culture, it is perhaps not surprising that Panofsky should have felt, particularly keenly, the threat of its destruction at the hands of irrational forces. Reading *The Life and Art of Albrecht Dürer* in light of Panofsky's political values makes it clear that the role of humanism in his account of Dürer's art serves an ideological function. Dürer is characterized as an agent of reason in a benighted age and thus a worthy exponent of the values Panofsky identifies as those of the Western tradition. It is on the basis of Dürer's humanist values that Germany is to be permitted to join the ranks of the other "Great Powers" that have shaped the cultural history of the West.

According to Panofsky, the struggle between the two sides of Dürer's personality was a violent one. In his account, the victory of reason is always in

14. George Mosse, *German Jews beyond Judaism* (Bloomington: Indiana University Press, 1985), 3. For the assimilation of Jews in late nineteenth- and early twentieth-century Germany, see Peter Gay, *Freud, Jews, and Other Germans: Master and Victims of Modernist Culture* (New York: Oxford University Press, 1979), chap. 2.

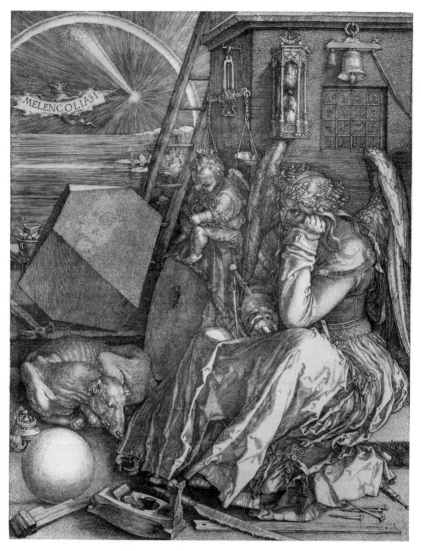

1. Albrecht Dürer, *Melencolia I,* 1514 engraving. Courtesy The Herbert F. Johnson Museum of Art, Ithaca, N.Y.

question, and in his most famous iconographic analysis, his discussion of the engraving *Melencolia I* (ill. 1), reason suffers a dramatic defeat. Panofsky's analysis offers a richly textured historical context within which to develop the metaphysical conflict between reason and unreason; Dürer, he says, rejected the medieval understanding of the melancholic temperament as unattractive and undesirable, replacing it with a humanist conception of melancholy as the temperament of genius. Far from characterizing melancholy in a positive

light, however, Dürer's allegorical figure appears to be overcome with anxiety: "Winged, yet cowering on the ground—wreathed, yet beclouded by shadows—equipped with the tools of art and science, yet brooding in idleness, she gives the impression of a being reduced to despair by an awareness of insurmountable barriers which separate her from a higher realm of thought."[15] This representation of melancholy as a genius disabled by the impossibility of realizing in practice what it aspires to in theory is then interpreted by Panofsky as a spiritual self-portrait of Dürer himself. In his words, the image "typifies the artist of the Renaissance who respects practical skill, but longs all the more fervently for mathematical theory—who feels inspired by celestial influences and eternal ideas, but suffers all the more deeply from his human frailty and intellectual finiteness."[16]

Melencolia I plays a crucial role in the structure of Panofsky's book. It is an emblem of Panofsky's thesis concerning the struggle between the rational and irrational tendencies of the German national temperament, and, being found in the historical horizon under discussion rather than that occupied by the author, it serves as a corroboration or validation of his interpretation. On the one hand, it is the vehicle for a claim to national greatness—that is, Dürer's genius justifies Germany's inclusion in a "Great Power" history of Western civilization—and on the other, it is a heuristic device by means of which the historian can collapse the distinction between historical horizons as a means of validating his own narrative. By claiming access to the artist's intentions, Panofsky can pierce the material veil of *Melencolia I* in order to discern what lies beneath the surface. By these means, the historian's interpretation can be inscribed in "the order of things." The work of interpretation is naturalized and suppressed by means of its identification with the ostensible subject of interpretation.

Panofsky's strategy, which renders the historian's "point of view" opaque by projecting it into that which is to be interpreted, is perhaps one of the fundamental characteristics of historical interpretation. Indeed, Leonardo's observation that "every painter paints himself" could be extended to cover the activity of the historian.[17] Whether or not we accept the plausibility of Panofsky's interpretation of *Melencholia I* as a spiritual self-portrait of Dürer, it is possible to argue that the interpretation reveals an identification of the

15. Panofsky, *Dürer*, 168.

16. Ibid., 171. For a recent interpretation of this print as well as an evaluation of the literature since Panofsky wrote, see Peter-Klaus Schuster, *Melencolia I: Dürers Denkbild*, 2 vols. (Berlin: Mann, 1991).

17. See Martin Kemp, "'Ogni dipintore dipinge se': A Neoplatonic Echo in Leonardo's Art Theory?" *Cultural Aspects of the Italian Renaissance: Essays in Honour of Paul Oskar Kristeller*, ed. Cecil Clough (Manchester, England: Manchester University Press, 1976), 311–23. For a discussion of the role of transference in historical interpretation, see Dominick LaCapra, "History and Psychoanalysis," in *Soundings in Critical Theory* (Ithaca: Cornell University Press, 1989), 30–66.

author with the subject of his analysis.[18] Just as Dürer is said to have identified with the melancholic temperament because his theoretical ambitions were compromised by empirical practice, so Panofsky may have identified with Dürer because he saw in the artist's struggle an allegory of the battle between reason and unreason which characterized the political events of his own time. The defeat of reason represented in *Melencolia I* is an emblem of the destruction of Panofsky's ideal of German culture. Just as Germany is said to join the "Great Powers" that had determined the cultural history of the West on the basis of Dürer's involvement in the humanist theory of the Italian Renaissance, a commitment to rationality that offset the subjectivism of his typically German temperament, so Germany falls from the company of civilized nations as a consequence of the eclipse of reason.

Panofsky's identification with Dürer and his use of *Melencolia I* as an emblem of the artist's personality may also have had an unconscious dimension (ill. 2). That is, Panofsky's choice of this particular image as the focus of the text may have had more meaning than he could have acknowledged in a scholarly essay, perhaps even to himself. I do not intend to engage in psychohistory, to embark on a futile attempt to analyze Panofsky on the basis of what little we know of his personal life. Instead, I prefer to consider his choice of *Melencolia I* in the light of psychoanalytical mechanisms he may have shared with many of his contemporaries, particularly those who also experienced the trauma of exile. According to Freud's famous essay "Mourning and Melancholia," published in 1915, mourning is the conscious acknowledgment of the loss of a love object, whereas melancholy results from an individual's inability to acknowledge loss consciously. The melancholic cannot mourn because he or she cannot break the narcissistic identification that formed the basis of the original attachment to the lost object:

> First there existed an object choice, the libido had attached itself to a certain person; then, owing to a real injury or disappointment concerned with the loved person, this object relationship was undermined. The result is not the normal one of withdrawal of the libido from this object and transference of it to some new one. . . . The object cathexis proved to have too little power of resistance and was abandoned; but the free libido was withdrawn with the ego and not directed at another object. It did not find application there, however, . . . but served simply to establish an *identification* of the ego with the abandoned object.[19]

18. Panofsky's interpretation has been rejected on the ground that the notion of the artist as a melancholy genius was not part of sixteenth-century art theory. See Martin Kemp, "The 'Super-Artist' as Genius: The Sixteenth Century View," in *Genius: The History of an Idea,* ed. Penelope Murray (Oxford: Basil Blackwell, 1989), 32–53.

19. Sigmund Freud, "Mourning and Melancholia," in *General Psychological Theory,* ed. Philip Rieff (New York: Collier, 1963), 170.

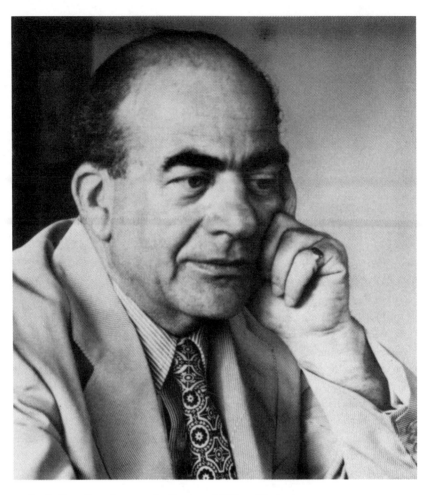

2. *Erwin Panofsky*, photograph. Courtesy William Heckscher.

As a result of the introjection of the object, the subject reproaches itself with anger that is actually occasioned by what it perceives as its abandonment by the other. Instead of venting the feelings of disappointment and hostility toward the object by means of grief, the self-critical faculty of the subject vents them against the self. If we reflect on Panofsky's situation in the context of these ideas, it seems possible to think of his choice of *Melencolia I* as an emblem of the conflict between theory and practice which he discerned in Dürer's personality, an emblem that must have had special significance for him in view of the struggle between the forces of reason and unreason which characterized the political situation of his own time and which had led to his exile from Germany. His choice also provided him with a way of manifesting

the melancholy he felt as a result of his inability to mourn the destruction of his ideal of German culture, with which he had identified so strongly.

The rising anti-Semitism of the Weimar Republic placed German Jews in an impossible position by defining the concepts of Jew and German as mutually incompatible.[20] Jews were asked either to reject their religion and their community in order to "become" German or to give up their status as Germans in order to "become" Jews. For a religious community that had existed in Germany since time immemorial and whose culture was thoroughly German there could be no choice. Panofsky was as much German as he was Jewish, and his exile did not alter that fact. Deprived of his German citizenship, Panofsky nevertheless identified with the lofty ideals of rationality and education which had been ascribed to German culture by the Jewish community of which he was a part. *Melencolia I* can thus be said to represent the condition that prevented him from rejecting the culture he had lost. Panofsky's own melancolia enables us to understand the nationalist sentiments of his Introduction. The paradoxical affirmation of Germany's cultural greatness at a moment when he could no longer claim to be a German citizen can be interpreted as manifesting a sense of loss with which he could never be reconciled.

Panofsky's claims for the Dürer's genius, claims that depend on humanist assumptions regarding the status of the artist as an autonomous agent, are intimately related to the personal identity of the author. Far from being "objective" in the sense of providing us with a disinterested and unbiased account of the past, Panofsky's book derives its intellectual power from its complex agenda. There is a concern, on the one hand, to find for Germany a worthy representative of its national character, one of such artistic achievement that he would ensure its membership in the "Great Power" club of Western culture. On the other, there is the equally, if not more, powerful concern to ensure that this representative epitomized the ethical values that are closest to the author's heart. As a consequence, Dürer must be characterized as an exemplar of rationality not just in order to compete with that which Panofsky considered a quality of the great artists of the Italian Renaissance but in order to comment on the crucial importance of reason within the cultural politics of the twentieth century. Panofsky's identification with Dürer

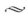
20. For discussions of this dilemma, see, for example, George Mosse, *Germans and Jews: The Right, the Left, and the Search for a "Third Force" in Pre-Nazi Germany* (New York: Fertig, 1970); Ruth Pierson, "German Jewish Identity in the Weimar Republic" (Ph.D. diss., Yale University, University Microfilms, 1970); Ismar Schorsch, *Jewish Reactions to German Anti-Semitism, 1870–1914* (New York: Columbia University Press, 1972); Sidney Bolkosky, *The Distorted Image: German-Jewish Perceptions of Germans and Germany, 1918–1935* (New York: Elsevier, 1975); Uriel Tal, *Christians and Jews in Germany: Religion, Politics, and Ideology in the Second Reich, 1870–1914*, trans. Noah Jonathan Jacobs (Ithaca: Cornell University Press, 1975; 1st Hebrew ed., 1969).

also allowed him to suggest that *Melencolia I* was not the allegory of melancholy it proclaimed itself to be, but an image of the artist's own conception of himself. The value of this strategy is that it allowed the twentieth-century art historian to attribute to the sixteenth-century artist the very conflict between reason and unreason on which his interpretation depended. As a consequence, his analysis is presented as historical "truth," rather than a contingent historical interpretation that responds as much to the historian's personal viewpoint as it does to the historical evidence under consideration.

While part of Panofsky's interpretation may well have been conscious—a product of the historical circumstances that shaped his personality—part may have been unconscious. His choice of *Melencolia I* as an emblem of Dürer's struggle with unreason appears to have been overdetermined. It not only served the conscious goals of his interpretation by marking Dürer as an outstanding representative of the German national temperament, but it also manifested the melancholy of Panofsky's own relation to the national culture that had formed his values and shaped his sensibilities. Panofsky's confidence that his method allowed him such intimate access to Dürer's intentions that he was empowered to assert that *Melencolia I* was the artist's spiritual self-portrait may have depended on the extent to which he was unaware that his own relation to the image was motivated by forces beyond his control.

The Paradox of Mimesis

It is true that the methods of art history, *qua* methods, will prove as effective when applied to Dürer's *Melencolia* as when applied to an anonymous and rather unimportant woodcut. But when a "masterpiece" is compared and connected with as many "less important" works of art as turn out, in the course of the investigation, to be comparable and connectable with it, the originality of its invention, the superiority of its composition and technique, and whatever other features make it "great" will automatically become evident—not in spite of but because of the fact that the whole group of materials has been subjected to one and the same method of analysis and interpretation.

— Erwin Panofsky, *Meaning in the Visual Arts*

The discipline of art history has traditionally been confined to a consideration of a narrowly circumscribed number of works of art thought to constitute a canon of aesthetic excellence. The notion of aesthetic quality depends on a distinction between "high" and "low" art, of which only the former, the art of an educated elite, is regarded as the province of disciplinary competence. In this chapter I reflect on how the pictorial characteristics of the so-called high and low forms of artistic production belonging to the early modern period were coded so as to serve different social functions and how this pictorial distinction has been used to constitute the history of art as an academic discipline.[1]

1. The relation between high and low culture has often been discussed and theorized. For early modern Europe, see, for example, Mikhail Bakhtin, *Rabelais and His World*, trans. Helene Iswolsky (Bloomington: Indiana University Press, 1984; 1st Russian ed., 1965); Carlo Ginzburg, *The Cheese and the Worms: The Cosmos of a Sixteenth-Century Miller*, trans. John Tedeschi and Anne Tedeschi (Baltimore: Johns Hopkins University Press, 1982; 1st Italian ed., 1976); idem, *Night Battles* (Baltimore: Johns Hopkins University Press, 1983); Emmanuel Leroy-Ladurie, *Montaillou* (New York: Braziller, 1978); Peter Burke, *Popular Culture in Early Modern Europe* (London: T. Smith, 1978); Robert Muchembled, *Popular Culture and Elite Culture in France, 1400–1750*, trans. Lydia Cochrane (Baton Rouge: Louisiana State University Press, 1985; 1st French ed. 1978); Peter Stallybrass and Allon White, *The Politics and Poetics of Transgression* (Ithaca: Cornell University Press, 1986). For discussions of the relation between high and low art in the twentieth century, see Theodor Adorno, "Perennial Fashion—Jazz" and "The Culture Industry Reconsidered," in *Critical Theory and Society: A Reader*, ed. Stephen Bronner and Douglas Kellner (New York: Routledge, 1989), 199–209 and 128–35; Clement Greenberg, "Avant Garde and Kitsch," *Art and Culture* (Boston: Beacon Press, 1961); Dick Hebdige,

I am interested, first of all, in how the genres of high and low functioned to define and maintain class distinctions and how these distinctions served to mark the boundaries of gendered identities. At the same time, I want to examine the means by which the difference between the high and low art of the early modern period was deepened and widened by art historical scholarship in the twentieth century as a means of establishing and defining the boundaries of a discipline that could be readily distinguished from other types of interpretative activity in the humanities. I am, in other words, interested in how art history has framed its own enterprise.

For the purposes of this discussion, I have chosen as my example of low art the broadsheet *There Is No Greater Treasure Here on Earth Than an Obedient Wife Who Covets Honor* (ill. 3), published in Nuremberg by Albrecht Glockendon in 1533. This cheap handbill, written by Glockendon himself, was illustrated with a woodcut by Erhard Schön. High art will be represented by Albrecht Dürer's engraving *Melencolia I* (ill. 1) of 1514. In searching for a way to articulate how these prints are related, that is, a way to define their pictorial forms and the social meanings with which they were invested, I have turned to the cultural theory developed in the 1960s by the Tartu school of Soviet semiotics under the leadership of Boris Uspenskii and Juri Lotman. The interest of this theory lies in the way in which it expands a conception of language as a signifying system to cover all aspects of the cultural production of meaning. Language is regarded as just one of the signifying strands by which cultural identity is established and supported. This theory is invoked here as a heuristic device. The characteristics of high and low art defined by Uspenskii and Lotman are thus to be regarded as useful categories rather than essentializing truths. The binary oppositions of the structuralist model are set up only to be collapsed. Far from establishing the differences between high and low art for all time, I hope to show that the distinction depends on social forces that assume different shapes in different historical periods.

Before addressing the images themselves, I would like to set out the principal elements of this interpretative model, which I shall be invoking repeatedly in what follows. According to Uspenskii, Lotman, and their collaborators, "culture" is a set of signifying systems which exists in a state of tension with regard to "nonculture." The two terms stand in a structural relation to each other, one being defined by the other and vice versa:

Subculture: The Meaning of Style (London: Methuen, 1979); and Thomas Crow, "Modernism and Mass Culture in the Visual Arts," *Modernism and Modernity: The Vancouver Conference Papers,* ed. Benjamin Buchloh, Serge Guilbaut, and David Solkin (Halifax: Press of the Nova Scotia College of Art and Design, 1983), 215–64. See also the catalog of the exhibition at the Museum of Modern Art in New York, *High and Low: Popular Culture and Modern Art* (1990), and the responses to it published in *October* 56 (1991).

The mechanism of culture is a system which transforms the outer sphere into the inner one: disorganization into organization. . . . By virtue of the fact that culture lives not only by the opposition of the outer and inner spheres but also by moving from one sphere to the other, it does not only struggle against the outer "chaos" but has need of it as well; it does not only destroy it but it continually creates it.[2]

A corollary to this postulate is that each culture creates its own conception of chaos:

> In this connection it may be said that each type of culture has its corresponding type of "chaos," which is by no means primary, uniform and always equal to itself, but which represents just as active a creation by man as does the sphere of cultural organization. Each historically given type of culture has its own type of nonculture peculiar to it alone.[3]

The culture/chaos distinction is maintained by means of signifying systems. According to Uspenskii and Lotman, a culture consists of "primary" and "secondary" modeling systems. The primary modeling system is defined as language, and the secondary modeling system can be any other form of social communication, such as rituals, gestures, and so forth. What is of interest here is the relationship between word and image, which characterizes the broadsheet that concerns me. Uspenskii uses this relationship as an example of the dependency as well as the autonomy of two different types of sign systems:

> For the functioning of culture and accordingly for the substantiation of the necessity of employing comprehensive methods in studying it, this fact is of fundamental significance: that a single isolated semiotic system, however perfectly it may be organized, cannot constitute a culture—for this we need as a minimal mechanism a *pair* of correlated semiotic systems. The text in a natural language and the picture demonstrate the most usual system of two languages constituting the mechanism of culture.[4]

Finally, Uspenskii's and Lotman's distinction between cultures that are oriented toward the hearer and those that are oriented toward the speaker will help me articulate some of the formal qualities that characterize this broadsheet:

2. Boris Uspenskii, Juri Lotman, et al., "Theses on the Semiotic Study of Cultures (as Applied to Slavic Texts)," in *Structure of Text and Semiotics of Culture,* ed. Jan van der Eng and Mojmir Grygar (The Hague: Mouton, 1973), 1–28, 2.
3. Ibid.
4. Ibid., 19–20.

An example of a culture oriented towards the hearer would be one in which the axiological hierarchy of texts is arranged in such a way that the concepts "most valuable" and "most intelligible" coincide. In this case the specifics of secondary superlinguistic systems will be expressed to the least possible degree—the texts will strive for minimal conventionality and will imitate "doneness," consciously orienting themselves towards the type of "bare" message found in a natural language. The chronicle, prose (especially the essay), the newspaper article, the documentary film, and television will occupy the highest value stages. "Authentic," "true," and "simple" will be regarded as the highest axiological characteristics.[5]

According to this model, the signifying systems of a hearer-oriented culture will, therefore, be characterized by their accessibility and simplicity. The systems will not call attention to themselves, to the way in which their formal structure exceeds the significance they try to convey, but rather they will model themselves on the communicative power possessed by the structured linearity of language. This type of culture is then contrasted to what is termed a speaker-oriented culture:

> A culture oriented towards the speaker possesses as its highest value the sphere of the closed, inaccessible, or completely unintelligible texts. It is a culture of the esoteric type. Prophetic and priestly texts, glossolalia, and poetry occupy the highest place. The orientation of the culture toward the "speaker" (addressor) or the "hearer" (addressee) will be revealed in the fact that in the first case the audience models itself according to the pattern of the creator of texts (the reader seeks to approach the poet's ideal); in the second case, the sender constructs himself according to the pattern of the audience (the poet seeks to approach the reader's ideal).[6]

The signifying systems of a speaker-oriented culture are thus characterized by their complexity as well as their opacity. These systems delight in developing formal qualities that detract from their ability to serve as a medium of communication. Far from being accessible to all members of the culture, the significance of such systems will be available only to the members of a privileged elite or may even threaten to escape definition altogether.

Before discussing my example of low art, or "hearer-oriented" cultural production, I should add a few words about the type of image I am discuss-

5. Ibid., 9. The definition of low art as simple and readily understandable is open to challenge and suggests the limitations of this particular theoretical model. As John Tagg pointed out to me, many forms of popular representation are undecipherable without expert knowledge. A ready example is graffiti art in which signatures belonging either to the artists or to a group are illegible to the uninitiated.

6. Ibid.

ing. Illustration 3 reproduces a German broadsheet composed of a woodcut and a text, produced in Nuremberg in the first half of the sixteenth century. Such broadsheets were produced by entrepreneurs who commissioned both images and texts from different artists and authors. The precise nature of the collaboration is unknown, but usually the image appears to be an illustration of an extant text. In this case the artist was a follower of Albrecht Dürer called Erhard Schön, and the text was supplied by the publisher himself, a man called Albrecht Glockendon. These broadsheets were produced in large editions of several thousand copies. They were cheaply priced and sold directly from the print shops or at fairs by traveling salesmen. It is fair to assume that they had a relatively wide circulation and that their appeal cut across class lines. Some indication of their audience may be inferred from the texts that accompany the woodcut, for they presuppose a certain degree of literacy. It has been estimated that at the beginning of the sixteenth century only 5 percent of the German population was literate. In cities and towns, however, this proportion was considerably higher, amounting to about a third of the inhabitants.[7]

Access to these texts was not necessarily limited to the literate. Several studies have shown that communal reading was part of the process by which the meaning of these texts was disseminated.[8] During this period, moreover, there was a growing interest in the printed word. In the context of the divisive doctrinal struggle of the Reformation, people appear to have been motivated to familiarize themselves not only with the Scriptures that were the object of debate but with the interpretations to which they were subjected. The result was a striking increase in literacy, which has been compared with similar increases in the context of the French and Russian revolutions.[9] It is likely that artisans from a variety of trades joined those occupational groups, such as merchants, professionals, and the clergy, which had traditionally been able to read. Like the printing of books, the publication of these broadsheets was strictly controlled and censored by the Nuremberg city council, which was concerned about their religious and political content.[10]

In the broadsheet *There Is No Greater Treasure Here on Earth Than an Obedient Wife Who Covets Honor* (ill. 3), a woman is shown beating a man who

7. Rolf Engelsing, *Analphabetum und Lektüre: Zur Sozialgeschichte des Lesens in Deutschland Zwischen feudaler und industrieller Gesellschaft* (Stuttgart: J. B. Metzler, 1973), 8.

8. Ibid., 22–24; Natalie Zemon Davis, "Printing and the People," in *Society and Culture in Early Modern France* (Stanford: Stanford University Press, 1965), 189–226, 201–2; Robert Scribner, "Flugblatt und Analphabetum: Wie kam der gemeine Mann zur reformatorischen Ideen?" *Flugschriften als Massenmedium der Reformationszeit,* ed. Hans-Joachim Köhler (Stuttgart: Klett-Cotta, 1981), 65–76.

9. Engelsing, *Analphabetum,* 38.

10. For further information about these works, see my book *Peasants, Warriors, and Wives: Popular Imagery in the Reformation* (Chicago: University of Chicago Press, 1989), chap. 2.

3. Erhard Schön, *There Is No Greater Treasure Here on Earth Than an Obedient Wife Who Covets Honor*, 1533, woodcut. Reproduced from Max Geisberg, *The German Single-Leaf Woodcut*, 4 vols., trans. Walter Strauss (New York: Hacker Art Books, 1974), vol. 3, cat. no. 1176

is attached to a cart like a beast of burden. The text above the couple and at the bottom of the image purports to give us the words of the different protagonists. Those of the man pulling the cart, prominently placed in the upper part of the image, are a lament at his misfortune at having married. He complains that his wife has taken over his house, that she has taken his sword, his pants, and his purse and that she contradicts him at every turn. His wife replies that all that may be true, but if he will not be quiet, she will hit him over the head. If he wants a sweet little woman who will always do his bidding, then he should stay at home instead of gadding about. If he will not work so as to earn enough to support her, then he must wash, cook, and do the housework. Since the cart is laden with a barrel full of clothes on which rests a paddle for beating out the dirt, it is the laundry she has in mind in this instance.

Watching the arguing couple are a young woman and her fiancé. The man

asks whether she would also be such a shrew, and take his sword, pants, and purse. He adds that if he has to pull the wagon like the poor man in the illustration and give up his free life to wash, cook, and clean, he would gladly forgo marriage. His fiancée replies that she does not covet such power, and that if he values her alone and loves and honors her in time of need, then she stands ready to serve him in all things. The exchange of opinions is closed by those figures at the right-hand side of the composition. A woman dressed in the costume of a court fool, and thus clearly a personification of folly, says that she hears a lot of good said about marriage but that it seems to her to be a life of anxiety, uncertainty, worry, and want. She advises the young man to find a woman who will do his will for a bottle of wine. This counsel, however, is decisively rejected by the last speaker, an old man who serves as a personification of wisdom. He advises the man to guard himself from whores because they will betray him. He should get married and be patient, accepting all trials and tribulations as God's will, for it is through suffering that eternal life is to be achieved.[11]

I have argued elsewhere that this print operates according to the principle of the world upside-down. That is, the wife who beats her husband usurps the authority traditionally granted to males in patriarchal societies, and this violation of established cultural practice articulates the need for a sexual hierarchy in marriage. Certainly, the exchange of roles within the social context is important for the interpretation of this print, but our interpretation will be enhanced if the roles ascribed the couple are understood as a transgression of the very boundaries of culture itself. The husband, for example, has not simply lost his social status but has been transformed into a beast, a creature that lies beyond the pale of culture. More significant, in beating him as one would an animal, the wife also falls out of the realm of culture and becomes a figure of fantasy. She is not simply exchanging roles with her husband, for in treating him like an animal, she transgresses the social codes through which she had been gendered female. The ascription of violence to the wife exceeds the terms of understanding afforded by the notion of the world upside-down, because such violence transgresses the boundaries of her cultural definition as a woman. It is not that female violence is inconceivable, but that it is part of patriarchal culture's definition of nonculture. A violent woman is the very definition of chaos, of the horror of disorder on which the notion of culture depends for its maintenance of the status quo. The notion of what constitutes nonculture is thus elaborately gendered. In the case of man, nonculture is defined as the loss of authority and dignity implicit in his identification with the subordinate position of domestic animals as the servants of human beings. In the image of the woman, on the other hand, a man might perceive a mirror image of male violence which both questions and subverts the very grounds

11. For a fuller discussion of both the image and the text of this broadsheet, see ibid., chap. 5.

on which male dominance depends. The difference in these characterizations is, of course, an index of the gendered nature of the power relations between the sexes. There is nothing symmetrical about them: culture is coded in terms of male values, and it therefore seems likely that this call for male dominance was addressed to men rather than to women.

The disposition of the figures across the surface of the image may have called to mind two separate traditions in Nuremberg's popular culture. On the one hand, their processional arrangement, the way in which they seem to follow the figure of the man pulling the cart, bears a general resemblance to carnival celebrations such as the *Schembartlauf,* in which a float called the *Hölle,* or "hell," representing a theme taken from folklore or everyday life in the city, was pulled through the streets before being burned.[12] More specifically, an image of a man pulling a cart might have invoked the carnival custom of forcing young women who had failed to get married in the course of the preceding year to pull a plow either through or around a village, as a way of mocking their preference for the single life.[13] In both cases the procession uses the substitution of humans for draft animals to illustrate the distinction between culture and nonculture.

The disposition and rhetorical relation of the figures to one another may also have suggested images of the theater. The vertical axis uniting each figure with the appropriate implied speech in the text, that is, the disposition of the figures in accordance with the order in which they speak their lines, has a distinctly "theatrical" quality. As Juri Lotman has pointed out:

> The intermediate position of the theater between the moving, continuous real world and the still, discrete world of visual arts determined the possibility of the frequent exchanges of codes between theater and everyday behavior, on the one hand, and between theater and visual arts, on the other hand. Consequently, life and painting communicate in a number of instances through [the] theatrical medium, which functions in this process as the intermediate code, the translator code.[14]

12. See Samuel Sumberg, *The Nuremberg Schembart Festival* (New York: Columbia University Press, 1941); Hans Ulrich Roller, *Der Nürnberger Schembartlauf: Studien zum Fest und Maskenwesen des späten Mittelalters* (Tübingen: Tübinger Vereinigung für Volkskunde, 1965); Samuel Kinser, "Presentation and Representation: Carnival at Nuremberg, 1450–1550," *Representations* 13 (1986): 1–41.

13. Hans Moser, "Die Geschichte der Fastnacht im Spiegel von Archivforschungen: Zur Bearbeitung bayerische Quellen," in *Fasnacht,* ed. Hermann Bausinger (Tübingen: Tübinger Vereinigung für Volkskunde, 1964), 15–41; idem, "Städtische Fastnacht des Mittelalters," in *Masken Zwischen Spiel und Ernst,* ed. Hermann Bausinger (Tübingen: Tübinger Vereinigung für Volkskunde, 1967), 135–202. For a broadsheet that illustrates this theme, accompanied by a text by Hans Sachs, see Max Geisberg, *The German Single-Leaf Woodcut,* 4 vols., trans. Walter Strauss (New York: Hacker Art Books, 1974), vol. 3, cat. no. 1181.

14. Juri Lotman, "Painting and the Language of Theater: Notes on the Problem of Ironic Rhetoric" (1978), trans. Alla Efimova, in *Tekstura: Russian Essays on Visual Culture,* ed. Lev

Nuremberg had a rich tradition of carnival plays, the *Fastnachtsspiele,* which
were performed in the street and in taverns.[15] These skits, often enacted by
characters dressed in peasant costume, indulged in a crude and sometimes
obscene sexual and scatological humor. Like the broadsheet, these plays,
which were performed by city dwellers in an urban setting, clearly depended
on the culture/nonculture distinction for their effect.

The mediating role played by the theater in the word-image relationship in
this broadsheet should not distract us from the hierarchical relationship of its
primary and secondary modeling systems. An approach to the broadsheet
colored by an appreciation of its relation to the spoken words and gestural
rhetoric of the theater, a medium in which words and images often appear
fused, should not prevent us from registering the aggression perpetrated by
the linguistic code against the visual. For example, the autonomy of the image
as an independent sign system is both recognized and compromised by the
placement of the husband's text above the cart-pulling incident. Rupturing
the frame of the image, the text violates its pictorial conventions. By breaking
the visual code, the text asserts its authority in order to dramatize the man's
debasement and humiliation in its own terms. The broadsheet betrays the
insistence of the text or of language as the primary modeling system of
culture. In Uspenskii's and Lotman's terms, the "discrete" quality of its lexical
system of signification is privileged above a system whose codes are "non-
discrete," and a hierarchy of signifying chains is established in the interest of
the preservation of culture.[16]

One of the characteristics of this image is the relative simplicity of its
pictorial structure. This quality may also be analyzed in terms of Uspenskii's
and Lotman's distinction between speaker- and hearer-dominated cultures.
The definition of the figures against a blank ground—the absence, that is, of
any attempt at spatial illusion either through depiction of a setting or through
modeling in light and dark—marks this image and those of other similar
broadsheets as radically different from the type of woodcut produced at the
same time by the likes of Albrecht Dürer for a humanistically educated elite.
The broadsheet could be defined as belonging to a hearer- or a viewer-
oriented culture. That is, the concept "most valuable" appears to overlap with
the value "most intelligible." As Uspenskii and Lotman put it, "The specifics
of secondary superlinguistic systems will be expressed to the least possible

Manovich and Alla Yefimov (Chicago: Chicago University Press, 1993). I am grateful to Mikhail
Iampolski for this reference.

15. Eckehard Catholy, *Das Fastnachtspiel des Spätmittelalters: Gestalt und Funktion* (Tübingen:
M. Niemeyer, 1961); Werner Lenk, *Das Nüremberger Fastnachtspiel des 15. Jahrhunderts* (Berlin:
Akademie der Wissenschaften zu Berlin, 1966); Hagen Bastian, *Mummenschanz: Sinneslust und
Gefühlsbeherrschung im Fastnachtspiel des 15. Jahrhunderts* (Frankfurt am Main: Syndikat, 1983).

16. Uspenskii et al., "Theses," 7.

degree—the texts will strive for minimal conventionality and will imitate 'doneness,' consciously orienting themselves towards the type of 'bare' message found in a natural language."[17] The simplicity of the image thus results from its dependence on the text with which it is associated. The image could be described as self-effacing. The pictorial codes have been kept as rudimentary as possible so as not to distract the viewer from appreciating the message of the text. Finally, the broadsheet as a whole, text and image together, models itself on the experience of its audience. The message is cast in terms familiar to all the classes that constituted Nuremberg society. The text discusses the advantages and disadvantages of marriage, an institution that gained new prominence in the age of the Reformation as a consequence of Luther's rejection of celibacy as the most desirable form of social life for the Christian.

Albrecht Dürer's engraving *Melencolia I* (ill. 1), my example of high art, or a "speaker-oriented" cultural production, was produced in very different circumstances and was intended for a very different audience. Instead of being the creation of a small publisher, an entrepreneur interested in marketing items to a large public, *Melencolia I* was executed by an artist who had become aware of the high status accorded to art in the Italian Renaissance, a status that depended on the revival of ancient learning. During his two visits to Italy, Dürer had an opportunity to familiarize himself with humanist art theory that emphasized the techniques by which illusionistic effects might be obtained, as well as the artist's display of humanist learning. The medium of engraving in which *Melencolia I* was executed was more expensive than that of woodcut, not only because its material support (that is, the copperplate on which it was incised) was more expensive than wood, but because it was more difficult to work and thus demanded greater expertise. In addition, one could not obtain as many impressions from printing a single plate as one could from a block of wood on which woodcuts were carved. As a consequence, engravings were substantially more expensive than woodcuts and appear to have been collected primarily by a wealthy elite.

17. Ibid., 9. The reductive quality of the imagery of early printed books, to which this broadsheet is closely related, may also be approached by means of Norman Bryson's distinction between "discursive" and "figural" images. See his book *Word and Image: French Painting of the Ancien Régime* (Cambridge: Cambridge University Press, 1981), chap. 1. Bryson finds that images associated with texts tend to be "discursive," that, in an effort to relay linguistic information, they avoid visual complexity, whereas images that are autonomous of texts are characterized by the "redundancy" or "density" of their visual signs. This distinction has recently been used by Michael Camille to compare the woodcuts that illustrated early printed books and the miniatures of illuminated manuscripts. See "Reading the Printed Image: Illumination and Woodcuts of the *Pélerinage de la Vie Humaine* in the Fifteenth Century," in *Printing the Written Word: The Social History of Books, ca. 1450–1520*, ed. Sandra Hindman (Ithaca: Cornell University Press, 1991), 259–91.

In contrast to the broadsheet, *Melencolia I* insists upon what Uspenskii and Lotman call the "specifics" of its superlinguistic system by elaborating and multiplying its pictorial codes. Dürer's image appears to be almost wholly independent of the primary modeling system, namely, language, which makes an appearance only in the banderole unfurled by the bat. The image displays a panoply of pictorial signs that call attention to themselves as products of extraordinary ingenuity and skill which have the power to reproduce the qualities of visual perception. The carefully rendered figure of the woman, together with the little boy, the dog, and the artifacts and geometric shapes that occupy the space she inhabits, are given a strong sense of presence by means of the elaborate play of light and shade. The light that falls across the composition suggests the three-dimensionality of the objects that interrupt its path. Every detail of the woman's costume, as well as the distant landscape, has been meticulously described, as have the texture of her heavy dress, the soft feathers in her wings, the coarse fur of the dog, and the fine-grained stone from which the geometric shape was hewn. Despite the woman's allegorical status and the eccentric circumstances in which she finds herself, despite the curious disjunction between foreground and background, the comet in the sky and bats with banderoles, the image convinces us that what it represents may at least be related to the world we live in. Indeed, it is because of Dürer's skill in creating what Roland Barthes would have called a "reality effect,"[18] that his allegory transcends its status as an intellectual abstraction in order to convey the human significance of the physical and mental condition it seeks to represent.

What are the cultural values that lie behind this proliferation of pictorial techniques aimed at capturing the qualities of our perceptual experience? The "reality effect" appears to offer us immediate, untrammeled access to the world, a window onto the familiar objects of our perception, as well as a demonstration of unparalleled artisanal skills. The image is both transparent and opaque, capable of duplicating the process by which we know the world and calling attention to the artistic means by which that illusion is achieved. When considered in relation to the broadsheet or even to the conventions of late Gothic painting, Dürer's control of the techniques of illusionism must have seemed remarkable. Roland Barthes described the photograph as "a message without a code"[19] because this form of illusionism mechanically effaces the technical apparatus on which it depends. By contrast, the means by which Dürer obtained his effects are readily apparent. The paradox of mimesis—its capacity to suggest that the image is self-evident because it

18. Roland Barthes, "The Reality Effect" (1968), in *French Literary Theory Today: A Reader,* ed. Tzvetan Todorov, trans. R. Carter (Cambridge: Cambridge University Press, 1982), 11–17.

19. Roland Barthes, "Rhetoric of the Image," in *Image, Music, Text,* ed. and trans. Stephen Heath (New York: Hill and Wang, 1977), 32–51.

provides us with a vivid illusion of our perception while calling attention to the complexity of its facture—was the means by which Dürer could code his works as manifestations of high art.

The quotidian banality of the fleeting and transitory impressions of everyday life are ennobled by their transformation into the fixed and stable registers of pictorial form. What was ephemeral becomes eternal through a process of translation. Passing effects of light, peculiar spatial arrangements, textural complexities, and the spectrum of color all gain new interest as a consequence of the illusionistic techniques of the artist. The instability of perception is rendered by means of a language that substitutes itself for our experience. As in the case of language itself—that is, the primary modeling system—translation can never be precise. Much of our fascination with mimesis depends on the impossibility of translation. The artist always offers us that which the eye cannot see. In terms of Lacan's psychoanalytic theory of the gaze, the image acts as a lure for the eye, a lure before which the gaze must lay down its arms.[20] The artist appears to offer us access to that which must always escape our glance. The mimetic image thus enables us to recognize the degree to which our vision is occluded.

It is in the slippage between the artist's translation of experience and our own perceptual memory that we become aware of the artist's personal screen. In recognizing that the illusionistic image is in fact opaque—that far from rendering the world with the accustomed immediacy and availability we associate with perception, it is actually a highly personal and idiosyncratic version of perception filtered through another consciousness—we come to appreciate the specificity of the pictorial forms that have been laid before us. The insertion of the artist into the mimetic process proves to be a way of ensuring that the image cannot be "read." It becomes impossible to reduce the signifying systems of the image to those of language in a way that the broadsheet encouraged us to do. Mimesis thus serves to maintain the autonomy of the image; it is a way of claiming that the image is endowed with a status equal or even superior to that of the primary modeling system.

The notion that the increasing complexity of the codes of the secondary modeling system, namely, the image, were as culturally important as those of the primary modeling system of language in the definition of the culture of the dominant classes meant that images that retained their traditional medieval association with the word, such as the broadsheet, were disregarded and even dismissed. Ironically, it was those images most identified with the primary modeling system, those that were transparent to the word and most porous to its meaning, that were increasingly associated with low social status. The

20. Jacques Lacan, *The Four Fundamental Concepts of Psychoanalysis,* ed. Jacques-Alain Miller, trans. Alan Sheridan (New York: Norton, 1981), 101.

dense and complicated imagery of the Renaissance became synonymous with the concept of culture, whereas the simple and rudimentary images of the broadsheets were consigned to the realm of nonculture.

Using the cultural semiotics of Uspenskii, Lotman, and others, I have suggested some of the ways in which the pictorial forms of the high and low art of early modern Europe were freighted with cultural values related to both class and gender. I want to turn now to the employment of the distinction between these two genres of artistic production in constituting the discipline of art history. Erwin Panofsky, author of the most influential study of Dürer, has argued that the allegorical figure of melancholy in *Melencolia I* represents a radical rethinking of the medieval conception of the nature of this temperament. According to his argument, the Middle Ages regarded melancholy as a state to be avoided since it was said to be "awkward, miserly, spiteful, greedy, malicious, cowardly, faithless, irreverent and drowsy."[21] Inspired by the pair of compasses with which she works and the geometric shapes that surround her, Panofsky suggested that the woman represented in the image personified a humanist reconception of the medieval idea of melancholy, which transformed the temperament into the psychic state of creativity. This reevaluation of melancholy as a desirable condition, Panofsky argues, depended on the work of the Florentine philosopher Marsilio Ficino, who in turn had based his own positive evaluation on a rediscovered treatise by Aristotle. According to Panofsky's historical detective work, Ficino's ideas were made available to an educated audience of humanist intellectuals in northern Europe through the writings of Agrippa of Nettesheim.

Panofsky's imaginative interpretation of *Melencolia I* as a manifestation of a new humanist identification of melancholy with creative intellectual activity did not rest there. He went on to claim that the image depicted the melancholy of Dürer himself and that it constituted his "spiritual self-portrait." According to Panofsky, the image depicted the artist torn between theory and practice, between an awareness of perfection and the inability to render it in material terms. The image is said to represent the artist's despair at the impossibility of realizing his dreams: "It typifies the artist of the Renaissance who respects practical skill, but longs all the more fervently for mathematical theory—who feels 'inspired' by celestial influences and eternal ideas, but suffers all the more deeply from his human frailty and intellectual finiteness."[22] The significance of the image for a small group of humanist intellectuals as an allegory of a reconceived notion of melancholy is here expanded so as to make the engraving a personal document of Dürer's state of mind. The

21. Erwin Panofsky, *The Life and Art of Albrecht Dürer* (Princeton: Princeton University Press, 1955; originally published in 2 vols. in 1943), 158.

22. Ibid., 171.

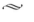
image is thus invested with a significance that transcends its time and place. If it is self-referential, pointing to the role of the artist as a supremely gifted individual, then the image is in fact an allegory of the power of the artist as an autonomous genius. By means of this argument, Panofsky anachronistically inserted an aesthetic concept of genius, first developed at the end of the eighteenth century and a feature of nineteenth- and twentieth-century aesthetics since Kant, into the discussion of a work of Renaissance art.[23] *Melencolia I* is lifted out of its historical context and endowed with transhistorical or metaphysical significance. Panofsky's gesture, the invocation of personal genius, is one of the most familiar strategies for separating the image from the culture of which it is a part, as well as one of the most effective ways of framing art historical discourse. Art history is that discipline which concerns itself with objects that are recognized to be the products of genius. High art becomes Art with a capital letter, while low art sinks to the level of cultural artifact. If high art documents the most sublime characteristics of the human spirit, then the gap between high art and low is widened to the point where it is no longer possible to conceive of both as dimensions of a related creative process. The culture/nonculture distinction already inscribed in Dürer's work by the humanist values of the sixteenth century becomes absolute in the hands of the twentieth-century art historian. A distinction that once served a social function is invested with philosophical significance.

What was it about Panofsky's time and his own aesthetic values, then, that enabled him to characterize Dürer's engraving in terms of the notion of artistic genius? One of the factors that undoubtedly determined his attitude toward aesthetic value was his adherence to a resemblance theory of representation. If mimesis is the central value of artistic representation and the history of art is a history of the gradual perfection and occasional loss of the technical skills required for illusionism, then it is easy to see how Dürer, the first German artist to respond to the illusionism of the Italian Renaissance, should have been preferred to the illustrator of the broadsheet.

As I argued in Chapter 4, the importance of inscribing Dürer, a German artist, into an artistic canon built around the figures of Leonardo, Michelangelo, and Raphael depended on Panofsky's complicated relation to German nationalism. As an assimilated Jew, Panofsky both identified with and rejected the anti-Semitic German culture of his time. He was anxious to extol those aspects of the German personality he found valuable and to reject those he considered harmful. Dürer's struggle between theory and practice becomes an allegory of the struggle between reason and unreason in the German spirit.

23. Immanuel Kant, *Critique of Aesthetic Judgement,* trans. James Meredith (Oxford: Clarendon, 1952). For criticism of Panofsky's interpretation as anachronistic, see Martin Kemp, "The 'Super-Artist' as Genius: The Sixteenth Century View," in *Genius: The History of an Idea,* ed. Penelope Murray (Oxford: Basil Blackwell, 1989), 32–53.

Dürer's interest in theory, translated as the rationality of the German cultural tradition, is what entitles Germany to representation in the Renaissance canon.

By treating mimesis as if it were an end itself rather than an illusionistic language designed to perform a specific social function, Panofsky and the scholars of his generation consistently ignored the low art tradition of the Renaissance. Unable to recognize the excess of meaning characteristic of a "reality effect," Panofsky set out to explain every detail of *Melencolia I.* By locating the significance of the image in the thought of Marsilio Ficino and the biography of the artist, he found an absent presence by which the opaque window of mimesis could be made to speak. In doing so, he unwittingly paralleled the text/image juxtaposition of the broadsheet. If the gulf that allegedly separates the two forms of artistic production was to be properly marked, it became necessary to supply one with a greater and more ambitious text than the other. Panofsky's claims for the speaker-oriented status of *Melencolia I* narrowed its original audience so severely that it was limited to the immediate circle of Dürer's acquaintance. Because the mark of the great work of art is alleged to lie in the genius of its creator, only those familiar with Dürer's alleged personal struggle could conceivably have recognized it for what it was.

It seems more likely that it was not Dürer's contemporaries who identified *Melencolia I* as a "spiritual self-portrait" of the artist but rather Panofsky himself. His reluctance to recognize the opacity of Dürer's image, how its self-referentiality short-circuits the access to the world it purports to afford us, is paralleled by his failure to recognize that his own interpretation is invested with personal values. Nowhere does Panofsky acknowledge the contingency of his own account, how it is compromised by the circumstances in which it is formulated. Because of his inability to contextualize or circumscribe his own position, to put limits on his powers of discernment, his interpretation is one of the classic speaker-oriented texts of the history of art. Like the skill Dürer invested in his image, skill that placed a personal screen between its surface and our perceptual experience, the erudition and imagination Panofsky brought to bear on his task of interpretation creates a textual screen that calls attention to his own learning and rhetorical power and prevents him from granting that the significance of *Melencolia I* is ultimately and necessarily beyond our capacity to define.

The extent to which the humanist values that informed the pictorial codes of the high art of the Renaissance became part of the aesthetic values of the Romantic and Modern periods is too vast a topic to be broached here.[24] It is

24. For an account of how the Renaissance equation of artistic and divine creation was absorbed into the Kantian aesthetic, however, see, Jacques Derrida, "Economimesis," trans. R. Klein, *Diacritics* II (1981): 3–25.

sufficient for my purpose to note that our culture still tends to sneer at art that is "mere" illustration and to prefer that which is wholly autonomous and bears no relation to a text. This attitude, which was part and parcel of the abstraction of high modernism, has gradually been called into question in recent years by artists working in what has come to be called a postmodern mode. It is perhaps no accident that an essay that draws attention to a broadsheet, to a genre of artistic production long consigned to oblivion by art historians whose romantic conception of art prevents them from including such images in their purview, should be written in a contemporary context in which traditional notions of aesthetic value are being actively challenged.

It is instructive, for example, to consider how the high/low distinction inscribed in Western art at least since the Renaissance has been both recognized and subverted by many contemporary artists. Barbara Kruger's photograph *We won't play nature to your culture* of 1983 (ill. 4) plunders the world of advertising and commercial photography for her image—an image that is far removed from the high-art concerns of photographers such as Ansel Adams and Edward Weston—and uses it to articulate a message that depends on a text. In this case, the image of a woman's face, which has been rendered sightless by the leaves placed over her eyes, is associated with the phrase "We won't play nature to your culture." The woman's blindness serves to deny her subjectivity. Her face is available to the viewer's gaze, but she is prevented from looking back. Her inability to reciprocate objectifies her and suggests that she can be manipulated and subjected to the will of others. As in the case of the broadsheet, language invades the pictorial space in such a way as to subordinate the pictorial codes to its own process of signification. Like the text of the broadsheet, Kruger's message is didactic and moralizing. "We won't play nature to your culture" allows us to read the leaves that cover the woman's eyes as symbols. The leaves symbolize nature and suggest that women have been identified with a world distinct from that with which men are associated, namely, the sphere of culture. The text, in other words, challenges the gendered nature of the culture/nature dichotomy and calls it into question. Whereas the Renaissance broadsheet articulates and enforces a dichotomy based on culture/nonculture, in which the subordination of women was justified by defining female violence as beyond what was possible in the realm of culture, Kruger's work calls the dichotomy itself into question as a means of subverting a binary opposition that has worked to the detriment of the social status and power of women.

Despite Kruger's use of the anonymous and reductive imagery of the mass media and her readiness to subordinate pictorial to linguistic codes—characteristics that, as we have seen, were shared by the Renaissance broadsheet— her work is far from being an example of low art. Just as the original significance of Dürer's *Melencolia I* would have been accessible only to a human-

4. Barbara Kruger, *Untitled (We won't play nature to your culture)*, 1983, photograph. Copyright Barbara Kruger, courtesy Mary Boone Gallery, New York.

istically educated audience, so Kruger's photograph is accessible only to those aware of how feminist politics has called into question the definition of gender roles in patriarchal culture. The significance of *We won't play nature to your culture* depends on a relatively sophisticated awareness of how patriarchal culture has traditionally gendered creativity as male and passivity as female. Without this understanding, we could not read the woman's inverted head as an indication that she might be lying down, nor would the leaves over her eyes be intelligible as symbols of nature. Kruger has deliberately appropriated aspects of what is currently defined as low art (commercial photography) in the production of a work of high art. In doing so she undermines the very distinction. There is nothing, in other words, intrinsically low about low culture and nothing intrinsically high about high culture. This binary opposition is not something that is found in the "order of things" but rather something that is created by the imposition of cultural values.

It is interesting to contrast the political and pictorial strategies employed by Kruger to those of another contemporary artist, Julian Schnabel.[25] Whereas Kruger's message and her manipulation of pictorial codes call the political and pictorial values of our culture into question, Schnabel's painting supports our culture's traditional patriarchal bias as well as its received notions of aesthetic value. The most recognizable of the iconic images in his largely abstract composition *Exile* of 1980 (ill. 5) is a quotation of a painting, *Young Boy Holding a Basket of Fruit,* by the seventeenth-century Italian painter Michelangelo Caravaggio. Using Schnabel's title as a guide, we might interpret this quotation as a reference to Caravaggio's artistic career. That is, we might understand it as an invocation of the dramatic and lurid biography of an artist who fulfilled all the requirements of the romantic conception of the artistic personality. Caravaggio led a violent and troubled life and was ultimately exiled from Rome for killing a man who disagreed with him over the results of a tennis match. The quotation is thus a self-referential gesture that informs the viewer that the image is to be regarded as "art about art" and that it therefore shares the privileged status accorded to the work of Caravaggio by the canonical tradition of Western painting. Insofar as this canon principally extols the accomplishments of male artists, it serves to naturalize cultural creativity as a male enterprise. In contrast to Kruger's work, which called the patriarchal tradition into question, Schnabel's painting depends on it.

Like Dürer's engraving or Kruger's photograph, Schnabel's painting is aimed at an educated elite capable of recognizing the work of the great artists who constitute the canon. Unlike Kruger, Schnabel is uninterested in incorporating the characteristic qualities of low art in making of a work of high art. His appropriation of Caravaggio's painting is not based on facsimiles of this work readily available through processes of mechanical reproduction. Instead, Schnabel offers us a free variant on Caravaggio's original, one whose loose brushwork and rough handling call attention to Schnabel's own unique artistic personality. Like that of Dürer, the significance of Schnabel's work is conveyed by exclusively pictorial means so that the image remains independent of what Uspenskii and Lotman would have called the primary modeling system of language.

This analysis of the works of Kruger and Schnabel suggests that while the high/low distinction remains very much with us today, the extent to which it serves to mark not only class but gendered identities has been recognized. The characteristics that distinguish the high from the low shift and change, of

25. In playing Julian Schnabel off against Barbara Kruger, I am developing a distinction between "poststructuralist postmodernism" and "neoconservative postmodernism" first made by Hal Foster, "(Post)Modern Polemics," in *Recodings: Art, Spectacle, Cultural Politics* (Seattle: Bay Press, 1985), 121–36.

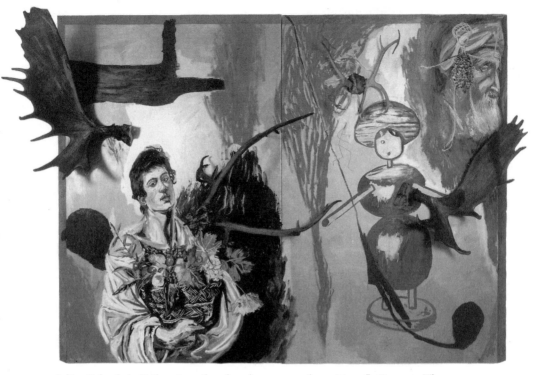

5. Julian Schnabel, *Exile,* 1980, oil and antlers on wood, 90 × 120". Courtesy The Pace Gallery, New York

course. Though Kruger makes use of reductive imagery with a heavy dependence on text in the articulation of a moralizing social message, as does the Reformation broadsheet, Schnabel calls attention to the facture of his work, not through the mimetic codes employed by Dürer, but by means of painterly abstraction and the incorporation of canonical references. Schnabel may nevertheless be said to join Dürer in the execution of a work whose significance is hermetic. Just as Dürer's *Melencolia I* was understood only by a small educated elite, so Schnabel's painting is available only to those who appreciate the founding gesture of abstraction, namely, the proposition that a painting need not represent or "stand for" anything but itself. In a contemporary culture dominated by the illusionistic imagery of photography, such an appreciation depends on class and education.

The paradox of mimesis, whose apparent duplication of certain qualities of our perceptual experience actually depends on a process of translation which can never be accomplished, which draws as much attention to the translator as to the translation, suggests that a mimetic theory of representation which

assesses artistic production in terms of its power of illusion is an inadequate basis for the traditional distinction between high and low art on which the history of Renaissance art has in large part depended. If we return, by way of conclusion, to the epigraph from Panofsky with which I began, the features that make a work of art "great" will never become evident "automatically." What makes a work "great" is what we bring to it when we come to it: the attitudes and values of our own culture and our own time which have taught us to organize and hierarchize the experiences that constitute the world in which we live.

CHAPTER SIX

Seeing Through

What I have been calling an aesthetics of extension or an art history of the proper name can be likened to a detective story or the *roman à clef,* where the meaning of the tale reduces to just this question of identity. In the name of the one "who did it" we find not only the solution, but the ultimate sense of the murder mystery; and in discovering the actual people who lie behind a set of fictional characters, we fulfill the goal of the narrative: whose characters' *real* names *are* its sense.

—Rosalind Krauss, "In the Name of Picasso"

The title of this chapter is meant to suggest the concern of much art historical writing and specifically the literature on Martin Schongauer to see through the material evidence offered by works of art in order to establish an artist's biography. This chapter is as much about the writing of history as it is a historical interpretation in its own right. It is concerned both with the scholarly literature on Martin Schongauer, reflecting how this artist has been presented to us by scholars in the past, and with how the historian might approach his work in the future.

A fitting metaphor for the concern with Schongauer's biography is the treatment of a portrait whose subject is alleged to be Schongauer in the Alte Pinakothek, Munich (ill. 6). This portrait, which has served as the frontispiece to every major monograph on the artist, has been used as a means of invoking his absent presence and a way of putting surviving works together with their long-dead creator.[1] The painting, which bears an inscription identifying the sitter as Martin Schongauer and a date that has been variously read as 1453 or 1483, has been attributed to a number of different artists. Pasted to the back is an inscription in a fifteenth-century hand which provides us with information about the artist. Recent historical research has shown some of it to be accurate and some of it inaccurate. Despite disclaimers issued by several biographers as to the trustworthiness of the text, it has played a major role in

1. See Julius Baum, *Martin Schongauer* (Vienna: Anton Schroll, 1948); Eduard Flechsig, *Martin Schongauer* (Strasbourg: Heitz, 1951); Lucien Blum, *Martin Schongauer, 1453?–1491: Peintre et graveur colmarien* (Colmar: Alsatia, 1958); Charles Minott, *Martin Schongauer* (New York: Collectors Editions, 1971); Fedja Anzelewski et al., eds., *Le Beau Martin: Gravure et dessin de Martin Schongauer (vers 1450–1491),* exhibition catalog (Colmar: Musée d'Unterlinden, 1991).

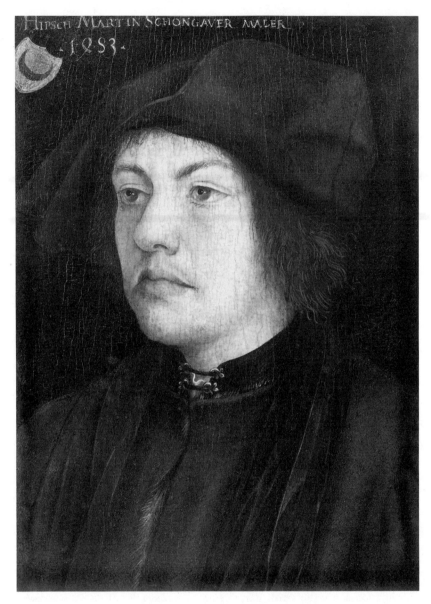

6. Hans Burgkmair the Elder, *Portrait of Martin Schongauer* (?), 1453/83(?). Alte Pinakothek, Munich. Courtesy Bayerische Staatsgemäldesammlungen, Munich

their understanding of Schongauer's life. The inscription informs us that Schongauer was born in Colmar but that he inherited Augsburg citizenship through his parents, who came from that city. The Schongauer family is described as patrician; the date of his death is given as 1499; and Hans Burgkmair, a prominent Augsburg painter, is said to have been his pupil in

1488. Art historical research in the nineteenth and twentieth centuries has been unable to establish Schongauer's place of birth but has determined that his father did indeed move from Augsburg to Colmar. Nevertheless, Schongauer is not recorded a citizen of Augsburg; the date of his death is not 1499 but 1491; it is hard to substantiate the claim that his family was patrician; and there is no evidence that Burgkmair was ever his pupil. In view of the limited accuracy of the inscription, its prominence in the discussion of Schongauer's life can be interpreted only as a literal manifestation of the desire to see through Schongauer, in this case to see through the panel on which the portrait is painted to get to the biography on the other side.

This obsession with the idea of the artist as an exceptional individual, as well as with the notion that art is the expression of the unique qualities of a particular personality, is a form of historical writing in which the historicist principle is reduced to a rehearsal of names, places, and dates. It has been possible for art historians to deal with Schongauer's art as an expression of his personality, an extension of himself. References to Netherlandish art in his work have been seen as evidence that Schongauer traveled in the Lowlands; representations of exotic vegetation and Moorish figure types are said to indicate that he visited Spain; and his secular subjects have been treated as if they were incidents in everyday life which he must have experienced personally. The rhetorical form adopted by this approach is description. Descriptive writing aspires to neutrality in which argument is made unnecessary because the point is allegedly obvious and self-evident once attention has been attracted to it by the author. Since it depends heavily on metaphors of perception to insist on the self-evidence of its conclusions, description serves to naturalize interpretation. The implicit analogy drawn between perception of the world and perception of works of mimetic art elides the differences that distinguish them. It reduces our conception of artistic representation to a duplication of our experience of the world and fails to come to grips with the complex process involved in the making of cultural artifacts that are freighted with social meaning.

Radical challenges to the view that language is a transparent tool have become a commonplace of poststructuralist theory. Critical theory has by and large subscribed to the view of Ferdinand de Saussure that language functions by means of a set of internal distinctions rather than by a direct relationship between the word and its referent.[2] Current theory claims that there is nothing natural about the way in which a particular word can be used to invoke a particular object and that the relationship is arbitrary and depends on convention for its force. Language is not a value-free instrument with which human beings manipulate the world around them but rather a cultural

2. Ferdinand de Saussure, *Course in General Linguistics,* ed. Charles Bally and Albert Sechehaye, trans. Roy Harris (La Salle, Ill.: Open Court, 1986; 1st French ed., 1915).

representation that has a materiality, a thickness, and an opacity of its own. On this view, "pure" description is impossible, for the language used to describe objects is itself redolent with the values of its authors. Every description must necessarily interpose a layer of value, so that it is just as interpretive as any other form of historical interpretation. If Saussure's insight is correct and the status of language as representation is accepted, then it follows that the autonomy of those who use it is restricted to the combination and transformation of preestablished conventions.

Saussure's views on language have also had profound repercussions on theories of human subjectivity. Jacques Lacan used the notion of language as representation in his theorization of the concept of the self.[3] According to Lacan, the subject is split on the acquisition of language between a sense of itself and a sense of its existence within the symbolic network of the culture of which it is a part. Since language exists prior to the subject, it determines the subject's shape within the context of established social structures. The implication of this conclusion is that the subject is itself a representation: it is as much the product of language as it is capable of producing it. Lacan's view entails a drastic rethinking of the humanist concept of the subject. Instead of regarding artists as free to act upon the circumstances in which they find themselves, the distinction between the subject and its context is collapsed, the subject being as much the product of the context as vice versa. A further implication of Lacan's view of subjectivity is that the concept of intentionality becomes irrelevant. It makes little sense to ask what the artist intended to mean in a work of art, as if the intention were something separate and distinct from the work itself. Insofar as the work is a manifestation of the cultural values of the period to which it belongs, it is a manifestation of the personality of the artist at the moment of its creation. Artist and culture are not just contiguous but continuous with each other. The artist instantiates and materializes the culture of which he or she is a part.

What happens when we apply some of these contemporary critical principles to the study of Martin Schongauer? If it is the writing rather than the author, the image rather than the artist, which becomes the focus of historical attention, then it will be important to determine the genres or visual categories in which Martin Schongauer worked. If language is regarded as material and opaque because words bear no necessary relation to their referents, the same may very well be true of visual forms. Instead of regarding them as the means by which artists capture the qualities of the real world, as instruments with which nature may be translated into artistic likenesses—a mimetic view

3. Jacques Lacan, "The Mirror Stage as Formative of the Function of the I" and "The Agency of the Letter in the Unconscious, or Reason since Freud," in *Ecrits: A Selection,* trans. Alan Sheridan (New York: Norton, 1977), 1–7, 146–78.

of representation—we can approach visual forms as if they are value-laden interpretations of nature which vary from culture to culture and period to period. Although the literature on Schongauer has always been sensitive to the relation of his visual forms to those of Netherlandish art of the early fifteenth century, these qualities have been interpreted as "influences" that impinged on and molded Schongauer's own perception of nature. If we adopt a material notion of the image as a cultural artifact rather than an instrument of mimesis, then Schongauer's incorporation of earlier visual vocabularies would have to be regarded as value-laden references that he reused and reworked in constructing the visual culture of his society.

It is time, perhaps, to turn from the general to the specific, from the discussion of interpretation to the work of interpretation. Schongauer's most famous painting, *The Virgin in a Rose Arbor,* in the Dominican church of Saint Martin in Colmar (ill. 7), has long been the object of historical inquiry. Authors have used its date, 1473, in establishing the artist's stylistic development, but they have also seen beyond biography in defining its iconographic type and flower symbolism. Ewald Vetter traced the iconography of the Virgin in a Rose Arbor, pointing out how the subject matter represented the fusion of two ideas, the notion of the Virgin as the *hortus conclusus,* or enclosed garden, on the one hand, and the symbolism of the Virgin as the paradisiacal rose, the rose without thorns, on the other.[4] Vetter also claimed that the Virgin's location, seated on an earthen bank, related the composition to the iconography of the Virgin of Humility. The painting was thus thought to refer both to the virginity of Mary and to her exemplary humility when presented, at the Annunciation, with God's plan for the redemption of humanity. The inscription, "Pluck me also for thy son, O holiest Virgin," on her halo may be interpreted in the light of other paintings of the same theme. In Stefan Lochner's painting in Cologne dating from the middle of the fifteenth century, for example (ill. 8), an angel plucks a rose in order to offer it to Christ. Just as the angel offers Christ a rose, so the inscription asks the Virgin to involve herself in the worshiper's salvation. Finally, Charles Minott has pointed out that not just the rose but all the flowers in the painting, whose number and variety were considerably greater before it was cut down, are symbols of the Virgin's virtues.[5]

In contrast to the wide-ranging discussion of the theological implications of the painting's iconography, little consideration has been given to its function. The whole thrust of interpretation has been to classify and define, to establish the theme's meaning at the moment of its creation. To my knowl-

4. Ewald Vetter, *Maria im Rosenhag* (Düsseldorf: L. Schwann, 1956).
5. Minott, *Martin Schongauer,* 20. He cites Robert Koch, "Flower Symbolism in the Portinari Altarpiece," *Art Bulletin* 46 (1964): 70–76.

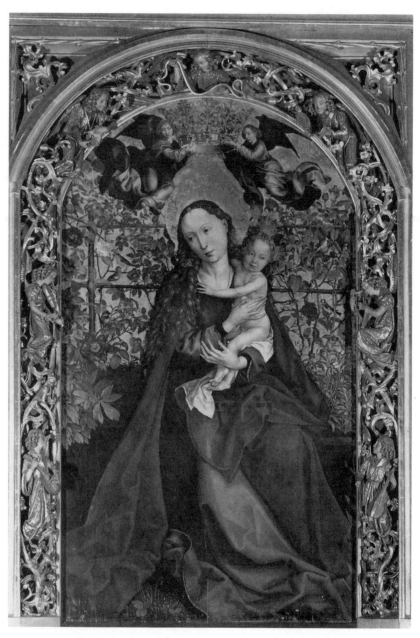

7. Martin Schongauer, *Virgin in a Rose Arbor,* 1473. Saint Martin's Church, Colmar. Courtesy Giraudon/Art Resource, New York

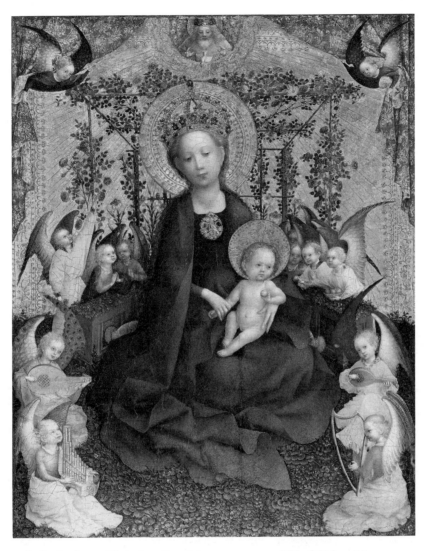

8. Stefan Lochner, *Virgin in a Rose Arbor,* ca. 1440–50. Walraf-Richart Museum, Cologne. Courtesy Rheinische Bildarchiv, Cologne

edge, only Vetter has speculated on the role of the iconography of the Virgin in a Rose Arbor in Schongauer's culture. He suggests that the iconographic allusion to the Virgin's humility may have been a means by which the preaching orders, the Franciscans and Dominicans, manifested the values they considered most important.[6] That is, should the painting have been commissioned by either of these orders, it would have been a vehicle for promoting a

6. Vetter, *Maria,* 17.

vital aspect of the faith. Furthermore, he believes that the theme of the Virgin in a Rose Arbor demonstrates a desire for union with the divine which is characteristic of mystical thinking in Germany in the fourteenth century.[7]

Interesting as they are, these suggestions can be further complicated and enriched in a number of different ways. Consideration of Schongauer's painting as a specific example of the Virgin in a Rose Arbor type which was created to function in a particular set of historical circumstances may allow us to add texture to Vetter's generalizations. Bearing in mind that description constitutes interpretation, let me attempt to describe the component elements of the composition. The Virgin, a mere mortal according to biblical accounts, has been extracted from the narrative of Christ's life and promoted to the realm of the divine. She sits in a paradisiacal garden filled with birds and flowers; her unblemished skin and regular features mark her as exceptionally beautiful; her sumptuous robes and the crown about to be lowered on her head imply that she has royal status. The earthen bench on which she sits, a reference to her humility, does not disturb the magnificent splendor of the otherworldly vision arrayed before us. Far from rupturing the charm of the heavenly setting, the reference to the Virgin's humility serves to inflect and modulate it. The consequence is a poetic paradox; the Virgin appears both approachable and removed, immediate and distant.

How did the many strands of Marian iconography on which Schongauer's work depends relate to the social function it served in fifteenth-century Colmar? What importance should we ascribe to Mary's role as Queen of Heaven and as a personification of the institution of the church? Is it possible that her royal status, together with the symbolism of the enclosed garden, made reference to the doctrine of the Immaculate Conception? In which case does her sinlessness grant her a role equal to that of Christ in the process of salvation? What emphasis should we place on the reference to the Virgin's humility and its association with Franciscan poverty? In the absence of information about the nature of religious life in Colmar during Schongauer's lifetime, I intend to use the records relating to the foundation of the confraternity of the rosary to find answers to some of these questions. Since we are relatively well informed about the organization and devotion of this group, these documents can provide a way of gaining access to the quality of Colmar's spiritual life.

The foundation of the brotherhood of the rosary by members of the Dominican order took place in 1485, ten years after the brotherhood had first been established in Cologne. The central focus of the devotion was the use of the rosary, a mechanical aid to prayer, which, according to legend, had first been given to Saint Dominic by the Virgin herself. According to the docu-

7. Ibid., 30.

ments associated with the foundation, the rosary was to be prayed at least three times a week.[8] The rosary consisted of fifty repetitions of the Hail Mary, dedicated to a meditation on the joys of the Virgin, and five repetitions of the Our Father, as a meditation on the passion of Christ. Later this original program was varied by meditations on the joys and sufferings of the Virgin and the so-called glorious mysteries, the Ascension, Descent of the Holy Spirit, Assumption of the Virgin, and the Coronation of the Virgin.

The repetition of these prayers was intimately related to the cult of indulgences. According to the documents, if one recited the rosary three times a week, one obtained an indulgence of 23 years, 23 weeks, and 3 days; if one recited the rosary three times a day one obtained 168 years, 231 weeks, and 21 days; if one recited it three times a day for a week, one received a bonus of 150 years; and finally, if one recited it nine times a day for a year, one was entitled to 15,492 years of indulgence.[9] The success of the confraternity was enormous. In a city whose population hovered around six thousand people, over twenty-eight hundred became members. Heading the list were members of the religious orders (principally Dominicans), who constituted almost 9 percent of the total. While it is impossible to break down the list according to social class (occupations are not given), apparently members of the city council, as well as artisans belonging to a number of different trades, were represented.[10] The confraternity's success would appear to be linked to the importance ascribed to indulgences. Its regulations afforded members the means by which not only they, but their parents, children, other relations, and friends, might escape the terrors of purgatory in the life after death. By means of a simple process of mechanical repetition, the worshiper was assured an easily calculated guarantee of assistance in the hereafter.

The popularity of the confraternity of the rosary is inexplicable without a consideration of the rising importance of the notion of purgatory in the late Middle Ages. As Jacques Le Goff has shown, the invention of the theological concept of purgatory represented an audacious extension of the church's authority into the afterlife.[11] According to this doctrine, the soul did not just await resurrection at the Last Judgment and then experience consignment

8. For these documents, see Jean-Claude Schmitt, "La confrérie du rosaire de Colmar (1485): Textes du fondation, 'exempla' en allemand d'Alain de la Roche, listes des prêcheurs et de soeurs dominicains," *Archivium fratrum praedicatorum* 40 (1970): 97–124.

9. Ibid., 108–9.

10. Jean-Claude Schmitt, "Apostolat mendiant et société: Une confrérie dominicaine à la veille de la réforme," *Annales E.S.C.* 26 (1971): 83–104.

11. Jacques Le Goff, *The Birth of Purgatory,* trans. Arthur Goldhammer (Chicago: Chicago University Press, 1984; 1st French ed., 1981). For the development of a "guilt culture," see also Jean Delumeau, *Sin and Fear: The Emergence of a Western Guilt Culture, 13th–18th Centuries,* trans. Eric Nicholson (New York: St. Martin's Press, 1990; 1st French ed., 1983).

either to heaven or hell. Instead, it was claimed, there existed a place of torment known as purgatory where the souls of the dead went immediately after death in order to be purified of the sins they had committed while on earth. The purification experienced by souls in purgatory, usually described in terms of the metaphor of fire, made it possible for them to join the ranks of the blessed at the Last Judgment. The doctrine suggests an anxiety about the process of salvation, an anxiety that intensified during the course of the late Middle Ages, reaching a crisis at the Reformation. It manifests a pessimism about the sinfulness of human nature and the capacity of human beings to obtain the grace necessary for salvation.

What, the reader will be asking, has all this got to do with Schongauer's *Virgin in a Rose Arbor?* The Colmar confraternity of the rosary was founded in 1485, but the painting is dated 1473. The institution of the brotherhood thus postdates the execution of the painting by more than ten years. This historical anachronism serves to bring home the interpretative point I wish to make: works of art can affect manifestations of culture as well as be affected by them. Far from defining the intentions that lie behind the work, far from attempting to "see through Schongauer," I am using the devotion to the rosary to bear on the reception of his work, on the way it may have been used during Schongauer's lifetime.

Schongauer's *Virgin in a Rose Arbor* is not, of course, the type of image associated with devotion to the rosary. Typically the Virgin and Child were represented distributing rosaries to the faithful. Occasionally, other iconographic types, such as the Coronation of the Virgin or the Apocalyptic Woman, were used for this purpose. Nevertheless, it is likely that Schongauer's painting, located in Saint Martin's, the Dominican church of Colmar, and thus intimately associated with the clergy who were most deeply involved in the promotion of devotion to the rosary, would have been regarded in light of this new form of popular spirituality. There is, first of all, an immediate connection to be made between the flower symbolism of the painting and that of the beads that make up the rosary. In both cases, the rose was used to invoke the paradisiacal status of the Virgin and her freedom from earthly stain. The roses in the arbor may have been counted along with the beads as an aid to the repetition of prayers.[12]

The devotion to the rosary must also have enhanced the significance of certain of the iconographic strands that constitute Schongauer's image, at the

12. See Sixten Ringbom, "*Maria in sole* and the Virgin of the Rosary," *Journal of the Warburg and Courtauld Institutes* 25 (1962): 326–30, fig. 45c, for an example of the use of the iconography of the Virgin in a Rose Arbor in connection with the devotion to the rosary. For the use of illusionistically painted flowers in the devotion to the rosary, see David Freedberg, "The Origins and Rise of the Flemish Madonnas in Flower Garlands: Decoration and Devotion," *Müncher Jahrbuch der bildenden Kunst,* 3d ser. 32 (1981): 115–50.

expense of others. The painting's reference to the humility of the Virgin, for example, may have brought to mind verbal exchange between the angel and the Virgin at the Annunciation, in which she describes herself as the "hand-maiden of the Lord," thus emphasizing her humility in her acceptance of God's plan. Yet the Virgin is about to be crowned queen of heaven, and she sits in an enclosed garden symbolic of her virginity and her freedom from sin. These aspects of the iconography reflect the power accorded to the Virgin by the devotion to the rosary, in which meditations on her life outnumber those on the life of Christ, ten to one. This paradoxical combination of humility and power must also be considered in light of the fear of purgatory which prompted the cult of indulgences. If the rosary offered one mechanical aid to mitigate the torments of the afterlife, then the image afforded another. Considering the popularity of the confraternity of the rosary, the significance of the inscription on the Virgin's halo takes on new significance. If we are to understand the power of the words "Pluck me also for thy son, O holiest Virgin," we cannot forget the anxiety at the heart of the pursuit of indulgences. Such a plea is not just a manifestation of mystical desire for union with God, as Vetter suggests, but also a cry of mortal terror provoked by the doctrine of purgatory.

Finally, we should consider that Schongauer's image may well have served a gendered function for the members of his community. According to Jean-Claude Schmitt, who has done a demographic study of the first thousand lay members inscribed in Colmar's brotherhood of the rosary, 583 were women and 417 were men. Schmitt suggests several ways to account for the popularity of the confraternity among women. First, unlike other confraternities, the brotherhood of the rosary did not exclude women. Second, the simplicity of the devotion to the rosary, which required only the repetition of prayers and did not involve attendance at mass, participation in processions, or any other observances outside the home, might have appealed to the domestic character of women's lives in a patriarchal culture. The gendered nature of the devotion to the rosary, therefore, suggests that *The Virgin in a Rose Arbor* possessed special resonance for women.

Such a conclusion offers insight into the gendered quality of late medieval imagery. The first impulse of feminist historians, such as Marina Warner and Margaret Miles, was to posit that the cultural significance of devotional images of the Virgin was related to the fact that she was a woman.[13] Although their interpretations of particular images are historically sensitive, they ultimately depend on some universal and unchanging notion of femininity.

13. See Marina Warner, *Alone of All Her Sex: The Myth and Cult of the Virgin Mary* (New York: Vintage Books, 1983; first published 1976); and Margaret Miles, *Image as Insight: Visual Understanding in Western Christianity and Secular Culture* (Boston: Beacon Press, 1985).

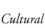
Warner also argues that the characterization of the Virgin as humble, in images such as Schongauer's, was simply a metaphor for the subordinate position assigned to women in medieval society.[14] Caroline Bynum, however, has shown that cross-gendered identifications were typical of mystical thought in the late Middle Ages. Both the male and female metaphors associated with the roles of Christ and the Virgin in human redemption were developed by men and women authors alike.[15] In other words, women found Christ's life and theological function a source for maternal as well as paternal and spousal metaphors, and men exploited the maternal, spousal, and paternal metaphors to be found in the figure of the Virgin. Bynum's studies make it difficult to argue both that the gendered value of representations of the Virgin depended on her identification as a woman and that her characterization as humble is related to the status of women in general. Her persuasive analyses suggest that claims for the gendered function of the image must be argued according to particular instances, rather than across the board. If this is the case, then the claim that Schongauer's image was viewed in the context of the devotion to the rosary provides us with a historical example of the grounds on which men and women developed different responses to the same image.

What I have tried to argue in this chapter is that forms of interpretations based on the notions of the artist as an autonomous subject and artistic representation as limited to mimesis have unnecessarily restricted our understanding of the work of Martin Schongauer. An approach that views the work of art as a cultural artifact designed to perform particular social functions empowers us to move away from considerations of intention toward considerations of reception. This different perspective enables us to analyze how the work makes meaning, not only in its own time but in subsequent ages as well. Instead of viewing the work as a repository or a reflection of cultural values, instead of treating it as if it were the final product of social processes that preceded its elaboration, my concern has been to show that the work is itself an active agent in the production of culture. Rather than penetrate the image in an effort to see through Schongauer, I suggest that the work of interpretation lies on the surface of the image, for it is there that what we and others have brought to its understanding can be reworked and reused in the production of new cultural meaning.

14. Warner, *Alone of All Her Sex,* chap. 12.

15. See Caroline Walker Bynum, *Jesus as Mother: Studies in the Spirituality of the High Middle Ages* (Berkeley: University of California Press, 1982); idem, *Holy Feast and Holy Fast: The Religious Significance of Food to Medieval Women* (Berkeley: University of California Press, 1987).

CHAPTER SEVEN

Making "Genius"

What is this place, *locus voluptatis,* and other such gardens of lovers and mystics? What happens there? The painting becomes progressively more opaque as the prolific epiphany of its forms and colors becomes more detailed. The former hides itself in displaying the latter. The painting organizes, aesthetically, the loss of meanings.

—Michel de Certeau, *The Mystic Fable*

The writing of art history is often regarded as if it were a self-evident enterprise in which historians share common assumptions and common goals. What matters, it is thought, are not the theoretical assumptions and methodological procedures that animate the work so much as the empirical "evidence" the study brings to bear on the interpretation in question. The lack of articulated assumptions implies that such theoretical considerations are unnecessary because all practitioners share the same point of view. As a consequence, it is possible for the discipline to operate on the basis of a hidden agenda that is difficult to challenge because it is not supposed to exist. This chapter, however, is as much concerned with the ways in which we have tried to make sense of the work of Hieronymus Bosch, as it is with the construction of a new interpretation of that work's significance. It is especially interested in what the historian brings to the work of interpretation. I shall try, therefore, to define some of the most important presuppositions underlying current scholarship on Bosch, as well as the perspective from which my own proposal is made.

A superficial acquaintance with the scholarly literature reveals that although Bosch's work has almost universally been acknowledged to be enigmatic, one author after another has approached it as if it were a puzzle that needed solving or a code that should be broken. Erwin Panofsky epitomized this attitude in *Early Netherlandish Painting:* "In spite of all the ingenious, erudite and in part extremely useful research devoted to the task of 'decoding Jerome Bosch,' I cannot help feeling that the real secret of his magnificent nightmares and daydreams has still to be disclosed. We have bored a few holes through the door of the locked room; but somehow we do not seem to have discovered the key."[1] Many competing interpretations suggest that Bosch's

1. Erwin Panofsky, *Early Netherlandish Painting: Its Origins and Character,* 2 vols. (Cambridge: Harvard University Press, 1966), 357–58.

visual forms are symbols that can be explained through recourse to esoteric knowledge that was part of Bosch's historical horizon but is unknown to us today. As a consequence, the literature is strewn with attempts to explain his imagery in terms of astrology, alchemy, rare forms of heresy, illustrated puns, and so forth.[2]

There are, of course, notable exceptions to this rule. Interestingly enough, such approaches tend to favor a broader understanding of the cultural significance and social function of Bosch's art.[3] Paul Vandenbroeck, for example, has provided an analysis of the social values manifested in Bosch's subject matter, thus affording insight into his role as a member of a new, humanistically educated elite.[4] He shows not only that such paintings as *The Ship of Fools, The Cure of Folly, The Death of the Miser,* and *The Haywain Triptych* manifest the secular morality of this group but that it used these moral values to distinguish its culture from those of other classes. Another of Van-

2. It would be impossible to represent the entire interpretive spectrum here. The following are examples of some of the alternatives that still command scholarly interest: Andrew Pigler, "Astrology and Jerome Bosch," *Burlington Magazine* 92 (1950): 132–36; Lotte Brand Philip, "*The Peddler* by Hieronymus Bosch: A Study in Detection," *Nederlands kunsthistorisch jaarboek* 9 (1958): 1–81; Anna Spychalska-Boczkowska, "Materials for the Iconography of Hieronymus Bosch's Triptych of *The Garden of Earthly Delights,*" *Studia Muzeale Poznan* 5 (1966): 49–95; Jacques van Lennep, *Art et alchimie: Etude de l'iconographie hermétique et de ses influences* (Brussels: Meddens, 1966); Madeleine Bergman, *Hieronymus Bosch and Alchemy,* trans. Donald Bergman (Stockholm: Almquist and Wiksell, 1979); Laurinda Dixon, *Alchemical Imagery in Bosch's "Garden of Earthly Delights"* (Ann Arbor: UMI Research Press, 1981); Wilhelm Fraenger, *The Millennium of Hieronymus Bosch: Outlines of a New Interpretation,* trans. Eithne Williams and Ernst Kaiser (Chicago: University of Chicago Press, 1951); idem, *Die Hochzeit zu Kana: Ein Dokument semitischer Gnosis bei Hieronymus Bosch* (Berlin: Gebr. Mann., 1950); Patrik Reutersward, *Hieronymous Bosch* (Stockholm: P. A. Norstedt, 1970); Dirk Bax, *Hieronymus Bosch: His Picture Writing Deciphered,* trans. M. A. Bax-Botha (Rotterdam: A. A. Balkema, 1979); idem, *Beschrijving en poging tot verklaring van het Tuin der Onkuisheiddrieluik van Jeroen Bosch, gevolgd door kritiek op Fraenger* (Amsterdam: Noord-Hollandische Utig. Mij., 1956). For an introduction to the Bosch literature, see Walter Gibson, *Hieronymus Bosch: An Annotated Bibliography* (Boston: G. K. Hall, 1983).

3. See Pater Gerlach, *Jheronimus Bosch: Opstellen over Leven en Werk,* ed. P. M. le Blanc (The Hague: SDU uitgeverij, 1988); J. K. Steppe, "Jheronimus Bosch: Bijdrage tot de historische en ikonographische studie van zijn werk," in *Jheronimus Bosch: Bijdragen bij gelegenheid van de herdenkingstentoonstelling te 's-Hertogenbosch* ('s-Hertogenbosch: Noordbrabants Museum, 1967), 5–41; Walter Gibson, *Hieronymus Bosch* (New York: Praeger, 1973).

4. Paul Vandenbroeck, *Jheronimus Bosch: Tussen volksleven en stadscultuur* (Berchem: Uitgeverij EPO, 1987). Vandenbroeck's identification of Bosch's values with those of a humanist bourgeoisie anxious to define itself as distinct both from those who were less well off and from the aristocracy must now be considered in the light of the discovery of tax records that identify Bosch as one of the wealthiest citizens of his native city of Hertogenbosch. See Bruno Blonde and Hans Vlieghe, "The Social Status of Hieronymus Bosch," *Burlington Magazine* 131 (1989): 699–700.

denbroeck's contributions is his discussion of Renaissance art theory in rela-
tion to Bosch's visual imagery. He maintains, however, that while Bosch made
use of concepts such as invention, fantasy, and genius in the elaboration of an
apparently hermetic art, his work was nevertheless decipherable by a human-
istically trained elite. The hermetic quality of Bosch's work is thus interpreted
as a device by which meaning could be hidden from those who were regarded
as socially (and morally) inferior: "His work may be accounted for down to
the smallest detail, as [Dirk] Bax has demonstrated and maintained against all
other interpreters. Bosch is a pseudo-visionary (a concept which we have used
without pejorative connotations), who sought the greatest possible control
over the thought, that is to say the subject-like *inventio,* which was the basis
for his visual imagery."[5] This interpretation is confirmed in Vandenbroeck's
book on *The Garden of Earthly Delights,* in which meaning is ascribed to every
aspect of the pictorial fabric.[6]

In what follows, I will suggest that while the function of Bosch's paintings
may very well have served the moral and social purposes ascribed to them by
Vandenbroeck, his visual motifs did not possess the specific meanings that
Vandenbroeck and others have attributed to them. In other words, I will
argue that, far from being "accounted for down to the smallest detail," Bosch's
imagery was to a large extent incapable of being read and that it was this very
quality that enhanced its appeal for a humanistically educated audience. In
place of the pictorial *symbol,* I would substitute the pictorial *sign.* Rather than
attempt to ascribe to Bosch's pictorial motifs symbolic or allegorical status,
that is, to claim that the work's material substance refers to an ideal substruc-
ture that is fixed, separate, and distinct, I think of them as signs in which both
material and ideal qualities are indissolubly united. In doing so, I want to
draw attention not to the depths of meaning which are said to lie behind
Bosch's forms but to the surfaces they animate. Rather than look through the
work, I suggest we examine how it resists our gaze. Instead of valuing trans-
parency, by which paintings are said to afford us access to an intellectual realm
behind the surface, I should like to emphasize opacity, their insistence that
the interpreter create meaning before them. As a contrast to Panofsky's model
of historical scholarship as an enterprise dedicated to the discovery of secrets
and the penetration of sealed chambers, I should like to call on Michel
Foucault, who writes: "The contemporary critic is abandoning the great myth
of interiority. . . . He finds himself totally displaced from the old themes of
locked enclosures, of the treasure in the box that he habitually sought in the

5. Vandenbroeck, *Jheronimus Bosch,* 178, my translation.
6. Vandenbroeck, "Jheronimus Bosch' zogenaamde *Tuin der Lusten," Jaarboek van het Ko-
ninklijk Museum voor schone Kunsten, Antwerpen* (1989): 9–210.

depths of the work's container. Placing himself at the exterior of the text, he constitutes a new exterior for it, writing texts out of texts."[7]

By means of the notion of the sign, I wish not only to point out that the signifying systems of the past can be interpreted only in the light of the signifying systems of the present, but also to suggest that both the systems of the past and those of the present are ideologically informed. Rather than define the sign as something that draws its meaning from all the other units that constitute the system of which it is a part—as, for example, Saussure does in defining the word's relation to language, thus abstracting signification from its cultural and social circumstances—I wish to use a notion of the sign developed in the Soviet reaction to Saussure by Valentin Volosinov and Mikhail Bakhtin.[8]

According to this view, signs are not part of an abstract, timeless system but are engaged in specific social and cultural transactions. They obtain their meaning from the specific circumstances of their use. To suggest that signs may be ascribed specific meaning is not, of course, to suggest that they are univocal or that the interpreter can ever arrive at the "true" significance of the sign systems of the past. Instead, a recognition that signs are defined by their social and historical location implies that every interpretation is itself constituted by sign systems that have their own social and historical specificity. In other words, an understanding of the signifying processes of the past involves a recognition that the work of the interpreter is also a signifying process and that both the signs of the past and the signs of the present are colored and compromised by the circumstances of their production.[9]

7. Michel Foucault, *Foucault Live (Interviews, 1966–84)*, ed. Sylvère Lotringer, trans. John Johnston (New York: Semiotext(e), 1989), 21.

8. Ferdinand de Saussure, *Course in General Linguistics*, ed. Charles Bally and Albert Sechehaye, trans. Roy Harris (La Salle, Ill.: Open Court, 1986); Mikhail Bakhtin, *The Dialogic Imagination: Four Essays*, ed. Michael Holquist, trans. Caryl Emerson and Holquist (Austin: University of Texas Press, 1981); Valentin Volosinov, *Marxism and the Philosophy of Language*, trans. Ladislav Matejka and I. R. Titunik (Cambridge: Harvard University Press, 1986).

9. For an expanded treatment of these ideas, see Chapter 1. This is not the first attempt to approach Bosch's visual forms from a semiotic perspective; see Albert Cook, *Changing the Signs: The Fifteenth-Century Breakthrough* (Lincoln: University of Nebraska Press, 1985). Cook made use of the arbitrariness of the Saussurean sign, which draws its meaning solely from its relation to all the other words in the language rather than from its relation to its referent, to argue for an endless proliferation of meaning. His interpretation suggests that Bosch's forms can mean everything his interpreters have claimed them to mean. By relativizing the act of interpretation to this extent, Cook fails to acknowledge the ideological freight and political investment that are a feature of signs both in the past and the present. For another, more recent semiotic interpretation of Bosch's visual forms, of which I became aware only after this essay was completed, see Michel de Certeau, *The Mystic Fable*, 2 vols., trans. Michael Smith (Chicago: University of Chicago Press, 1992), chap. 2, "The Garden: Delirium and Delights of Hieronymous Bosch,"

If Bosch's visual imagery is to be understood in terms of signs as I have defined them, then it will be important to locate them within the other signifying systems that constituted the culture in which he worked. Insofar as this analysis is indebted to the historicist assumption that events are shaped by the historical context in which they take place, it is important to ascertain how the signs that articulate his work intersected with the rest of the sign systems that organized the social and historical circumstances of their creation. Like those interpretations that depend on astrology, alchemy, heresy, or the identification of puns, this interpretation must move beyond the boundaries of the picture plane into the culture that surrounded it. Far from penetrating the image so as to see through its forms to intellectual traditions they allegedly symbolized or embodied, however, this analysis will attempt to move across their surfaces to examine the conventional and thus social sign systems with which they are both contiguous and continuous. Instead of treating the image as a finished product occupying a passive place in the life of culture, a reflection of intellectual activity taking place in another sphere, I will regard the image as an active participant in a social process.

In seeking to interpret Bosch's place among the signifying systems that constituted the culture of which he was a part, it goes without saying, perhaps, that it will be impossible for me to survey the entire spectrum. As Norman Bryson has pointed out, there is nothing self-evident about the choice of circumstances the historian adduces in an attempt to build a causal narrative about his or her subject.[10] Bosch's imagery must have served a variety of functions for those who originally experienced it. Since matters relating to class figure prominently in the narrative I propose to tell, however, the context I consider most appropriate is the role played by Bosch's works in the artistic collections of the Burgundian nobility of his time.

What little information we have concerning the early patronage of Bosch's art suggests that his work was collected by members of the aristocracy, especially by those who had been most affected by the introduction of humanist culture. Bosch's painting, *The Garden of Earthly Delights* (ill. 9), for example, was almost certainly commissioned by Henry III of Nassau, adviser and

49–72. Certeau contends that Bosch's forms are deliberately intended to elude interpretation; his "reading" concludes that they are "unreadable." That is, he comes to the opposite conclusion to Cook's. Instead of seeing their mystery as a means of justifying all the interpretations to which they have been subjected, Certeau sees Bosch's *Garden of Earthly Delights* as an aesthetics of incomprehensibility. Bosch is said to have used recognizable objects, intelligible gestures, and quotidian forms in such a way that the meanings with which they are usually associated cannot be used to account for their representation in this particular instance.

10. Norman Bryson, "Art in Context," in *Studies in Historical Change*, ed. Ralph Cohen (Charlottesville: University Press of Virginia, 1992), 18–42.

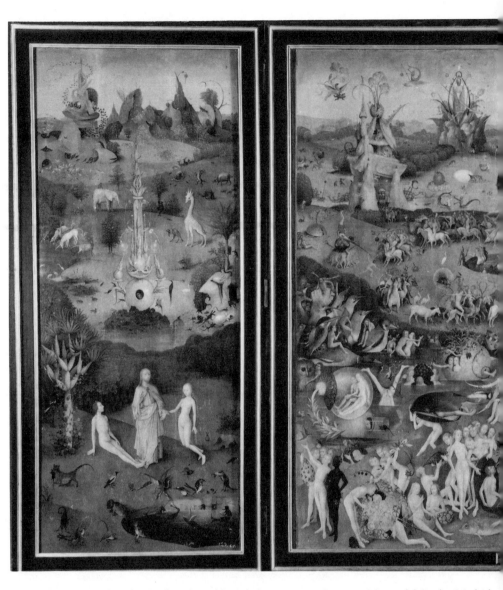

9. Hieronymus Bosch, *The Garden of Earthly Delights,* ca. 1500. Courtesy Museo del Prado, Madrid

chamberlain to the reigning duke, Philip the Handsome.[11] According to Antonio de Beatis, an Italian who traveled in the Netherlands in 1516–1517, the *Garden* hung in the Brussels palace of the counts of Nassau in the

11. See Sir Ernst Gombrich, "The Earliest Description of Bosch's *Garden of Delights,*" *Journal of the Warburg and Courtauld Institutes* 30 (1967): 403–6; also Steppe, "Jheronimus Bosch"; Gerlach, "De Nassauers van Breda en Jeroen Bosch' *Tuin der Lusten,*" in *Jheronimus Bosch,* 171–

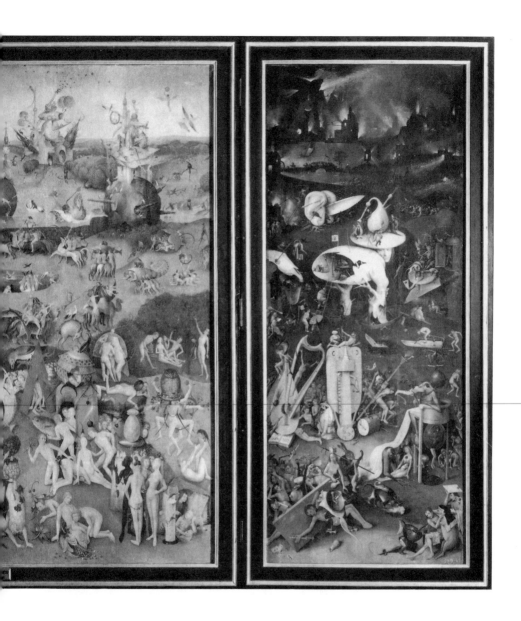

company of a painting representing Hercules and Dejaneira, in which the figures were depicted nude. Ernst Gombrich has plausibly suggested that this painting may be identified with a work by Jan Gossaert which is now in the

86. The following account of Bosch's humanist patrons is by no means complete. Among those with documented humanist interests are Margaret of Austria, regent of the Netherlands, Cardinal Domenico Grimani, and Damiao da Gois, the Antwerp agent of John III of Portugal.

10. Jan Gossaert, *Hercules and Dejaneira*, 1517. Courtesy The Barber Institute of Fine Arts, The University of Birmingham

Barber Institute in Birmingham (ill. 10). Bosch's work was thus included in a collection that had been decisively marked by the humanist taste of the Italian Renaissance.[12] The pictorial conventions, or signs, with which Gossaert has

12. For other aspects of Henry III's interest in the artistic forms of the Italian Renaissance, see R. van Luttervelt, "Renaissance kunst te Breda: Vijf studies," *Nederlands Kunsthistorisch Jaarboek*

constructed this cultural representation are deeply indebted to the Italianizing art of Albrecht Dürer. It was through Dürer's absorption of the canon of anatomical proportions codified in antiquity by Vitruvius and revived in the Renaissance by artists such as Leonardo, that Gossaert could present his figures as representative of the pictorial ideals of humanist culture.[13] Yet the erotic intimacy that characterizes the mythological couple is typical of the way such subjects were handled by Netherlandish artists in the early years of the sixteenth century.[14]

The collection of paintings assembled after the death of Henry III by his third wife, the Spanish princess Mencía de Mendoza was consistent with this kind of aesthetic taste. That is, she included works by Bosch among those executed largely by Italianizing artists. Shortly before her departure for Spain in 1539, the princess instructed her agents to buy at least one work by Bosch, a version of one of his best known paintings, *The Haywain Triptych*.[15] Inventories of her collection taken in 1548 and after her own death in 1554 reveal that several other works ascribed to Bosch were in her possession. Bosch's paintings would thus have formed part of a collection that included Jan Gossaert, Bernard van Orley, Jan Vermeyen, Jan van Scorel and Maarten van Heemskerck—all leading exponents of the Italianizing tendency in Netherlandish painting in this period.[16]

13 (1962): 55–104, 14 (1963): 31–60; and Nicole Dacos, "Tommaso Vincidor: Un élève de Raphael aux Pays-Bas," in *Relations artistiques entre les Pays-Bas et l'Italie à la renaissance: Etudes dédiées à Suzanne Sulzberger* (Brussels: Institut historique belge de Rome, 1980), 61–99.

13. For Gossaert's dependence on Dürer, see Sadja Herzog, "Tradition and Innovation in Gossaert's *Neptune and Amphitrite* and *Danae*," *Bulletin van het Boymans van Beuningen Museum* 19 (1968): 25–41.

14. For the use of mythological subjects in the production of erotic imagery, see G. Denhaene, "Les collections de Philipe de Clèves, le goût pour le nu et la renaissance aux Pays-Bas," *Bulletin de l'Institut historique belge de Rome* 45 (1975): 309–42; Larry Silver and Susan Smith, "Carnal Knowledge: The Late Engravings of Lucas van Leyden," *Nederlands kunsthistorisch jaarboek* 29 (1978): 239–98; Larry Silver, "*Figure nude, historie e poesie*: Jan Gossaert and the Renaissance Nude in the Netherlands," *Nederlands kunsthistorisch jaarboek* 37 (1986): 1–40.

15. J. K. Steppe, "Mencia de Mendoza et ses relations avec Erasme, Gilles de Busleyden, et Jean-Louis Vives," in *Scrinium erasmianum: Mélanges historiques publiés sous le patronage de l'Université de Louvain à l'occassion du cinquième centenaire de la naissance d'Erasme*, ed. J. Coppens, 2 vols. (Leiden: Brill, 1969), 1:449–506.

16. Mencia's art collection is not the only record of her humanist interests. Her library contained many works by ancient authors as well as by the leading humanist intellectual of her own time, Desiderius Erasmus. Mencia was, in addition, a patron of Erasmus's friend, the Spanish humanist Juan Luis Vives, who lived in the Nassau palace at Breda from 1537 until his death in 1540. After her return to Spain, Mencia provided two professorships at the University of Valencia, and her will contains instructions for the foundation of a secondary school in Toledo, in which there were to be professors of Latin, Greek, and Hebrew. See Th. M. Roest van Limburg, *Een Spaansche gravin van Nassau: Mencia de Mendoza, markiezin van Zenete, gravin van Nassau* (Leiden: Sijthoff, 1908).

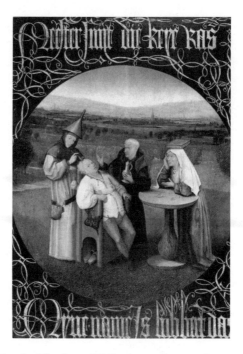

11. Hieronymus Bosch, *The Cure of Folly,* date unknown. Courtesy Museo del Prado, Madrid

Henry III and Mencía de Mendoza appear to have been the rule rather than the exception among those who first collected works by Bosch. A version of *The Cure of Folly* (ill. 11) hung in the dining room of Philip of Burgundy's palace at Duurstede in 1524. Like *The Garden of Earthly Delights,* it shared the walls with three large paintings of nudes, probably representing mythological subjects. J. J. Sterk has proposed that one of these paintings may have been a lost work by Jan Gossaert representing Hercules and Antaeus which is known from a copy now in a private collection in Germany.[17] Philip of Burgundy, an illegitimate son of Philip the Good, duke of Burgundy, had filled important positions of state before becoming bishop of Utrecht in 1517. His humanist interests are well documented. His court poet, Gerrit Geldenhauer, who wrote a biography of Philip, tells us that his patron studied painting and goldsmithery as a youth and that his conversation revealed an intimate knowledge of the work of the ancient theorist Vitruvius. Philip was also the patron of Jan Gossaert, whom he took with him on a diplomatic mission to Rome in 1508. He employed both Gossaert and Jacopo de Barbari, a Venetian painter and theorist, in the decoration of his palace at Souburg. The interest of both of these artists in Italian Renaissance art theory is evident in Gossaert's painting of Neptune and Amphitrite (ill. 12), in which the fig-

17. J. J. Sterk, *Filips van Bourgondie* (Zutphen: Walburg Pers., 1980), 137.

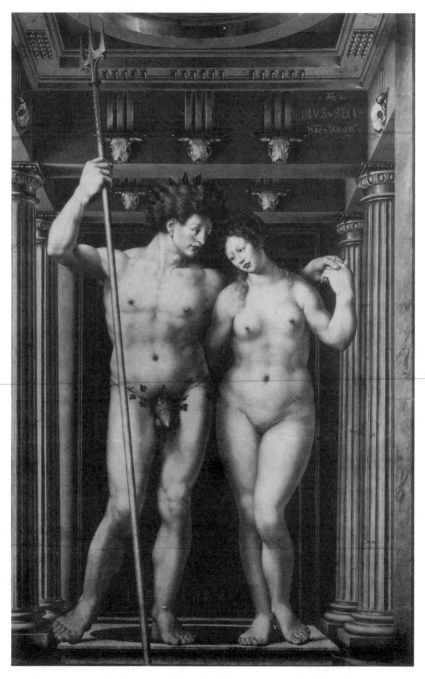

12. Jan Gossaert, *Neptune and Amphitrite,* 1516. Courtesy Staatliche Museen, Berlin

ures are constructed in accordance with the Vitruvian canon of human pro-
portions.[18]

What was it that made Bosch's visual imagery so attractive to a humanist
audience? How did the sign systems that constitute the surface of his works
intersect with the sign systems that organized and structured the humanist
culture of an aristocratic elite? What access do we have to the taste that
enabled this class to appreciate representations of both ideal nudes and the
imaginary world we find in the works of Bosch? My narrative, at this point,
shifts from the analysis of Bosch's patrons to an analysis of the intellectual
culture to which those patrons subscribed. One of the means of obtaining
access to the aesthetic values of Bosch's original audience is to examine their
beliefs about the nature and function of artistic products. Many of their ideas
on such matters must have been shaped by what they knew about the theory
of art, in this case, the humanist theory of the Italian Renaissance. A piece of
art criticism by Antonio de Beatis, whom I mentioned earlier, offers a way
into the topic. As part of his description of a visit to the palace of Henry III of
Nassau, Beatis mentioned a painting that can only be *The Garden of Earthly
Delights:*

> And then there are some panels on which bizarre things have been painted.
> Here seas, skies, woods, meadows, and many other things are represented, such
> as those [figures] that emerge from a shell, others that defecate cranes, men and
> women, whites and blacks in different activities and poses. Birds, animals of all
> kinds, executed very naturally, things that are so delightful and fantastic that it
> is impossible to describe them properly to those who have not seen them.[19]

It is remarkable that Beatis should have ignored any possible symbolic mean-
ing for Bosch's visual motifs, any allegorical significance of the work, empha-
sizing, instead, the powers of invention and fantasy. Most telling of all is his
admission that he cannot find words to describe the painting adequately to
those who have not seen it themselves. By remarking on the differences
between visual and linguistic signification, Beatis suggests how Bosch's picto-
rial signs establish the singularity of their author.

The notion of fantasy, already mentioned by Beatis, becomes central in the
account written by a Spanish scholar at the beginning of the seventeenth
century. Drawing an elaborate analogy between poetic and artistic creation
based on Horace's dictum *ut pictura poesis* (as in painting, so in poetry), José
de Siguenza maintained that Bosch had distinguished himself from his great
contemporaries Dürer, Michelangelo, and Raphael by means of the strategy

18. See Herzog, "Tradition and Innovation"; also, J. Duverger, "Jacopo de Barbari en Jan
Gossaert bij Filips van Burgondie te Souburg (1516)," *Melanges Hulin de Loo,* ed. P. Bergmans
(Brussels: Librairie nationale d'art et d'histoire, 1931), 142–53.

19. Beatis, quoted in Gombrich, "Earliest Description," 404, my translation.

adopted by Teofilo Folengo, the "macaronic" (or satiric) poet of the Italian Renaissance.[20] According to Siguenza, Folengo had created a highly personal, idiosyncratic style in order to set himself apart from his great predecessors Virgil, Terence, Seneca, and Horace:

> Hieronymus Bosch certainly wished to resemble this poet, not because he knew him (for, as I believe, he painted his fantasies before him), but because the same thinking and the same motive impelled him: he knew that he had great gifts for painting and that in regard to a large part of his works he had been considered a painter who ranked below Dürer, Michelangelo, Raphael (Urbino) and others, and so he struck out on a new road, on which he left all others behind him, and turned his eye on everything: a style of painting satirical and macaronic, devoting much skill and many curiosities to his fantasies, both in innovation and execution and often proved how able he was in his art . . . when he spoke seriously.[21]

The value attached to fantasy in the criticism of Beatis and Siguenza, together with Siguenza's justification by means of the notion of *ut pictura poesis,* is characteristic of Italian Renaissance art theory of the fifteenth and sixteenth centuries. Beginning with Cennino Cennini's *Libro dell'arte* of about 1400, Italian art theorists had extolled the values of fantasy and artistic license as a means of exalting the artist. Cennini claims that painting "deserves to be placed in the next rank to science and to be crowned with poetry. The justice lies in this: that the poet is free to compose and bind together or not as he pleases, according to his will. In the same way the painter is given freedom to compose a figure standing, sitting, half man, half horse, as it pleases him, following his *fantasia.*"[22] Undoubtedly the greatest claims for the importance of fantasy in artistic creation were made by Leonardo da Vinci. An aspect of his thinking on the subject is found in his equation of fantasy and reason in a personal adaptation of Aristotelian faculty psychology. According to Aristotle, whose views had dominated psychological theory during

20. For Folengo and his poetry, see William Schupbach, "Doctor Parma's Medicinal Macaronic: Poem by Bartolotti, Pictures by Giorgione and Titian," *Journal of the Warburg and Courtauld Institutes* 41 (1978): 147–91.

21. José de Siguenza, *Tercera parte de la historia de la orden de S. Geronimo* (Madrid, 1605), quoted by Charles de Tolnay, *Hieronymus Bosch* (Baden-Baden: Holle, 1966), 402.

22. Quoted in Martin Kemp, "From 'Mimesis' to 'Fantasia': The Quattrocento Vocabulary of Creation, Inspiration, and Genius in the Visual Arts," *Viator* 8 (1977): 368. See also Jean Hagstrum, *The Sister Arts: The Tradition of Literary Pictorialism in English Poetry from Dryden to Gray* (Chicago: University of Chicago Press, 1958), 55; and David Summers, *Michelangelo and the Language of Art* (Princeton: Princeton University Press, 1981), 133. For the role of art theory in the establishment of the "autonomy" of art, see Michael Müller, "Künstlerische und materielle Produktion: Zur Autonomie der Kunst in der italienischen Renaissance," in *Autonomie der Kunst: Zur Genese und Kritik einer bürgerlichen Kategorie,* ed. Gunther Busch (Frankfurt-am-Main: Suhrkamp, 1972), 9–87, 24.

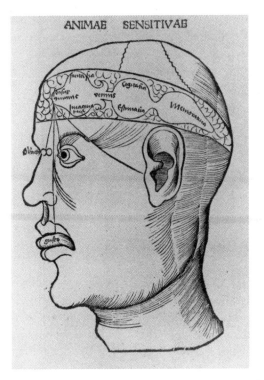

ANIMAE SENSITIVAE

13. Anonymous, *Ventricles of the Brain,* woodcut, from Georg Reisch, *Margarita philosophica,* Freiburg, 1503. Reproduced in Martin Kemp, "From 'Mimesis' to 'Fantasia': The Quattrocento Vocabulary of Creation, Inspiration, and Genius in the Visual Arts," *Viator* 8 (1977), 347–98, fig. 4. Reprinted with permission of the Regents of the University of California

the Middle Ages, fantasy was located in the foremost ventricle of the brain and thus separated from the operations of reason, which were thought to be located in the central ventricle. Aristotle's theory is clearly illustrated in a woodcut from Georg Reisch's encyclopedia, the *Margarita philosophica* (The philosophical pearl), which appeared in Freiburg in 1503 (ill. 13).[23] According to the woodcut, fantasy is located in the foremost ventricle, reason in the central one, and memory in the third ventricle, at the back of the brain. Leonardo, however, in a drawing of about 1489 (ill. 14)—which Martin Kemp identified as an illustration of psychological theory rather than an anatomical study of the skull—placed fantasy in the central ventricle, so that it was linked to reason. In doing so, he associated fantasy with what had tradi-

23. Kemp, "From 'Mimesis' to 'Fantasia,'" 379; idem, "'Il Concetto dell'Anima' in Leonardo's Early Skull Studies," *Journal of the Warburg and Courtauld Institutes* 34 (1971): 115–34; idem, *Leonardo da Vinci: The Marvellous Works of Nature and Man* (Cambridge: Harvard University Press, 1981), 125–27.

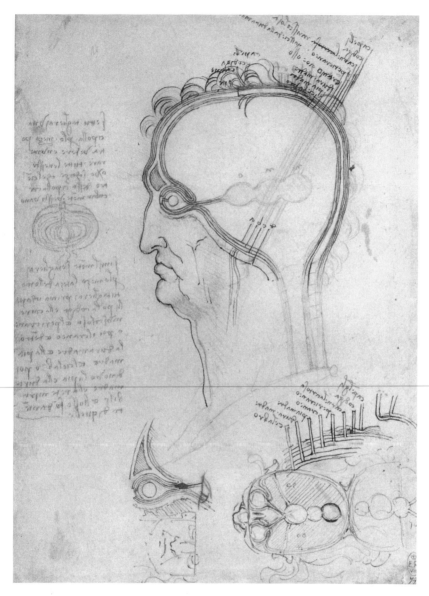

14. Leonardo da Vinci, *Ventricles of the Brain,* ca. 1489, drawing. Courtesy The Royal Library, Windsor Castle

tionally been regarded as the most privileged activity of the brain. Leonardo's view of the importance of fantasy was accompanied by extraordinary claims for artistic license, which had profound implications for the social status of the artist. He wrote, for example, "The divinity which is in the science of painting transmutes itself into a resemblance of the divine mind in such a

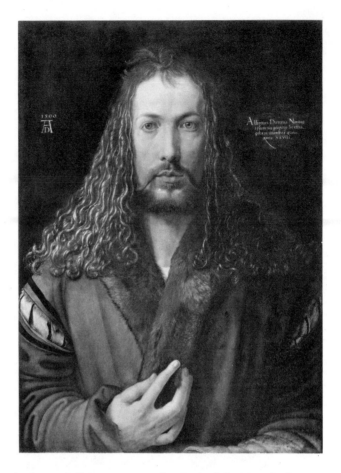

15. Albrecht Dürer, *Self-Portrait,* 1500. Alte Pinakothek, Munich. Courtesy Bayerische Stattsgemäldesammlungen, Munich

manner that it discourses with free power concerning the generation of the diverse essences of various plants, animals and so on."[24]

An awareness of the importance humanist art theory ascribed to fantasy as the basis for artistic license was not confined to Italy. Both patrons and artists north of the Alps appear to have recognized that its implications had the potential to transform their relationship. Its importance can also be demonstrated in the career of Bosch's contemporary, Albrecht Dürer. Dürer, whose theoretical writings and artistic practice are both deeply indebted to Leonardo, seems to have been aware of the Italian's claims about the divine nature of artistic creation. While his *Self-Portrait* of 1500 (ill. 15), whose format is thought to have been derived from fifteenth-century representations of the "Holy Face" of Christ (ill. 16), may have made reference to the notion of the

24. Kemp, "From 'Mimesis' to 'Fantasia,'" 383.

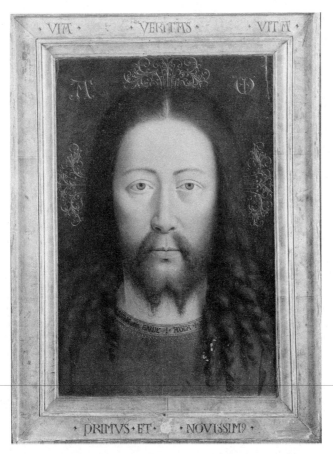

16. Jan van Eyck (copy), *Holy Face of Christ,* 15th c. Alte Pinakothek, Munich. Courtesy Bayerische Staatsegemäldesammlungen, Munich

imitatio Christi (imitation of Christ), it may also be regarded as a self-conscious assertion of the analogy between divine and artistic creation.[25] In a draft of the introduction to his treatise on painting, written in 1512, Dürer wrote:

> Many centuries ago the great art of painting was held in high honour by mighty kings, and they made excellent artists rich and held them worthy, accounting such inventiveness a creating power like God's. For the imagination of the good painter is full of figures, and were it possible for him to live forever he

25. Erwin Panofsky, *The Life and Art of Albrecht Dürer* (Princeton: Princeton University Press, 1955), 43; also, Milton Nahm, "The Theological Background of the Theory of the Artist as Creator," *Journal of the History of Ideas* 8 (1947): 362–72; Joseph Koerner, "Albrecht Dürer and the Moment of Self-Portraiture," *Daphnis* 15 (1986): 409–39, and *The Moment of Self Portraiture in German Renaissance Art* (Chicago: University of Chicago Press, 1993).

would always have from his inward "ideas," whereof Plato speaks, something
new to set forth by the work of his hand.[26]

In this passage Dürer explicitly equates the divinelike quality of artistic cre-
ation with the need for social recognition. The situation that existed in the
past, the honor paid to artists by royalty, is clearly invoked as a model for the
present.

Another artist working in Germany (before his journey to the Nether-
lands), the Venetian Jacopo de Barbari, composed an appeal to his patron
Frederick the Wise of Saxony for the recognition of painting as the eighth
liberal art.[27] Barbari argued that far from being a mechanical art, painting
presupposed a knowledge of all the other liberal arts. In addition, the artist
not only imitated nature but had the capacity to reproduce nature, a creative
activity without parallel among the rest of the arts.[28] He concludes:

> From which most illustrious prince, elector of the Roman Empire, you can con-
> template in these few precepts the excellence of painting which, in an inani-
> mate nature, makes visible that which nature creates as palpable and visible.
> And one can deservedly seat painting among the liberal arts, as the most impor-
> tant of them. For when men have investigated the nature of things in their
> number and in their character, they still have not been able to create them.
> It is to this creation that painting is so suited that it deserves its freedom.[29]

It would appear that Barbari expressed such views wherever he went. After
leaving Germany, he worked first for Philip of Burgundy (1509) and later for
Margaret of Austria, regent of the Netherlands. J. J. Sterk has discerned
Barbari's teaching in a Latin poem in praise of painting written in 1515 by
Philip's court poet and biographer, Gerrit Geldenhauer. The poet praises the
painter for his ability to reproduce nature, as well as to create naturalistic
depictions of historical and mythological narratives. Like Barbari, Gelden-
hauer suggests that these qualities deserve the recognition of rulers.[30] The
career of Jacopo de Barbari thus enables us to reconstruct at least one avenue
by which new humanist ideas concerning the artistic license of the artist and

26. William Martin Conway, *The Writings of Albrecht Dürer* (New York: Philosophical Li-
brary, 1958), 177.

27. Paul Stirn, "Friedrich die Weise und Jacopo de Barbari," *Jahrbuch der preussischen
Kunstsammlungen Berlin* (1925), 130–34. For Barbari's restless career, see André de Hevesy, *Jacopo
de Barbari: Le maître au caducée* (Paris: Librairie Nationale d'art et d'histoire, 1925); and Luigi
Servolini, *Jacopo de Barbari* (Padua: Le Tre Venezie, 1944).

28. For the history of the idea of *natura naturans* in the Renaissance, see Jan Białostocki, "The
Renaissance Concept of Nature and Antiquity," *Acts of the Twentieth International Congress of the
History of Art*, 2 vols. (Princeton: Princeton University Press, 1963), 19–30.

29. Quoted in Sterk, *Filips van Bourgondie*, 180 n. 40, my translation.

30. Ibid., 111.

their implications for his status, first developed in fifteenth-century Italy, were
disseminated among artists and patrons living in the Netherlands.

The realization that notions of fantasy and artistic license played a role in
the aesthetic values of the humanistic elite for which Bosch worked does not
immediately help us understand the significance his art had for them. After
all, the rising importance of the notion of fantasy in Renaissance art theory
was not directly related to the development of nonmimetic imagery of the
kind we associate with Hieronymus Bosch. The role of fantasy in artistic
creation as envisioned by Leonardo and Dürer, for example, had nothing to
do with departing from the principles of mimesis. Fantasy enabled the artist
to depart from nature, in the sense of reproducing or creating nature, rather
than to neglect or defy it. Although fantasy and mimesis were regarded as
completely congruent concepts, however, fantasy could also be invoked to
account for imagery that deliberately broke the rules of resemblance.[31] Inter-
estingly enough, such justifications of nonmimetic imagery were also under-
taken in terms of *ut pictura poesis*. For example, the popularity in Renaissance
Italy of "grotesques," the nonmimetic decorative ornaments based on Roman
wall decorations discovered during the excavation of the Golden House of
Nero in the late fifteenth century, was justified in terms of artistic license.[32]
An engraving by the anonymous Italian Master of the Die (ill. 17), dating
from the early sixteenth century, is accompanied by the following text:

> Poet and Painter as companions meet
> Because their strivings have a common passion
> As you can see expressed in this sheet
> Adorned with friezes in this skilful fashion.
>
> Of this, Rome can the best examples give
> Rome toward which all subtle minds are leading
> When now from grottoes where no people live
> So much new light of this fine art is spreading.[33]

When the subject of the new fashion for grotesques was raised during Fran-
cisco de Holanda's discussions with Michelangelo, the artist is said to have
defended them by expressly quoting Horace:

> In this sentence he [Horace] does in no way blame painters but praises and fa-
> vours them since he says that poets and painters have license to dare to do, I

31. See Murray W. Bundy, *The Theory of the Imagination in Classical and Medieval Thought*
(Urbana: University of Illinois Press, 1927), 114–16.

32. For the history of this fad, see Nicole Dacos, *La découverte de la Domus Aurea et la
formation des grotesques à la renaissance* (London: Warburg Institute, 1969).

33. Translated from the Italian by Ernst Gombrich, *The Sense of Order: A Study of the
Psychology of Decorative Art* (Ithaca: Cornell University Press, 1979), 280.

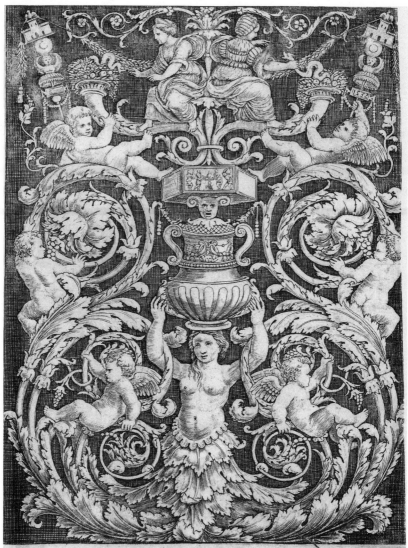

Il poeta el pittor Vanno di pare
Et tra il lor ardire tutto ad un fegno
Si come efpreffo in quefte carte appare
Fregiare dopre & dartificio degno

Di quefto Roma ci puo effempio dare
Roma ricetto dogni chiaro ingegno
Da le cui grotte oue mai non faggior
Hor tanta luce afi bella arte torna

17. Master of the Die, *Grotesque Ornament*, 1532, engraving.
The Metropolitan Museum of Art, New York

say to dare . . . what they choose. And this insight and power they have always had; for whenever (as rarely happens) a painter makes a work that seems false and deceitful, . . . this falseness is truth; and greater truth in that place would be a lie. For he will not paint a man's hand with ten fingers, nor paint a horse with the ears of a bull or a camel's hump; nor will he paint the foot of an elephant with the same feeling . . . as the foot of a horse, nor the arm or face of a child like those of an old man; nor an eye nor an ear even half an inch out of its proper place; nor even the hidden vein of an arm may he place where he will; for all such things are false. But if, in order to observe what is proper

to a time and place, . . . he change . . . the parts of limbs (as in grotesque work, . . . which would otherwise be without grace and most false) and convert a griffin or a deer downward into a dolphin or upward into any shape he may choose, putting wings in the place of arms, and cutting away the arms as if wings are better, this converted limb, of lion or horse or bird will be most perfect according to its kind . . . ; and this may seem false but can really only be called well invented or monstrous. . . . And sometimes it is more in accordance with reason to paint a monstrosity (for the variation and relaxation of the sense and in respect of mortal eyes, that sometimes desire to see that which they never see and think cannot exist) rather than the accustomed figure (admirable though it be) of men and animals.[34]

What is important in this discussion of the justification of the fashion for grotesques in terms of *ut pictura poesis* is not the grotesques themselves, since there is little likelihood that Bosch could have known them and they bear no resemblance to his own pictorial forms. The importance lies, rather, in the justification of a nonmimetic tradition of representation in terms of the artist's license, his right to the untrammeled exercise of his fantasy.

The inspiration for Bosch's development of his own nonmimetic vocabulary would appear to lie in the fantastic forms traditionally used in the decoration of ecclesiastical architecture and furniture, objects of decorative art, and the margins of illuminated manuscripts. Before suggesting some of the ways in which Bosch may have used these forms to his own ends, we must first of all ask what their original function and significance were within the cultural and social context in which they were produced. The apparent frivolity of these imaginative forms, which seem to bear no relation to the religious function of the buildings, objects, and books in which they are so often found, proved deeply offensive to medieval moralists. The well-known letter of Saint Bernard of Clairvaux, written in the twelfth century, affords us an account of their "beautiful depravity," while condemning them as useless fancies:

34. Quoted in Summers, *Michelangelo,* 135–36. I have eliminated his quotations of the original Portuguese.

18. Anonymous, "Men Defending Castle against Hares," *Metz Pontifical,* Flemish, early 14th c., mss. 298, f. 41. Courtesy Fitzwilliam Museum, Cambridge

But in the cloister, before the eyes of penitent brethren, what is that ridiculous pageant of monstrosities, that beauty of ugliness doing? What place is there for dirty monkeys, for ferocious lions, for monstrous centaurs, for half-men, for spotted tigers, for fighting soldiers, for huntsmen winding their horns? You may see there a number of bodies with a single head, or again many heads upon a single body. Here a four footed beast is seen with a serpent's tail, there the head of a quadruped upon a fish. Here a beast whose forepart is a horse and it drags half a goat after it: there is a horned creature with the hind quarters of a horse. So copious, in short, and so strange a variety of diverse forms is to be seen that it is more attractive to peruse the marbles than the books, and to spend the whole day gazing at them rather than meditating on the law of God. In God's name! if men are not ashamed of the folly of it, why do they not at least smart at the thought of the cost?[35]

Scholars of illuminated manuscripts, the art form from which, as we shall see, it is most likely that Bosch derived his ideas, have proposed that these motifs often constituted a satirical or entertaining form of humor.[36] Many of the themes depend upon the notion of the world upside-down. They satirize classes, occupations, and the sexes by inverting the relationships in which they usually stand in society. Among the favorite targets of the illuminators are the aristocracy and the clergy. Chivalric ideals, for example, are disparaged when knights are shown attacked by hares (ill. 18), and the clergy is mocked when

35. M. R. James, "Pictor in Carmine," *Archaeologia, or Miscellaneous Tracts relating to Antiquity* 94 (1951): 141–66, 145. See also Meyer Schapiro, "On the Aesthetic Attitude in Romanesque Art" (1947), in *Romanesque Art* (New York: G. Braziller, 1976), 1–27.

36. See H. W. Janson, *Apes and Ape Lore in the Middle Ages and the Renaissance* (London: Warburg Institute, University of London, 1952); Rosy Schilling, "Drolerie," in Otto Schmidt ed., *Reallexicon zur deutschen Kunstgeschichte* (Stuttgart: Alfred Druckenmüller, 1959), vol. 4,

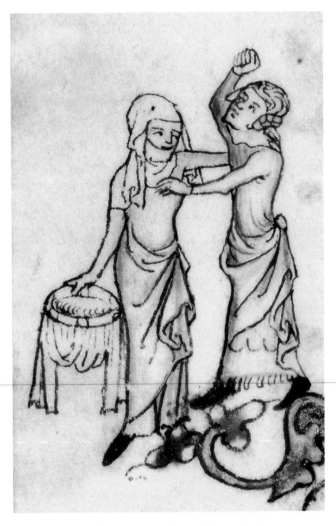

19. Anonymous, "Battle for the Pants," *Voeux du Paon,* Franco-Flemish, mid-14th c., Glazier ms. 24, f. 30v, Courtesy The Pierpont Morgan Library, New York

its ecclesiastical functions are performed by apes. Alternatively, knights are defeated by women in jousts and clerics are seduced by nuns. Dominant women are frequently satirized in representations of marital strife: one of the favorite themes being the "battle for the pants," which, then as now, seemed to metaphorize the issue of gendered authority in marriage (ill. 19). Other

cols. 567–88; Jurgis Baltrusaitis, *Reveils et prodigues: Le gothique fantastique* (Paris: S. Colin, 1960); Lillian Randall, *Images in the Margins of Gothic Manuscripts* (Berkeley: University of

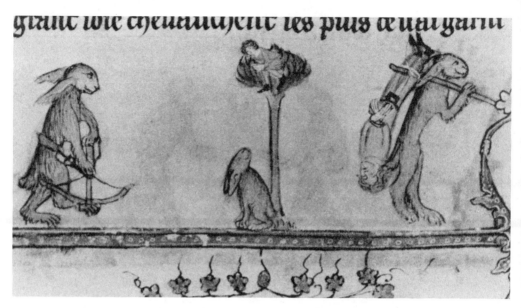

græne luie cheuauicheiit les puis de uat gariu

20. Anonymous, "Man Hunted by Hare," *Romance of Alexander,* 14th c., ms. Bodl. 264, f. 81v detail. Bodleian Library, Oxford. Reproduced from Lillian Randall, *Images in the Margins of Gothic Manuscripts* (Berkeley: University of California Press, 1966), fig. 356

images are more entertaining than satiric and depend on the inversion of relationships in nature. In such scenes, rabbits execute dogs or hunt human prey (ill. 20).[37] An important dimension of this marginal imagery is made up of monsters or hybrids composed of various combinations of human and animal forms.[38] Such monsters are comic because they mimic forms

California Press, 1966); Gerhard Schmidt, "'Belehrender' und 'befreiender' Humor: Ein Versuch uber die Funktionen des Komischen in der bildende Kunst des Mittelalters," in *Worüber Lacht das Publikum im Theater? Spass und Betroffenheit—Eins und Heute: Festschrift zum 90. Geburtstag von Heinz Kindermann,* ed. Margret Dietrich (Vienna: Hermann Böhlaus Nachfolge, 1984), 9–39. For an opposing point of view, that marginal illustrations are usually related in some didactically meaningful way to the texts with which they are associated, see D. K. Davenport, "Illustrations Direct and Oblique in the Margins of an Alexander Romance at Oxford," *Journal of the Warburg and Courtauld Institutes* 34 (1971): 83–95. Like Davenport, Michael Camille has recently approached marginal imagery on the assumption that it is related to texts. This relationship, however, is conceived of as multifaceted and not confined to moral comment. See *Images on the Edge: The Margins of Medieval Art* (Cambridge: Harvard University Press, 1992). I am grateful to Jonathan Alexander and Lucy Sandler for useful suggestions and help with bibliography.

37. For an interpretation of this scene as a reference to a passage in the "life" of Alexander the Great recounted in the manuscript it illustrates, see Davenport, "Illustrations Direct and Oblique," 90–91.

38. See Lucy Freeman Sandler, "Reflections on the Construction of Hybrids in English

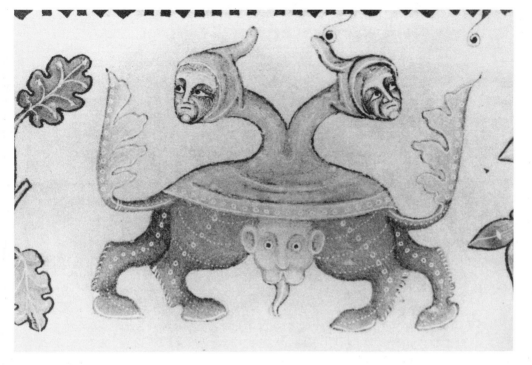

21. Anonymous, "Double-headed Monster," *Luttrell Psalter,* early 14th c., ms. Add 42130, f. 211. British Museum, London. Reproduced from Eric Millar, *The Luttrell Psalter* (London: British Museum, 1932), fig. 151b

of human activity or exploit the limitations of their own curious forms (ill. 21).

Bosch, in all likelihood, had personal knowledge of the fantastic imagery of the manuscript margins. Not only have direct borrowings from manuscripts been documented in his work, but recent scholarship suggests that he was trained as a manuscript illuminator rather than as a panel painter.[39] Far from suggesting that Bosch appropriated the images of the manuscript margins to create his own images, however, as had previously been claimed, I believe that Bosch transformed the earlier tradition by imaginatively reworking its principles on the basis of *ut pictura poesis.* It is my argument that Bosch used the satirical and entertainment value of the notion of the world upside-down, as

Gothic Marginal Illustration," in *Art, the Ape of Nature: Studies in Honor of H. W. Janson,* ed. Moshe Barasch and Sandler (New York: H. N. Abrams, 1981), 51–65.

39. Frederic Lyna, "De Jean Pucelle à Jérôme Bosch," *Scriptorium* 17 (1963): 310–13; Suzanne Sulzberger, "Jérome Bôsch et les maîtres de l'enluminure," *Scriptorium* 16 (1962): 46–49; Walter Gibson, "Hieronymus Bosch and the Dutch Tradition," in *Album amicorum J. G. van Gelder,* ed. J. Bruyn et al. (The Hague: Nijhoff, 1973), 128–31.

well as fabricated monsters, in order to demonstrate the humanist artist's new claim to artistic freedom.[40]

An example of his use of the principle of inversion, in this case one that is well known in the manuscript margins, is the reversal of natural relations of scale. In the landscape of the central panel of *The Garden of Earthly Delights*, humans are often dwarfed by birds and animals as well as by fruits and other vegetation. The magnificent, brilliantly hued birds in the pool in the middle distance are many times the size of the humans who ride on their backs.[41] Not only are the birds larger than human beings, but the inversion of the usual relationship is dramatized in that here, birds feed humans, rather than vice versa. The intense naturalism that characterizes Bosch's depiction of these birds may also have its sources in the manuscript margins. During the fifteenth century, the satiric and humorous nonmimetic world of the manuscript margins was transformed by the introduction of trompe l'oeil borders, in which the manuscript text was surrounded by meticulously described objects from the real world.[42] While the earlier traditions did not entirely die out, the borders were increasingly filled with illusionistic representations of flowers, jewels, peacock feathers, and other precious objects. Fruits, like birds, also find their relation to humans dramatically altered. Giant raspberries, strawberries, and cherries, painted with a marked attention to their luscious shapes and glossy surfaces, offer sumptuous feasts to groups of human beings. The delectable appearance of the fruits and their effect on the people that populate the landscape, many of whom feed off them voraciously, add to the air of sensual abandon that characterizes the scene.

It would appear that Bosch's appreciation of the subversive potential of these world upside-down reversals—the possibility, for example, of using inversions of scale to marginalize the activities of humans by centralizing the presence of birds and fruit, thus suggesting that humans are captive to their sensual desires—enabled him to extend the principle so as to organize certain sections of the composition and even to plan the central panel as a whole. Walter Gibson, for example, has proposed that the beautiful nude young women who occupy the pool in the center of the central panel (ill. 22), and who are comely enough to have attracted the attention of a cavalcade of gesticulating male riders, might be a reference to the misogynist idea of the

40. The connection between the world upside-down of the manuscript margins and Bosch's *Garden of Earthly Delights* has been noted by Gloria Vallese, "Follia e mondo alla rovescia nel *Giardino delle Delizie* di Bosch," *Paragone*, n.s. 38 (1987): 3–22. The author does not link Bosch's use of the principle to *ut pictura poesis*. I thank Christopher Johns for this reference.

41. Vallese, "Follia e mondo," 13, has pointed out that Bosch's birds are in the water while the sky is filled with flying fish.

42. See John Plummer, *The Hours of Catherine of Cleves* (New York: G. Braziller, 1966).

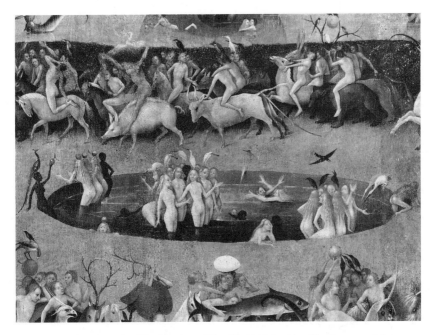

22. Hieronymus Bosch, *The Garden of Earthly Delights* (detail). Courtesy Museo del Prado, Madrid

"power of women," according to which women were held responsible for male lust.[43] This popular idea is more clearly enunciated in an allegory by an anonymous German engraver dating from the middle of the fifteenth century (ill. 23). A banderole above the woman's head reads:

I ride a donkey whenever I want
A cuckoo is my lure
With it I catch many fools and monkeys.[44]

The sense of the image depends on the equation of lust and folly, for the German words *Esel* for donkey, *Gauch* for cuckoo, and *Affe* for ape all carried

43. Gibson, *Bosch* (cited in note 3), 85. For the "power of women" theme, see Friedrich Maurer, "Der *Topos* von den Minnesklaven: Zur Geschichte eine thematischen Gemeinschaft zwischen bildende Kunst und Dichtung im Mittelalter," *Deutsche Vierteljahrschrift für Literatur-wissenschaft und Geistesgeschichte* 27 (1953): 182–206; Susan Smith, "To Woman's Wiles I Fell: The Power of Women *Topos* and the Development of Medieval Secular Art" (Ph.D. diss., University of Pennsylvania, 1978).

44. This translation is from A. Hyatt Mayor, ed., *Late Gothic Engravings of Germany and the Netherlands: 682 Copperplates from the "Kritischer Katalog" of Max Lehrs* (New York: Dover, 1969), 343 n. 30.

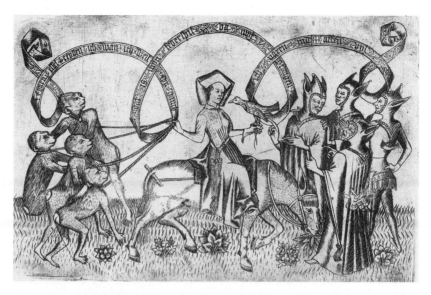

23. Master of the Power of Women, *Allegory of the Power of Women*, ca. 1450, engraving. Courtesy Bayerische Staatsbibliothek, Munich

the secondary connotation "fool." The significance of this equation carried special moral opprobrium in an age when the concept of folly was closely linked with that of sin. The "power of women" idea may also be contained in one of the most striking images of the central panel, the couple encased in a bubble (ill. 24). The woman is the most prominent of the nude pair, not only on account of her placement and size but because of the pallor of her skin. She appears as the lure that has attracted the attentions of the man beside her. While comment on the transitory and evanescent nature of sexual pleasure may be found in the fragility of the bubble in which the scene unfolds, it also seems to be implied by the nude figure standing on his head immediately to the right. This figure, whose gesture serves to display rather than to hide his genitals, may, as we have seen, constitute a graphic reference to the idea of the world upside-down.

Gibson also noted how the springtime loveliness of the central panel echoes literary and pictorial representations of the "Garden of Love"—a theme whose inspiration lay in the literary tradition initiated by the *Roman de la Rose*.[45] The characterization of this garden of sensual delectation contrasts markedly to the sober mood of the garden of paradise in the left wing, to

45. Walter Gibson, "*The Garden of Earthly Delights* by Hieronymus Bosch: The Iconography of the Central Panel," *Nederlands kunsthistorisch jaarboek* 24 (1973): 1–26, 9.

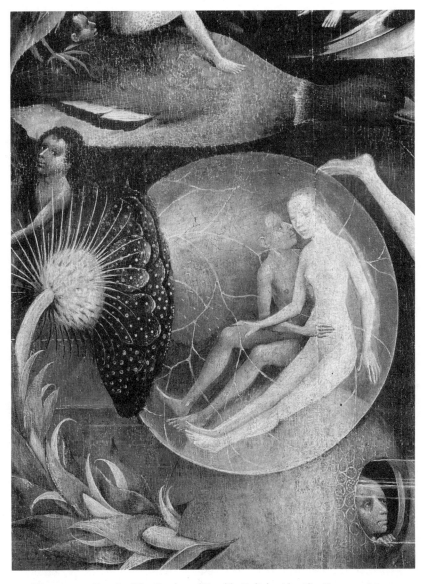

24. Hieronymus Bosch, *The Garden of Earthly Delights* (detail). Courtesy Museo del Prado, Madrid

which it bears a striking resemblance. Both landscapes, for example, have a fountain at the center from which four channels of water flow. Their structural similarity appears deliberately ironic, for the significance of the biblical story in one directly contradicts the sensual abandon of the other. In one the

marriage of Adam and Eve is enacted for the sole purpose of human procreation; in the other sexual ecstasy takes place in the absence of children.[46] This interpretation gains strength when it is associated with an incident taking place at the center of the fountain in the central panel (ill. 25), in which a man touches a woman suggestively, while another woman bends down so as to present her buttocks to the spectator. This scene takes place in the vicinity of a nude man standing on his head. The use of this pose to convey the idea of the world upside-down is not unknown in this period. A German engraver called the Housebook Master, who worked on the Middle Rhine in the third quarter of the fifteenth century, used just such a figure at the center of a parodic coat of arms (ill. 26), whose crest illustrates the theme of the hen-pecked husband.[47] Such themes, a commonplace of late medieval art, constitute a satire of sexual relations in which the "natural" hierarchy of male domination was not observed. The juxtaposition of this figure to the sexually explicit group at the center of the fountain suggests that such activities are to be condemned and rejected.

The right wing and its hell scene offer another series of inversions. Here, musical instruments, usually a source of entertainment and sensual enjoyment, are transformed into instruments of torture (ill. 27). One figure is stretched across the strings of an enormous harp, while others are forced into choral singing led by a monster who reads music that has been tattooed on the backside of one of the unfortunates in his power. Another figure, imprisoned in a drum, is deafened by the monster who beats it, while a third, tied to a flute, has had another flute inserted in his anus. In the foreground a pretty young woman is offered an image of herself in a mirror supported on a monster's behind—the vain satisfaction she may have taken from her reflection being sabotaged not only by its source but by the amorous attentions of a hideous black monster who fulfills the role of a male lover. Finally, a scene that not only manifests the principle of inversion but almost quotes the imagery of the manuscript margins: striding across the foreground is a hare blowing a hunting horn and bearing a human being on the spear he carries over his shoulder.[48]

What are the implications of Bosch's choice of the manuscript margins and the inversions of the world upside-down for the cultural context in which he worked? By making use of the traditions of manuscript illumination, Bosch turned to an art form that had traditionally been associated with the aristocra-

46. Ibid., 16–18.

47. See Jan Piet Filedt Kok, ed., *Livelier than Life: The Master of the Amsterdam Cabinet or the Housebook Master,* exhibition catalogue (Amsterdam, Rijksmuseum, 1985), cat. no. 89.

48. See Isabel Mateo Gomez, "El conejo cazador del *Jardín de las delicias* de Bosco en una miniatura del siglo XIV," *Archivo español de arte* 45 (1972): 166–67.

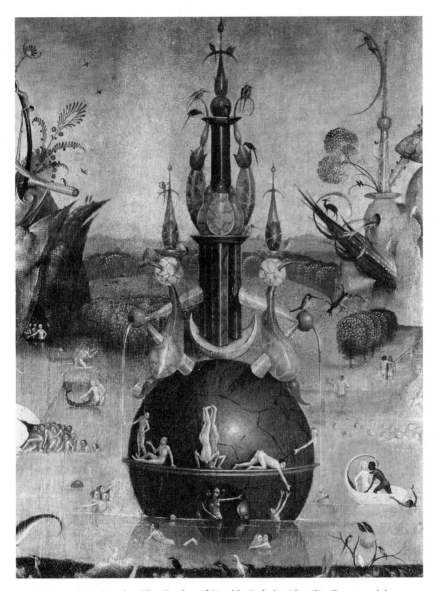

25. Hieronymus Bosch, *The Garden of Earthly Delights* (detail). Courtesy Museo del Prado, Madrid

cy. In the Middle Ages no other social group could undertake the enormous expense involved in the production of these sumptuous objects of display. It is perhaps not irrelevant to my discussion that Engelbert II of Nassau, father of Henry III, who, as we have seen, was in all likelihood the first owner of *The Garden of Earthly Delights,* should have collected these precious books and

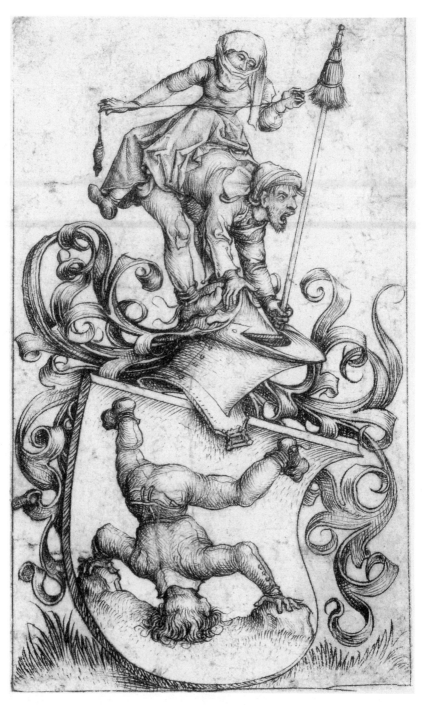

26. The Housebook Master, *Parodic Coat of Arms,* ca. 1485–90, engraving.
Courtesy Rijksprentenkabinet, Rijksmuseum, Amsterdam

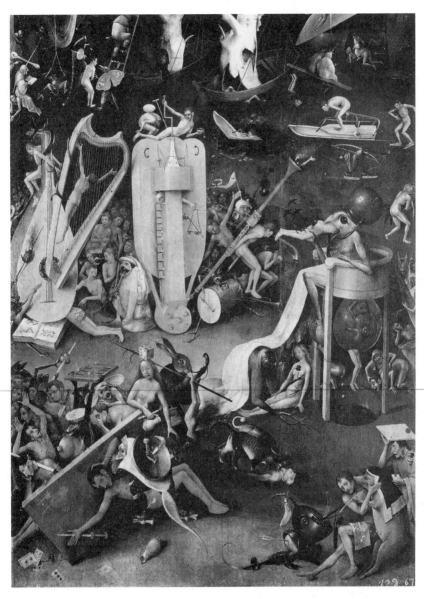

27. Hieronymus Bosch, *The Garden of Earthly Delights* (detail). Courtesy Museo del Prado, Madrid

have commissioned one of the most spectacular examples produced in the fifteenth century.[49] It is significant that it should have been in an aristocratic milieu that the satirical humor of the world upside-down flourished. As anthropologists and historians have so often pointed out, the social function of this carnivalesque theme is to demonstrate the need for order.[50] The satire of chivalric attitudes or of the role of the clergy could take place only in a context in which such questioning did not constitute a real challenge to the status quo. Indeed, it could be argued that the importance of the manuscript margins in chivalric romances, on the one hand, and missals, psalters, and prayerbooks, on the other, lies in supporting and reinforcing the assumptions of the classes and occupations of those who commissioned them.[51]

As we have seen, there are some aspects of the notion of the world upside-down which may be more effectively conceptualized in terms of a culture/nonculture distinction. The mechanism of turning the world upside-down, of moving the cultural repressed into a position of cultural dominance, sometimes serves to redefine the limits of culture.[52] In Bosch's case, this translation of the topsy-turvy world of the manuscript margins into the center of the image, the transposition of visual themes and motifs whose subversive potential relegated them to the periphery, represented a dramatic expansion of the high culture of his time. The movement from the margins to the center may thus be viewed not only as a momentary aberration whose anomaly serves to reinforce the values of the status quo, but as a means by which high culture could realign its boundaries so as to include motifs that had previously been excluded. This perspective on Bosch's art seems particularly relevant considering the long-lasting effects of his work on Netherlandish painting.[53] It has, for example, been possible to trace a series of artists working in a Boschian vein until well into the third quarter of the sixteenth century, a

49. J. J. Alexander, *The Master of Mary of Burgundy: A Book of Hours for Engelbert of Nassau* (New York: G. Braziller, 1970). For the house of Nassau's collection of illuminated manuscripts, see Anne Korteweg, "De bibliotheek van Willem van Oranje: De handschriften," in *Boeken van en Rond Willem van Oranje,* exhibition catalog (The Hague: Koninklijke Bibliotheek, 1984), 9–39.

50. Victor Turner, *The Ritual Process: Structure and Anti-structure* (Ithaca: Cornell University Press, 1977); Natalie Zemon Davis, *Society and Culture in Early Modern France* (Stanford: Stanford University Press, 1965).

51. For an example, see Michael Camille, "Labouring for the Lord: The Ploughman and the Social Order in the Luttrell Psalter," *Art History* 10 (1987): 423–54.

52. See Chapter 5 and Boris Uspenskii, Juri Lotman, et al., "Theses on the Semiotic Study of Cultures (as Applied to Slavic Texts)," in *Structure of Text and Semiotics of Culture,* ed. Jan van der Eng and Mojmir Grygar (The Hague: Mouton, 1973), 1–28.

53. See Gerd Unverfehrt, *Hieronymus Bosch: Die Rezeption seiner Kunst im frühen 16. Jahrhundert* (Berlin: Gebr. Mann, 1980).

series that includes some of the best-known artists of the period, including
Pieter Bruegel the Elder. In the field of twentieth-century art the appropria-
tion of elements considered beyond the realm of official culture, has been
interpreted as one of the most important strategies of the avant-garde.[54]
Thomas Crow has argued that the artistic elites have repeatedly turned to the
world of popular culture in search of artistic inspiration. He claims that it is
by means of these appropriations, these transformations of nonculture into
culture, that the avant-garde has legitimated its status and function as a source
of cultural production. The analogy between the practice of an artistic van-
guard and that of Hieronymus Bosch is striking. In Bosch's case, it seems that
the transformation of nonculture into culture was the means by which he
could establish himself as a unique and distinctive talent. The appropriation
of the world upside-down was thus part of the process of making "genius."

In moving the world upside-down from the margins to the center, Bosch
did more than make use of a cultural trope that was well known to his
audience. By making inversions the focus of his work, Bosch transformed
nonculture into culture and turned the tables on received notions of the work
of art. Although vestiges of the age-old format of the Last Judgment inform
the organization of *The Garden of Earthly Delights*—its panels offer us a
central scene that represents the earth and the world of human beings be-
tween scenes that represent heaven and hell—its moralizing message about
the need to repent and prepare for the life to come is scrambled by the
imposition of another system, another order, for which there was no prece-
dent. By replacing the Resurrection with a scene of human beings indulging
their sensual appetites, Bosch not only transformed a theological statement
into a moral commentary on sensuality and sexuality but also called attention
to the creative power of the individual artist. The new function of the work is
not only to instruct: animated by the concept of artistic license, it draws
attention to its facture as a manifestation of an unusual and exceptional
artistic talent. Bosch's use of the notion of the world upside-down thus serves
as a metaphor for the rising status aspired to by artists in the Renaissance. By
moving the author of the image from a marginal to a central position, from
one who carried out the instructions of others to one who was directly
involved in the creation of pictorial meaning, Bosch found a means of sug-
gesting that the artist could no longer be regarded as a mere craftsman.

The history of how the values of Renaissance humanism, the class values of
a narrow social elite, transformed the social function of artistic production is

54. Thomas Crow, "Modernism and Mass Culture in the Visual Arts," in *Modernism and
Modernity: The Vancouver Conference Papers,* ed. Benjamin Buchloh, Serge Guilbaut, and David
Solkin (Halifax: Nova Scotia College of Art and Design, 1983), 215–64.

not unrelated to the cultural circumstances of our own time. The historicist ideology created by nineteenth-century idealist philosophy so as to invest the transcendence ascribed to aesthetic value with purpose and meaning no longer dominates the circumstances of artistic production. The Hegelian claim that artistic changes pursue a necessary development, a claim born of a teleological view of history, has largely been abandoned. As a consequence, the modernist myth that attributed stylistic change to a historical imperative has been decisively challenged. The collapse of a motivated history of immanent aesthetic value has led to a questioning of the definition of aesthetic value itself. In this context, the self-referential gestures of the art of Hieronymus Bosch, gestures which have been institutionalized as the means by which aesthetic value may be asserted, have become suspect, and artists increasingly seek ways to integrate their work within broader cultural and social functions. The goal of some of the most progressive tendencies of postmodernism is not to draw attention to the artists so much as to articulate political messages of social importance.[55]

Whether or not the artist can escape commodification in an art market organized on capitalist principles remains uncertain. It is difficult for artists to earn a living from their work in a way that does not call attention to their role as individual creators in a cultural climate that still subscribes to the notion of the artist as genius. Nevertheless, the assertion of the autonomous power of the artist has increasingly been called into question as a legitimate ambition for artistic production. Considerations of this nature enable us to see how the sign systems of the present intersect with those of the past in the creation of new meaning. A historical moment concerned with the dissolution of transcendent notions of creativity enables us to appreciate how this idea was first inscribed in the work of art in the period of the Renaissance.

What are the stakes involved in interpreting *The Garden of Earthly Delights* as a manifestation of the rising aspirations of the Renaissance artist, as opposed to an allegory of the astrological, alchemical, heretical, or folkloric ideas of Bosch's own time? Whereas the allegorical view purports to explain the significance of Bosch's pictorial forms by accounting for his unknowable intentions—that is, they regard the surface of the work as the result of a complex process of symbolization in which Bosch encrypted his meaning behind a layer of baffling pictorial forms—I have argued that his enigmatic forms were the products of fantasy and a way to call attention to the artist's role in the process of artistic creation. Instead of taking for granted that *The Garden of Earthly Delights* is a work of "genius," I have tried to show how "genius" is a socially constructed category. I have attempted to look around

55. This is a theme of several essays in Hal Foster, *Recodings: Art, Spectacle, Cultural Politics* (Seattle: Bay Press, 1985).

the edges of the Boschian enigma in order to see it as part of a broader set of historical issues. Rather than account for its mystery, I have argued that this mystery is a deliberate creation of the artist. At stake in this interpretation is a recognition that Bosch's "genius" is not a precondition to the work of inter- pretation. Indeed, it is only by appreciating the pictorial gestures by which Bosch ensured himself a place in the canon of "great" artists admired by the Burgundian aristocracy and the humanistically educated upper classes that we gain insight into the quality and texture of his intelligence, ambition, and imagination, thus ensuring him a place in the canon of "great" artists we admire today.

In coming to these conclusions, I am aware that I may appear to have offered the reader a methodological paradox. The point of reading *The Garden of Earthly Delights* as a system of signs rather than as a system of symbols depends on the recognition that Bosch's intentions are necessarily unknowable. Yet my interpretation, that the painting's pictorial structure is the product of Bosch's manipulation of the visual codes of his age, may suggest that I lay claim to privileged insight into the artist's motives. Nothing could be further from the truth. Far from assuming access to Bosch's intentions, my interpretation merely assigns Bosch power of agency in the execution of his work. The characterization of *The Garden of Earthly Delights* as a manifestation of the social aspirations of this Renaissance artist depends upon what Foucault would have called an "author function."[56] In other words, the agency ascribed to Bosch is a heuristic device that belongs to the moment of interpretation rather than that of artistic creation. In this instance, the function attributed to Bosch's role as an author results from a desire to replace an immanent notion of aesthetic value with one that is constructed in the light of the cultural values of the present.

56. See Michel Foucault, "What Is an Author," *Language, Counter-Memory, Practice: Selected Essays and Interviews,* ed. Donald Bouchard, trans. Bouchard and Sherry Simon (Ithaca: Cornell University Press, 1977), 113–38.

Index
by Celeste Newbrough

Note: References to illustrations are given as italic page numbers. *The Garden of Earthly Delights* is abbreviated *Garden* throughout.

Aesthetics: elite humanism and, 88, 112, 144–47; Kantian, 37, 67; value of art and, 37–40, 79

Althusser, Louis, 45–46, 49–50

Anatomies of the brain, *124, 125*

Aristotle's theory of fantasy, 123, *124*

Art: aesthetic value in, 37–40, 79; compared with divine creation, 125–28, *127;* "high" and "low," 79–80, 94, 97, 98; as mimesis, 102–3, 110; resemblance theory of representation, 29–31

Art history, 1–3, 13–19, 40, 67; epistemological ground of, 10, 65–66; hidden agendas and, 111; historical or social context of, 8, 15–16, 38–39, 85–86; language and, 6–8, 12; semiotic theory and, 60–61. *See also* History

Artist, 75n; autonomy and intentionality of, 102, 108, 110, 146–47; as "genius," 73–74, 111, 145, 147; humanistic conception of, 56–57; as mad, 58–59; as subject, 51, 52–57. *See also* Authorship

Artistic license, 123, 128, 145, 146

Art market, 39

Art patrons and collectors, 115–20, 122, 141, 144

Authorship, 51, 56, 61, 113–14; and the "author function," 57; biography and, 58–59, 99; as a heuristic device, 58–60. *See also* Artist

Bakhtin, Mikhail, 35–36, 114

Bal, Mieke, 29

Barbari, Jacopo de, 128

Barthes, Roland, 31; on authorship, 51, 56; on the "reality effect," 89–90

Beatis, Antonio de, 122–23

Bennett, Tony, 23

Bernard de Clairvaux, Saint, 131

Biography, 58–59, 99

Bipartite signs or binaries, 10, 31, 34, 35

Bosch, Hieronymus, 111, 113; humanist conception of, 112; illuminated manuscripts and, 132, 135–36, 140–44; patrons and collectors of, 115–22, 144; use of inversion, 132–45, *137, 139, 141, 143;* works cited, 112

— *The Cure of Folly,* 112, 120, *120*

— *The Garden of Earthly Delights,* 115–16, *116–17,* 120, 122, 136–41, *137, 139, 141, 143,* 144–47

— *The Haywain Triptych,* 112, *119*

Brain, anatomies of, *124, 125*

Breugel, Pieter, 145

Bryson, Norman, 4–5, 29, 30–31

Burgkmair, Hans, the Elder, 101

Canonical works, 39–40, 79, 96, 147; concept of the canon, 39n, 40

Cennini, Cennino, 123

Certeau, Michel de, 111

Chaos. *See* "Nonculture"

Christie, John, 59–60

Class, 91, 112. *See also* Elite humanism

Coat of Arms, parodic, 140, *142, 143*

"Collective awareness," 37–38

Collectors, art, 115–20, 122, 141, 144
Conservatism, educational, 17, 25
Critical theory, 24, 59–60
Crow, Thomas, 145
Cultural heterogeneity, 67
Cultural knowledge, 13–19, 112–13
Cultural politics, 1, 21, 27, 40, 63; political correctness and, 16–17; postmodernism and, 8–12, 146–47
Cultural projection, 30
Culture/nonculture distinction, 80–81, 144–45
Cure of Folly, The (Bosch), 112, 120, *120*

"Death of the Author, The" (Barthes), 51, 56
Deconstructionism, 1–3, 6–12, 18–19
de Lauretis, Teresa, 32, 33
Derrida, Jacques, 1, 4–8
Disciplinary autonomy, 25
Discursive practices, 48–49
Divine and artistic creation, 125–28, *126*
Dominican confraternity of the rosary, 106–7, 108, 109
Dürer, Albrecht: on artistic creation, 127–28; Panofsky's interpretation of, 66, 69, 70, 72–78
—*Melencolia I, 73,* 73–78; figure of woman in, 74, 91–92; as high art, 80, 88–96
—*Self-Portrait,* 126–27, *126*
"Dynamic object," 32–33

Elite humanism, 88, 112, 145
Engravings, 89
Eurocentrism, 68
Exteriority, 114
"Extra-aesthetic values," 38

"False consciousness," 41–44
Fantasy in artistic creation, 122–29, 131–36
Feminism: cultural history and, 40, 65–66, 109–10; expressed in art, 94–96
Folengo, Teofilo, 123

Foucault, Michel: on authorship, 51, 56–57, 113–14; critique of institutions, 48–49
Freud, Sigmund, "Mourning and Melancholia," 75

Garden of Earthly Delights, The. See Bosch, Hieronymous
Garden motifs: "Garden of Love," 138; Virgin in the garden, 103
Gay and lesbian studies, 65
Gaze, the, 46, 52–54
Gender, 91, 95, 96; inversion of gender roles, 85–86, 133, *133;* "power of women" theme, 136–38, *138;* the rosary confraternity and, 109–10
"Genius," the artist as, 73–74, 111, 146–47
Gibson, Walter, 136, 138
Glockendon, Albrecht, 80, 83
Gombrich, Ernst, 29–30, 117
Goodman, Nelson, 30, 32
Gossaert, Jan, 117–19, *118, 121*
Graff, Gerald, 17
"Great" art, 79
"Grotesques" genre, 129, *130,* 131

Haywain Triptych (Bosch), 112, 119
"Hearer-oriented" culture, 81–83
Hell scene, in Bosch's *Garden,* 140, *143,* 145
Heterogeneity, 67
High art, 79–80, 96, 145; *Melencolia I* as, 80, 88–94
Hirst, Paul, 46
Historian, role of, 50, 60–61
"Historical horizon," 15–16, 38–39, 112
Historical/social context of art, 17–19, 85–86, 112–13, 146–47
History: Marxist approach to, 8–9, 11, 41–42; political engagement and, 17–19, 24–25; poststructural theory and, 5, 65, 99. *See also* Art history
Horace, 122, 129
"Horizon of expectation," 38

Horkheimer, Max, 24
Housebook Master, 140, *142*
Humanism, 56–57; elite, 88, 112, 145; of Panofsky, 70–72, 77, 93–94
Hunt, Lynn, 65

Ideology, 41, 114; as "false consciousness," 41–44; power and, 48–49; semiotic understanding of, 43–45, 46, 47, 49–50; state institutions and, 44–45
Illuminated manuscripts, 131–36, 140–41, 144, 145
Illusionistic art, 29–30, 54
Image, surface of, 110, 147
Institutions: canonical works and, 39–40; critiques of, 11–12, 45, 48–49; state, 44–45
Interpellation theory, 45–46
"Interpretant," 32, 33, 35
Interpreter, subject as. *See* Artist; Authorship
Inversion principle, 132–41, 144–45
Italian Renaissance art theory, 120, 122–29, 131, 146

Jauss, Hans Robert, 38–39

Kant, Immanuel, 37, 67
Krauss, Rosalind, 99
Kruger, Barbara, Untitled (*We won't play nature to your culture*), 94–98

Lacan, Jacques, 10, 13, 45–48; on the human subject, 51–54, 60, 102
LaCapra, Dominick, 2–4, 9, 15
Language: art history and, 6–8, 12, 80, 81, 101; epistemological claims of, 10, 43–44; poststructural theory and, 101–2; subjectivity and, 52–53; textuality and meaning in, 1, 3–5, 10, 23; transcendental narratives, 7, 8. *See also* Semiotic theory
Last Judgement format, in Bosch's *Garden*, 145–46
Lauretis, Teresa de, 32, 33

LeGoff, Jacques, 107
Lentricchia, Frank, 10
Leonardo da Vinci, 74, 123; *Ventricles of the Brain, 125*
Lesbian and gay studies, 65
Lévi-Strauss, Claude, 1
"Logocentrism," 6, 8
Lotman, Juri, 80, 89
Low art, 79–80; Schön's woodcut as, 80, 83–89, *86*

Madness and art, 58–59
Mannheim, Karl, 42
Marian iconography, 105–10
Marxism, 11, 27, 65–66; semiotic theory and, 35–36, 42–45; as theory of history, 8–9, 41–42
Mask, 47, 54, 55. *See also* Unmasking
"Master narratives," 11–12
Master of the Die, *130*
Meaning: creation of social, 45; "excess" of, 47–48, 54; and "meaning effects," 1. *See also* Language
Melencolia I. See Dürer, Albrecht
Michelangelo, 129, 131
Mimesis, 79, 98; artistic representation as, 29–31, 54, 102–3, 110
Minott, Charles, 103
Mirror stage, 46, 52–54
Monsters, 134, *135*
"Mourning and Melancholia" (Freud), 75
Mukarovsky, Jan, 31, 37–38
Museums, 39–40
Mysticism, 106, 110, 111

Narrative: cultural function of, 18; "master," 11–12; transcendental, 7, 8
National Gallery of Art, 11–12
Nationalism, 68–70, 76–77
Nationalist theories of art, 68–69
Naturalism, 64
Nature: art as mimesis of, 28–31, 35; inversion of relationships in, 134–36
Nehamas, Alexander, on the "author function," 57–58, 60–61

Nietzsche, Friedrich, 1, 23
"Nonculture," 80–82, 86
Nonculture/culture distinction, 80–81, 144–45
Nonmimetic imagery, 129, 131, 136
Nuremberg, popular culture of, 86–87

Opacity, 113
Oppositional values, 48–49
Orton, Fred, 59–60
"Otherness," historical, 15–16

Panofsky, Erwin, 26, 65, 66–67, *76;* on Bosch, 111–12; on Dürer, 66, 69, 70, 72–78, 91–92; humanism of, 70–72, 77, 93–94; nationalism of, 68–70, 76–77
Patrons, art, 115–20, 122, 141, 144
Pierce, Charles Sanders, 32; theory of semiotics, 32–35
Piercian sign, 32–34, 45
Pluralism, 14–15
Political correctness, 16–17
Political engagement, 17–19, 24–25
Politics. *See* Cultural politics
Pollock, Griselda, on biography, 58–59
Popular culture, 86–87, 145
Positivism, 2–3
Poster, Mark, 9
Poststructural theory, 1–3; language and, 101–2; as theory of history, 5, 9, 24
Power, social, 48–49
"Power of women" theme, 137–40, *138*
Prague school, 31
Preziosi, Donald, 6, 8–9
"Primary" modeling systems, 81, 91
Psychoanalytic theory (Lacanian), 13, 45–48; the human subject in, 51–54, 60, 102
Purgatory concept, 107–8

"Reality effect," 89–90
Relativism, 14
"Representamen," 32
Representation: deconstructionism and, 10; as mimesis, 102–3, 110; nonmimetic, 129, 132; resemblance theory of, 29–31; semiotic theory and, 43, 51, 101–2

Resemblance theory of representation, 29–31, 129; art as mimesis, 102–3, 110
Resistance, 48–49
Rorty, Richard, 7, 14
Rosary, history of devotion to, 106–9
Rose motif, 103

Said, Edward, 7, 10
Saint Bernard de Clairvaux, 131
Satirical art, 122, 132–33, 135
Saussure, Ferdinand de: Marxist critique of, 35–36; semiotic theory of, 31–32, 101–2
Schmitt, Jean-Claude, 109
Schnabel, Julian, *Exile,* 96–97, *97*
Schön, Erhard, woodcut by, 80, 83–89, *86*
Schongauer, Martin: portrait of, 99–101, *100; The Virgin in a Rose Arbor,* 103–10, *104*
"Secondary" modeling systems, 81, 91
Seeing through, 99
Self-Portrait (Dürer), 125–27, *126*
Semiotic theory: art history and, 60–61; "collective awareness" and, 37–38; Marxism and, 35–36, 42–45; Piercian, 32–35, 36; Saussurian, 31–32; Soviet, 35–36, 80–82, 114. *See also* Psychoanalytic theory (Lacanian)
Sexuality, 146
Signification: bipartite or binary, 10, 31, 34, 35; primary and secondary modeling systems of, 81, 91; tripartite, 32–36, 45. *See also* Semiotic theory
Silverman, Kaja, 46, 55
Social/historical context of art, 17–19, 85–86, 112–13, 146–47
Soviet semiotic theory, 35–36, 80–82, 114
"Speaker-oriented" culture, 81–82, 89
Sterk, J. J., 121, 129

Subject, interpreter as. *See* Artist; Authorship
Surface, image, 110, 147
Symbolic, the (Lacanian), 52, 53

Tagg, John, critique of institutions, 10–11
Tartu school of semiotics, 80–82
Textuality, 3–5, 10, 23, 114; transcendental narratives, 7, 8. *See also* Language
Theatre and visual arts, 87
Theory: critical, 24, 59–60; function of, 23–27. *See also* Deconstructionism; Poststructural theory; Psychoanalytic theory (Lacanian); Semiotic theory
There Is No Greater Treasure Than an Obedient Wife Who Covets Honor (Glockendon and Schön), 80, 83–89, *86*
Transcendental ideas of creativity, 146
Transcendental narrative, 7, 8
Tripartite signification, 32–36, 45
Trompe l'oeil, 54, 136

Universalist aesthetics, 37, 67

Unmasking, 10. *See also* Mask
Uspenski, Boris, 80, 89

Value: aesthetic, in art, 37–40; "extra-aesthetic" values, 38; oppositional, 48–49
Vandenbroeck, Paul, 112–13
van Gogh, Vincent, 59
Vetter, Ewald, 103, 105, 106
Virgin, iconography of the, 105–10
Virgin in a Rose Arbor, The (Schongauer), 103–10, *104*
Visual arts: subjectivity and, 52–54; theater and, 87
Vitruvian canon of anatomical proportions, 119, 120
Volosinov, Valentin, 35, 41, 43, 114

Warner, Marina, 109–10
White, Hayden, 1, 2, 12–13
Women. *See* Gender
Woodcuts, 83
World upside-down, 132–41, 144–45

Žižek, Slavoj, 47–48